Drawing From Within

Using Art to Treat Eating Disorders

Lisa D. Hinz

Jessica Kingsley Publishers
London and Philadelphia

First published in 2006
by Jessica Kingsley Publishers
116 Pentonville Road
London N1 9JB, UK
and
400 Market Street, Suite 400
Philadelphia, PA 19106, USA

www.jkp.com

Copyright © Jessica Kingsley Publishers 2006
Printed digitally since 2009

Library of Congress Cataloging in Publication Data
Hinz, Lisa D.
 Drawing from within : using art to treat eating disorders / Lisa D. Hinz.
 p. cm.
 Includes bibliographical references and index.
 ISBN-13: 978-1-84310-822-1 (pbk. : alk. paper)
 ISBN-10: 1-84310-822-4 (pbk. : alk. paper) 1. Eating disorders--Treatment. 2. Art
therapy. I. Title.
 RC552.E18H54 2006
 616.85'2606--dc22
 2006009136

British Library Cataloguing in Publication Data
A CIP catalogue record for this book is available from the British Library

ISBN 978 1 84310 822 1

Contents

List of Figures

Preface

As a young psychologist I thought that I had to have all of the answers for my patients. I provided them with information about the physical complications and adverse effects of eating disorders. I taught them coping and relaxation strategies, and together we examined their childhoods for contributing factors. I talked a lot. And it seemed that the more I talked and the more I gave, the more inadequate I felt. I experienced patients rejecting the information almost as if they had been force-fed food. They would hold it in for a while, but soon it would come back out, largely undigested. Despite my having what I believe was a good education in the treatment of eating disorders, only some patients were treated effectively; many were not.

I first encountered art therapy when I began supervising an art therapy student at a college counseling center. With my first exposures to art therapy, I observed the power of the art to heal and aid psychological growth. I saw that art could help patients express complex ideas for which words were inadequate. Art could contain emotions that previously patients were fearful of experiencing or communicating. Art could help isolated patients engage others by allowing them to share universal symbols. The process of creating could be soothing, or even invigorating.

I began experimenting with the use of art in psychotherapy and discovered that eating disordered patients could begin to use art instead of food to purge thoughts and feelings that were troublesome to them. Later they could be encouraged to use art not just to purge, but also to develop ideas and to communicate them (Levens 1995b). Art could be used to help patients envision a positive future. As I began to use art more regularly in the treatment of eating disorders, patients appeared to more readily accept therapeutic interventions. I realized that patients did not feel force fed when working with their own images. Using art in therapy helped me realize that I did not have to provide all of the answers to my patients. The art held the answers that they needed. And these answers came from within *them*, not me. Using art helped patients digest information and present it to themselves in ways that made sense – literally or symbolically. Over and over again I watched as patients realistically or abstractly

showed me that the healing wisdom they needed to recover from eating disorders existed inside of them.

My role as a psychologist and art therapist changed as I realized that patients possess this healing wisdom. They merely needed my help in accessing it. The process of using art in therapy has been likened to midwifery (Malchiodi 2002). Therapists help deliver ideas and feelings in the form of imagery that exists in patients, waiting to be born. When patients experience the birth of these very personal images, they experience hope and faith in themselves and their abilities to heal.

I was compelled to write this book for two reasons. First, I wanted to convey the power and promise of art in healing. Second, I wanted to give hope to therapists interested in treating eating disorders and to the patients with eating disorders themselves. I have often told my patients, there is no problem so big that it cannot be solved. And I sincerely believe that any problem *can* be solved and that art can be a stimulating and potent tool in the healing process.

I anticipate that readers of this book will be re-energized as they approach the treatment of eating disorders. Therapists can incorporate some or all of the art experiences into their practices. The work begins with basic concepts and proceeds to more complex issues, thus, using the art experiences will work best if they are done in the order presented. I hope that readers will be as inspired as I was by the promise and power of art in healing eating disorders. I also hope that this book will encourage readers to experiment with the use of art in treating eating disorders, to get more training in the use of expressive techniques, and to use art with joy in therapy and in life.

Lisa D. Hinz, Ph.D., ATR
St. Helena, California

Acknowledgments

Writing is a solitary activity, but I did not write this book alone. From the start there were people who inspired the book and in the end its intended audience, both influential presences throughout the writing. Also in my mind were the women and men with whom I have had the privilege to work as a therapist. I would like to thank them for allowing me to be a part of their healing journeys. From them I learned so much of what is written here.

I have had many creative and knowledgeable art therapy teachers, mentors, and colleagues. I have given credit for ideas and art experiences to those whom I know to attribute it. Sometimes ideas or experiences have been with me for so long that I do not remember their genesis. To the origi-nators of this knowledge and skill I thank you for your expertise and gener-osity. You are part of me.

There are others who have greatly helped and encouraged me along the way. Judy Tribble, Director of the Saint Mary-of-the-Woods College library, is a librarian extraordinaire. Her helpfulness and efficiency in so many areas made the research go smoothly. Miriam Iosupovici was a gift delivered from the past to help with editorial comment and advice, thank you. Alona Hinz was a tireless editor who improved the manuscript with her initial observa-tion about it, and has improved it with each subsequent comment. My won-derful family believed in me and encouraged me. They checked on my progress and kept me company or left me alone – whatever I needed at the time. A special thank you to Andreas, Elena, George, and Sophia Sakopoulos.

I would like to express my heartfelt thanks to the women and men who allowed me to use their powerful artwork and wise words to illustrate this book. Their stories made this work come alive.

Using Art to Treat Eating Disorders

Let each man exercise the art he knows.

Aristophanes (c. 448–c. 388 BC)

Why art?

Art can stimulate psychological growth and support healing in several ways. Inherent in the art itself are properties that can promote growth. Art can produce significant personal symbols as well as tap into universal themes. Art heals because of the way people react to the artistic process and to the images produced. Therefore, when using art in therapy, there is knowledge to be gained from observing the *person* creating the art, by witnessing the *process* of producing art, and from viewing the art *product* itself (Ball 2002; Schwartz 1996). All are equally valuable sources of therapeutic information.

Persons with eating disorders are often overly reliant on verbal defense mechanisms such as rationalization, intellectualization, and persuasion. They obsessively discuss and argue with friends and family about food and weight-related topics such as the caloric value of food, fad diets, and body image. Displaying this knowledge helps the eating disordered individual feel a sense of control in relationships (Reindl 2001; Way 1993). The same defense mechanisms, used to protect the self and provide a sense of control in the world, are also used in verbal psychotherapy (Matto 1997). Reliance on rationalization, intellectualization, or arguments can slow progress in therapy and create frustration in both patients and therapists. Eating disordered patients often try to protect themselves from the intimacies of psychotherapy, and relationships in general, by arguing about food, calories, and weight – issues irrelevant to psychological healing. The use of art can help focus therapeutic work on relevant issues. In addition, art provides a different method of communication where language does not interfere (Matto 1997; Rehavia-Hanauer 2003; Schaverien 1995). Art aids the focus on strengths and positive qualities because art often touches on universal healing themes (Levens 1995b; Makin 2002). Art more easily allows the practitioner to see beyond the symptoms and negative self-presentations of eating disordered persons. In addition, the use of art promotes

an active role for patients in treatment. Patients are empowered by their active participation in recovery (Farrelly-Hansen 2001).

Because art uses images it bypasses language. Consequently, using art in therapy can cut to the heart of an issue more quickly than verbal psychotherapy. Images can bypass language-based defenses to reveal inner truths (Levens 1995a; Malchiodi 2002). Persons who experience art-facilitated therapy are less likely to verbally censor, argue, or confuse themselves and are more likely to be open to the sometimes surprising image answers pulled by the art from deep within themselves (Levens 1995a, 1995b; Makin 2002; Rabin 2003).

An example of this openness came from a woman suffering from anorexia nervosa who was a reluctant participant in psychotherapy and who was especially resistant to art therapy. This woman talked about how little food she consumed and argued that despite eating so little she really was incredibly fat. She talked on and on about how worthless she was if she weighed more than a certain amount. Her primary therapist, who used verbal psychotherapy, experienced this woman as difficult to work with, controlling, and negativistic.

In her first session using art media, the woman chose a black paper and a yellow chalk pastel. In explaining her image, which is displayed in Figure 1.1, she stated that she purposely chose the color yellow because she disliked it and she was determined to dislike art therapy. However, she made some shapes and found that they were pleasing in several ways: She liked the circular and other organic forms. She liked the way the yellow pastel stood out against the black

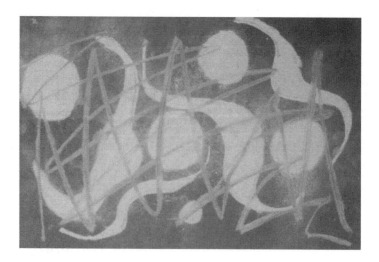

Figure 1.1: "Beautiful Symphony" – Art evokes healing responses from negativistic patients

background paper. Finally, she liked the way that the chalk dust flowed from the image making her think of the Milky Way. The woman admitted that the image was too pleasing so she chose another deeply disliked color, purple, and purposely made heavy jagged lines across it. Again, she was surprised that the resulting image was pleasing to her. She liked the contrast of the purple on yellow and she thought that the combination of jagged lines and circular shapes looked like a piece of music.

After silent contemplation, the woman said that the art experience and the image she created taught her something about her recovery from anorexia nervosa. She explained that recovery would likely consist of discovering parts of herself that were individually disliked or displeasing but, in the end, the overall effect would be like experiencing herself as a beautiful symphony. The art experience cut through her previous tendency to intellectualize and obsessively discuss her food intake, body image, and weight. The image revealed something beautiful about her regardless of how she would have liked to deny it. This same healing revelation probably would have taken much longer without the help of the art experience. The image and the process of making it pulled an affirming attitude from deep within this previously negativistic woman.

This example also demonstrates that the *process* of creating art can be just as important as the image produced. If the woman in the previous example had not gone through the process of purposely choosing colors and shapes that were disliked, but whose combinations resulted in pleasing images, she would not have had the same learning experience. In fact, the same lesson would not have been learned in verbal psychotherapy if the woman had tried to explain or rationalize her likes and dislikes. The artistic process played a vital role in teaching her about herself and helping her actively engage in recovery. Therapy with eating disordered patients often involves long periods of silence (Makin 2002). Patients are filled with shame which prohibits them from talking freely, or they are defensively guarding their secrets. The use of art helps fill periods of silence with productive activity. Patients can participate in therapy without having to reveal themselves verbally earlier than is comfortable.

Many people have not used art media since elementary school. Their struggles to master the half-forgotten materials during the creative process can teach or reinforce approaches to problem solving (Matto 1997; Schwartz 1996). This process can include finding something beautiful even when determined not to do so, as it did for the woman described previously. Sometimes mastering the materials means trying again and again. I have witnessed the creative process pull previously undemonstrated determination, perseverance, and resilience from patients as they work with unfamiliar art media and struggle to communicate essential information about themselves through images. Growing

competence with the media promotes a sense of mastery and control that is not rooted in eating disordered behavior. It has been my experience that when working with art media the *person* not the disorder is in charge. The person is no longer a prisoner of the eating disorder when involved in making art. Invariably there is a great deal of learning from the creative process and a great sense of pride in the self and the completed product.

The art product or image produced can convey information directly or indirectly to the creator. Directly communicated information comes in the form of representational images. However, even in what appear to be straightforward representations, variations in the formal artistic elements such as size and placement of figures, colors chosen, and the use of space are used to express additional information. Two persons, given the same directive to draw their families, can convey vastly different feelings with different sizes, colors, and placement of figures. One person might represent her family by drawing four separate small figures with white space surrounding them. The resulting picture would feel isolated and lonely. Another person might represent his family by placing four figures so closely together that there is no real separation between them. The feeling in the second picture would be undifferentiated and oppressive.

The use of art allows one to demonstrate what may be difficult to put into words (Fleming 1989; Lubbers 1991; Wiener and Oxford 2003). What patients find difficult to explain verbally may be more readily articulated with colors, shapes, and lines. Thus, images act as short-cuts to the expression of difficult concepts or emotions. Writing in *The Soul's Palette* (2002), the prominent art therapist Cathy Malchiodi called images "midwives" between experience and language. She explained that a simple image can express quickly and easily what would take hours to explain in words. Facilitating expression is especially important in working with people with eating disorders who have often given up their original voice to become what others wanted them to be (Andersen, Cohn, and Holbrook 2000; Reindl 2001; Thompson 1994). Sometimes confronting himself in the art product is a patient's first experience of his authentic self, or the first exposure to previously denied or split off parts of the self (Levens 1995b; Makin 2002; Rabin 2003).

Unlike words, images can easily include multiple feelings and relationships (Malchiodi 2002). Images can contain and explain varied ideas, emotions, and conflicts in ways that words cannot. Art is an effective container for, and liberator from, the ambivalence that persons with eating disorders feel about recovery. The ability to contain and explain two opposing feelings makes art images uniquely communicative. The young woman who made the image in Figure 1.2 used it to help clarify for her parents the ambivalence she felt about recovery. She explained that anorexia nervosa was a safe set of rules and rituals (the checker-

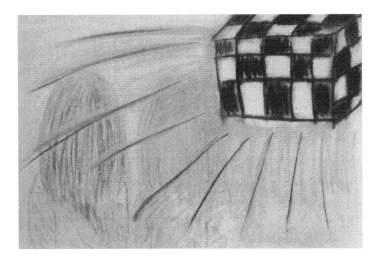

Figure 1.2: "Checkerboard Safety Net / Trap of Anorexia Nervosa" – Art helps demonstrate ambivalence

board box in Figure 1.2) that she used to govern her life. She added that while in psychotherapy, she had also realized that the eating disorder was a trap (also the checkerboard box, in Figure 1.2). She explained that she was working toward having relationships replace the eating disorder, but they did not yet feel comfortable. The young woman's parents were better able to understand their daughter's ambivalence after seeing this image; they could *see* her struggle: the safety *and* the trap of anorexia nervosa. They were less likely to admonish her with statements such as, "there is nothing positive about this deadly disease." They were better able to support their daughter in relating to others rather than retreating to food rituals. The empathy that the parents developed about their daughter's dilemma eased a conflict between them and greatly facilitated recovery.

Images can speak to us indirectly using metaphors. The checkerboard safety net/trap is a metaphor in the previous example. This communication process can be described as the unconscious (the part involved in creating) speaking to the conscious (the part involved in perceiving the finished product). The conscious self only had been aware of the safety of the eating disorder until the unconscious self revealed it to be a trap. The art product can have a dreamlike quality as metaphors speak in a similar fashion to dreams (Malchiodi 2002). For example, a person feeling emotionally overwhelmed might picture himself drowning or someone cut off from her emotions might depict herself as a robot.

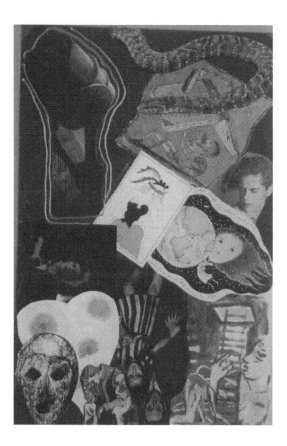

Figure 1.3: Art helps display the complexities of what purging means to a bulimic patient

Metaphors can be explored on many levels in order to deepen understanding about struggles and emotions. Figure 1.3 was a bulimic woman's metaphorical explanation of her purges. The large bucket in the upper left-hand corner of the picture is pouring out the emotions and thoughts being purged in the form of images. The young woman worked quickly to produce the collage and was not aware of everything that her purges contained until she was confronted with the finished art product. She was particularly struck by the heart in the lower left of the picture, which she found in a box full of precut images; it had been created by another person. She exclaimed with wonder that its inclusion in her collage showed her how she was purging "other people's pain" taken on inappropri- ately. She explained that until she viewed her collage, she was not aware that her purges had anything to do with her taking on other people's burdens.

bilities. Images can speak directly and metaphorically about long-buried positive qualities. Issues emerge more rapidly when painting, drawing, and sculpting than with words alone. Finally, the image on paper serves as an enduring testament to the work performed in therapy – a witness to the internal wisdom that every person suffering from an eating disorder has within him or herself.

art not Art

When embarking upon a therapeutic journey using art as a healing medium, it is important for patients and therapists to understand that *no artistic talent is required to be effective*. Art therapist and author Adriana Diaz (1992) has determined that talent is a product-oriented word. Our patients must know that the outcome of the therapeutic session is not exclusively the art product. The importance of the session resides in the insight that a person gains about him or herself from engaging in the creative process, from interacting with the therapist, as well as from the final product. According to Diaz talent has no association with the depth of human experience involved in the creative act. Art therapists agree, and many have written, that *anyone* can use art media in a creative manner for self-expression (Capacchione 2001a; Cornell 1990; McNiff 1998; Williams 2002). In order to reduce emphasis on product outcome and to encourage people to express themselves freely with art media, pioneering art therapist Janie Rhyne (1984) encouraged participants in expressive therapy to "doodle" rather than to draw. Doodles were then used to help participants gain insight into their inner thoughts and feelings.

The art experiences outlined in this book do not demand the production of Fine Art. Rather, the art images produced are used as a means of enhancing self-understanding. Art can be introduced as a different way to gather and communicate information about the self. Sometimes it is helpful to explain the different ways in which the two sides of the brain process information. Very simply, patients can be told that the left side of the brain processes information in a linear fashion. The left side of the brain contains the language center; information processed here is labeled, linear, and orderly. The right side of the brain is oriented to processing visual-spatial information. Information processed by the right side of the brain is intuitive, emotional, and spiritual (Edwards 1989; Riley 2004). Without words, and using images instead, information is more likely to be processed on the right side of the brain and to contain emotional and spiritual truths (Capacchione 2001b; Edwards 1989; Riley 2004). Riley hypothesized that the greatest potential for therapeutic growth occurs when information from art (predominately visual-spatial or right-brained) is discussed with a therapist (predominately verbal or left-brained). She asserted that integration of

information from *both* sides of the brain gives therapeutic answers more powerful than either type of information alone.

Upon entering art-assisted therapy, patients need to be assured that the images do not need to be beautiful in a classical sense. Patients need to understand that the images will inform; they do not have to adorn. In fact, sometimes patients are asked to make "ugly art" to free them from the idea that what they are producing has to be beautiful (Cooper and Milton 2003). Men and women with eating disorders need to be especially assured in this regard. They have been so long under the impression that they themselves have to adorn, that their looks were the most important attribute that they possessed. Often they have not felt free to be themselves (Andersen *et al.* 2000; Pipher 1995). Using art in therapy can be their first experience of the authentic self. Persons with eating disorders need to understand that there are no expectations of beauty or of any other sort. They need to be free to create whatever best embodies their feelings and thoughts at the time.

The rest of this book

The rest of this book is divided into eleven chapters. Chapter 2 defines eating disorders and their development and also explains the seven areas that are targeted for exploration and healing in art-assisted therapy. It includes explanations of why these particular areas were chosen, and discusses how they may be represented and expressed through art. Chapter 3, "Getting Started Using Art in Therapy," will guide the choice of art materials and introduce the process of using art for therapeutic exploration. It also contains the first structured art experience.

There are two broad approaches to the use of art in therapy. One is to allow spontaneous expression with art materials in an unstructured manner. In this approach no instructions are given to patients; they are allowed to express themselves in any manner they choose. In the other approach, structured experiences are specified in order to guide the direction of therapy and the type of information produced through the art images (Cooper and Milton 2003; Levens 1990; Matto 1997; McMurray, Schwartz-Mirman, and Maizel 2000). It is recommended that specific art experiences are used with persons suffering from eating disorders in order to limit the potential for acting out with the art media and the possible occurrence of destructive regression (Levens 1990; Matto 1997; McMurray *et al.* 2000).

Ball (2002) wrote about her experiences using art with patients prone to acting out their emotions. She stated that during therapy a change occurred in patients' ability to attribute meaning to emotions rather than impulsively act them out. This shift was attributed to having set out firm rules as a framework

for how to respond to emotions with art. Working within the confines of a structured activity promotes information processing on a cognitive level and the active working through of difficulties (Kagin and Lusebrink 1978; Levens 1990). This book contains specific art experiences with instructions to help patients identify and work through issues common to persons with eating disorders.

Chapters 4 through 10 provide in-depth explorations of targeted areas with recommended art experiences and response pieces for each. Response pieces are therapist designed art experiences meant to provide patients with corrective emotional experiences through the art. They are intended to change an initial negative reaction to a more realistic or positive one. I first began using response pieces many years ago with a patient who seemed to relive her childhood abuse and display her current self-destructive wishes through every art image. She seemed to present me with graphic images of abuse and self-harm as if to challenge whether I really wanted to know her secret wishes and fears. After accepting a few of these images without revision, I began challenging *her* to reorganize the images in constructive ways. She was asked to show herself as a child responding differently, or to depict her current self using the coping skills that she had been taught. The patient completed the response pieces as requested, and after a time her *original* art was characterized by coping skills and different cognitive and emotional responses to childhood trauma.

Response pieces as they are presented in this book are meant to provide patients with similar corrective cognitive and emotional experiences. Art experiences have the potential to evoke negative thoughts and feelings in response to difficult therapeutic questions. Response pieces are designed to counteract negativity and provide patients with action-oriented, positive answers which did not surface originally. By completing the art response pieces patients will be led toward regaining their inner wisdom and will take significant steps in recovery.

Each art experience and response piece is accompanied by a list of recommended materials and expected themes which may arise in response to the creation of the art product. These themes are related to characteristic behaviors, thought patterns, and personality characteristics typically seen among eating disorder patients. Chapters 4 through 10 also contain "Homework and Healing Dimensions" sections which suggest activities that can be completed by patients between sessions to extend and deepen learning. Research has demonstrated that the majority of psychotherapists assign homework to their patients (Kazantzis, Lampropoulos, and Deane 2005). It has been my experience that patients who use time between sessions to complete additional therapeutic work make more profound and long-lasting treatment gains than those who do not.

This observation was confirmed in recent research by Carroll, Nich, and Ball (2005) treating cocaine dependent patients. Therefore, homework assignments are suggested and encouraged. It is recommended that homework assignments be recorded in a creative journal so that another permanent record of change is created. The creative journal is described in detail in Chapter 3.

Chapter 11 discusses termination issues which are similar and different from termination concerns in other types of therapy. It also contains summary information and recommended resources. Finally, Chapter 12 concludes the book with a discussion of ethical considerations and cultural issues. In addition, Chapter 12 introduces the use of art with families and in groups. The final chapter also demonstrates the ways in which art can be used in prevention efforts.

CHAPTER 2

Eating Disorders and Target Areas for Healing

*What lies behind us and what lies before us are tiny matters
compared to what lies within us.*
Ralph Waldo Emerson (1803–1882)

Introduction

In twenty years of working with women and men suffering from eating disorders, I have witnessed many changes in various professional communities. Mental health professionals have debated about definitions of eating disorders and diagnostic criteria. Insurance companies have frequently changed the criteria for, and availability of, treatment covered. However, what have *not* changed in all of these years are the fundamental characteristics of men and women with eating disorders. I am not referring to caloric restriction, binge eating, or body image dissatisfaction, which also have remained disconcertingly similar over the years. Rather, I am referring to the intelligence, sensitivity, and caring consistently demonstrated by the persons with eating disorders whose healing journeys I have been privileged to witness.

These men and women have been so fundamentally out of touch with themselves, their strengths especially, that they have often described themselves to me as inconsiderate, lazy, and stupid. However, in my practice using the experiential art described in this book, I have witnessed eating disordered persons reclaim deeply buried positive qualities. Art gives fresh impressions to old ideas about the self. Art brings conflict to light and helps bridge the gap between contrasting parts of the self. Art puts a new face on fear and enlivens the process of change. Art helps people access inner wisdom and heal (Capacchione 2001b; Diaz 1992; Ganim 1999; Malchiodi 2002).

The purpose of this chapter is to provide an overview of the different types of eating disorders – their psychological and physical characteristics and complications. In addition, it will introduce common areas for healing that many

21

people share regardless of the specific type of eating disorder. These areas for healing will form the basis for later chapters and organize the art experiences in this book.

Definitions of eating disorders

Eating disorders are catalogued by the *Diagnostic and Statistical Manual of Mental Disorders, Fourth Edition, Text Revision* (DSM-IV-TR) as psychological disorders first diagnosed in infancy, childhood, or adolescence (American Psychiatric Association (APA) 2000a). In general, they are characterized by thoughts and behaviors about food, weight, and body image. There are three main types of eating disorders: anorexia nervosa, bulimia nervosa, and eating disorder not otherwise specified. A recent meta-analysis of worldwide medical and psychiatric literature demonstrated the incidence of anorexia nervosa increasing over the past century until the 1970s (Hoek and van Hoeken 2003). Using strict diagnostic criteria, the prevalence of anorexia nervosa was found to be 0.3 percent for young women and much lower for males. The prevalence rates of bulimia nervosa were 1 percent for young women and 0.1 percent for young men. Because binge eating disorder is not recognized as an official DSM diagnostic category, prevalence studies have not used consistent and rigorous diagnostic criteria. However, the prevalence of binge eating disorder was conservatively estimated to be 1 percent among both men and women (Hoek and van Hoeken 2003).

The main characteristic of *anorexia nervosa* is a failure to maintain a body weight within the normal range (APA 2000a). Body weight is at least 15 percent below what is considered ideal for height. Low weight in young women causes the menstrual cycle to cease, often for months at a time. In addition, there is body image distortion, meaning that a person with anorexia often believes that she is overweight when she is below normal weight. Anorexia nervosa also is characterized by an intense fear of weight gain which propels caloric restriction and further weight loss. Anorexia nervosa is further subdivided into two categories: restricting type, in which the sufferer has not regularly engaged in binge eating or purging behavior; and binge eating/purging type, in which binge eating episodes or the use of purging methods have characterized the episode of anorexia nervosa (American Psychiatric Association 2000a).

There are serious physical complications at drastically low weights including: hormonal abnormalities, hypothermia, anemia, compromised heart function, and bone density loss (Katzman 2005; Rome 2003). Anorexia nervosa is associated with death among 5 to 10 percent of those suffering from it which is one of the highest mortality rates among mental disorders (American Psychiatric Association 2000a). The self-starvation that characterizes anorexia

nervosa is excruciating to maintain. Men and women with anorexia often are plagued by dreams or nightmares about food, obsessive thoughts about food, and terrible hunger pains. As reported above, persons with anorexia nervosa sometimes succumb to eating binges and receive the subtype designator: binge eating/purging type. At times anorexia nervosa changes to bulimia nervosa.

Bulimia nervosa also occurs as a separate disorder with no relation to anorexia nervosa except that bulimia nervosa usually begins with a period of "normal dieting" (American Psychiatric Association 2000a; Stice 2001). In actuality, "normal dieting" usually turns out to be extremely restrictive eating which sets up the dieter for eating binges (Canetti, Bachar, and Berry 2002). Bulimia nervosa is typified by binge eating. That is, large amounts of food are eaten in short periods of time. Often more than one days' worth of calories is consumed in an eating binge. It should also be noted that persons with bulimia nervosa feel out of control during binge eating episodes; frequently eating is described as unconscious. In addition to binge eating, the other main characteristic of bulimia nervosa is inappropriate compensatory mechanisms. Patients with bulimia nervosa attempt to compensate for enormous caloric intake by getting rid of the food or calories through inappropriate means in order to prevent weight gain.

Inappropriate compensatory mechanisms can include purging behaviors such as self-induced vomiting, laxative abuse, or the use of other medications. The occurrence of these types of purging behaviors specifies bulimia nervosa as the "purging type" (American Psychiatric Association 2000a). Other compensatory mechanisms include excessive exercising (2–3 hours per day) and fasting which would specify the "nonpurging type" (American Psychiatric Association 2000a). By definition, the average occurrence of binge eating and inappropriate compensatory behaviors must be at least twice a week for three months.

Bulimia nervosa also is characterized by body image concerns and a sense of self that is inordinately affected by body weight and shape. Much of the day is spent thinking about body image, weight, obtaining food, counting calories, or purging. Persons suffering from bulimia nervosa can have serious physical symptoms such as electrolyte imbalance, malnutrition, tooth enamel erosion, permanent swallowing difficulties, and throat ulcerations (American Psychiatric Association 2000a; Mendell and Logemann 2001; Rome 2003). Many of the physical complications of eating disorders occur over time so that persons suffering from bulimia nervosa or even anorexia nervosa can think that they are physically well even when the body is wasting. Physical complications can take people by surprise after they have been practicing an eating disorder for many years believing that they were physically healthy.

Eating disorder not otherwise specified (ED NOS) is an umbrella term used to describe eating disorders that do not quite fit into the diagnostic categories of anorexia nervosa or bulimia nervosa. For example, eating disorder not otherwise specified might be used to describe a person who meets all of the criteria for anorexia nervosa, but has not stopped menstruating because he is a male or because the eating disorder started before the onset of menstruation. Eating disorder not otherwise specified is the diagnostic category used for what some have called binge eating disorder (Fairburn 1995).

Binge eating disorder is characterized by binge eating in the same manner as bulimia nervosa. People with binge eating disorder eat large amounts of food in discrete periods of time and report feeling out of control during binge eating episodes. However, in the case of binge eating disorder, there are no inappropriate compensatory mechanisms to rid the body of extra calories (Fairburn 1995; Herzog and Delinsky 2001). Therefore, people struggling with binge eating disorder are overweight or obese. Obesity is associated with serious physical complications such as type II diabetes, hypertension, hypercholesterolemia, and coronary artery disease (Hill, Catenacci, and Wyatt 2005).

The vast majority of eating disorder patients are female (Herzog and Delinski 2001; Smolak and Murnen 2001). Previously believed to be disorders of *young* women, recent years have seen an increase in the numbers of middle-aged women developing first time eating disorders (Bellafante 2003; Forman 2005; Gimlin 2002). In addition, more males have been identified with eating disorders despite patients' perceptions of physician bias for viewing eating disorders as exclusively female concerns (Andersen *et al.* 2000; Lawrence 1999; Pope, Phillips, and Olivardia 2000). Males with eating disorders often report shame about requesting treatment for what they believe is a female problem (Andersen *et al.* 2000). Nonetheless, a small percentage of males do seek psychological treatment with classical presentations of anorexia nervosa (excepting the cessation of menstruation) and bulimia nervosa (Andersen *et al.* 2000; Pope *et al.* 2000; Smolak and Murnen 2001). Perhaps a larger number of men suffer from binge eating disorder than women, but the majority of patients are female (Smolak and Murnen 2001). Finally, men demonstrate unique body image concerns related to increasing muscle mass and never feeling muscular enough, which is sometimes diagnosed as body dysmorphic disorder (Andersen *et al.* 2000; Pope *et al.* 2000) or informally termed muscle belittlement (Olivardia *et al.* 2004).

The genesis of eating disorders

The same positive traits of caring, sensitivity, and intelligence that characterize persons with eating disorders can often serve as the genesis of their disorders.

Research has shown that persons suffering from eating disorders are likely to come from divorced families or to have experienced childhood psychological, physical, or sexual abuse (Mahon *et al.* 2001; Reindl 2001; Rust 1995; Smolak and Murnen 2002; Way 1993). In abusive families children's emotional needs are neglected. In other dysfunctional families parents rely on sensitive children to understand complicated relationship dynamics and may call upon children to meet parental needs. Because they are caring, perceptive, and intelligent, these children try to fulfill inappropriate parental needs and expectations. Children's own needs go unmet and they adapt to this deprivation by meeting needs with food (Bachar *et al.* 2002; Schaverien 1995; Thompson 1994).

For example, a 26-year-old woman I worked with took it upon herself as a child, after experiencing her mother's distress and helplessness at her alcoholic father's violent temper, to shelter her younger brothers from their father. She never displayed her own fear when helping her brothers nor did she allow her anger at her father to surface. She was too afraid of her father's violence and too concerned about her mother's sadness. Instead, this sensitive, intelligent, and caring child shouldered the burden of her brothers' emotions and began binge eating to cope with her own feelings. Children choose food because it is readily available, does not cost them money when taken from family cupboards, and does not immediately impair functioning (Thompson 1994). Most importantly for the child, binge eating provides the desired effect of numbness from psychic pain (Reindl 2001; Thompson 1994).

Another young woman I worked with described herself as compulsive and the most stable and organized member of her family. In fact, an elementary school teacher told this young woman's parents to help her learn to not take life so seriously. Instead her desperate parents, who had two younger children whom they perceived as "out of control," turned to their oldest daughter for advice on how to parent her younger siblings. This oldest daughter sympathetically took on the parenting challenge but with great doubts about her abilities. These doubts, and a growing feeling of being in over her head, caused her to focus on controlling the one thing within her capacity: her caloric intake. A single-minded focus on caloric restriction nearly caused the death of this bright young woman from anorexia nervosa.

It has been written that anorexia nervosa turns psychic pain, which young eating disorder sufferers do not believe is genuine or justifiable, into an observable, physical phenomenon (Levens 1995b; Rabin 2003; Reindl 2001). The concrete physical symptoms of anorexia nervosa say what cannot be spoken in words. As the young woman in this example became more debilitated by anorexia nervosa, her parents no longer made inappropriate requests of her. In fact the young woman received help and support from her parents, something

that she never would have asked. The conflict of wanting help and not being able to ask for it is a central dynamic in anorexia nervosa (Rehavia-Hanauer 2003).

A young man that I worked with was the youngest child in a family of five. His father was verbally and physically abusive and his parents divorced when he was eight years old. At this time, he assumed responsibility for his mother's emotional well-being. The boy absorbed his older siblings' rage at their mother and father. He did housework and yard work without help and without being asked. His aim was to make his overburdened single mother feel better. Therefore he did not express his own sadness and rage at his father for being abusive and abandoning the family. Nor did he express his anger at his brother and sister for not helping. Rather, he swallowed these emotions with great quantities of food and then purged through a rigorous self-punishing exercise routine and fasting. This young man was unaware of how caring, sensitive, and intelligent he was; he was only aware of a great need to binge eat so as not to feel the emotions that threatened to overwhelm him. Persons who develop eating disorders often feel shame about having or expressing their own needs (Reindl 2001; Way 1993). In order to avoid the shame of expressing their needs, they eat. Food is perceived as meeting needs, but purging for the patient with bulimia nervosa is punishing. Thus, at least for the bulimic, the eating disorder is at once an expression of feelings and needs, and a punishment for having felt them (Reindl 2001).

These former patients were particularly sensitive to interpersonal dynamics and cared intensely about family members. Deep sensitivity and caring caused them to take on emotional burdens – usually without being asked – that eventually proved harmful to their physical and emotional health. Intelligence helped them achieve solutions to difficult situations at great personal cost. Children taking on adult burdens are frequently full of shame and self-doubt. Expecting themselves to solve adult problems, they are soon overwhelmed by them, often judging themselves harshly for their perceived failures. Because they are caring and extremely sensitive to the needs of others, they do not display their own anger, fear, or shame at the inequities of the circumstances that they have undertaken. They do not talk about their own needs that frequently have not been met. These children and adolescents use food to control their emotions and as a way to nurture themselves emotionally.

Food is used to occupy the mind. It distracts from thoughts of failure when situations seem impossible. Food soothes feelings that have not been allowed to surface, sometimes for years. Food is used in frantic attempts to fill spiritual voids. A growing dependence on food and rituals surrounding the eating disorder often fill sufferers with a profound sense of shame that overshadows

positive traits. Wisdom is replaced by detachment, lack of faith in abilities, and a spiritual void that leaves eating disordered persons feeling that they will never recover (Bullit-Jonas 1998; Knapp 2003; Way 1993). Nevertheless, eating disordered persons *can* heal using positive qualities that have existed within them since birth and resiliencies that they have not utilized. Help is needed to reacquaint the self with inner wisdom. Art can be an effective tool in this process.

Target areas for healing

As was mentioned earlier, women and men with eating disorders share fundamental characteristics. They are cut off from their emotions, often using food or food restriction to reduce awareness of their feeling and needs. They are disconnected from their positive qualities. Often they are self-rejecting and do not have faith in their abilities to solve problems regardless of their personal and academic achievements (Thompson 1994). Finally, many feel a spiritual void that they attempt to fill with food or food rituals (Bullit-Jonas 1998; Newmark 2001). The following chapters will explore each of these issues in depth. The chapters are divided into target areas for healing: problem solving, reclaiming emotions, body image, self-acceptance, and spirituality. Each of these issues is dealt with in turn. In addition, chapters dealing with childhood influences and exploring the effects of eating disorders on patients' lives are included in order to facilitate change. Patients entering therapy are asked to name the problem and recognize how and to what extent it has caused difficulties in their lives. Many authors have noted that patients with eating disorders, especially those suffering from anorexia nervosa, tend to deny that a problem exists (Levens 1995a; Matto 1997). Beginning therapy with an honest recognition of the problem increases the likelihood of positive change.

Effects of the eating disorder

The initial art experiences are those that explore the effects of the eating disorder on all aspects of patients' lives. These are the first tasks because patients must look unflinchingly at the havoc that the eating disorder has wrought on their lives before it will be possible to consider change. Patients must be willing to honestly assess how time, energy, and money spent on the eating disorder have robbed other areas of their lives. Patients will be asked to look at how they are most vulnerable to the eating disorder and what triggers urges that are most difficult to resist. The art experiences ask patients to look at their entire lives and trace the effects of the eating disorder. There will be effects on the patients themselves: their feelings and beliefs. In addition, there will be effects on relationships, activities, and life choices. Patients must spend time understanding

the impact of the eating disorder on important relationships in their lives. These relationships may need to be changed, repaired, or eliminated in order for patients to recover fully.

Art can help patients externalize the eating disorder and look at it more objectively (Levens 1995b; Makin 2002). Verbal therapy requires that patients talk about past events, whereas art requires an immediate focus on the present art process and product (Lubbers 1991). Focusing on the current difficulties embodied in the art can help free patients from the past. This present focus can decrease denial, increase awareness, and provide motivation for change (Luzzato 1995). Some writers have stated that the most difficult task involved with treating patients with eating disorders is breaking through the denial about the disorders' negative features (Fleming 1989; Matto 1997; Way 1993). Art can embody the negative and highlight the positive as well; art may be a tool for more quickly breaking through patient denial (Levens 1995a; Luzzato 1995).

Understanding childhood influences

Uncovering childhood influences is not meant to be an exercise in finger pointing. Blaming parents or other persons for the part they played in the development of the eating disorder is not productive. Most often, the eating disorder represents a type of adaptation that the sufferer made to a difficult situation. Understanding the eating disorder as an adaptation helps provide answers about how and why feelings were driven underground, positive qualities were covered up, and healing powers were denied. Blame is not helpful, understanding is. Art can be the first way in which order is imposed on the chaos of memories, thoughts, and feelings about childhood. Imposing this order can significantly increase understanding and motivation for meaningful work in psychotherapy (McNiff 1981; Ulman 1975).

Order and organization in the form of physical images can clarify understanding of childhood influences (Fleming 1989; Schaverien 1995). Through the art experiences in this chapter, patients will be challenged to remember their families at the time the eating disorder started, to investigate family dynamics, and to explore generational influences. Art can clearly and concretely illustrate intangibles such as complex family dynamics. In addition, future stress will likely provoke thoughts of, or a desire to return to, eating disordered behaviors (Fleming 1989; Rabin 2003). Understanding childhood influences is a crucial link in relapse prevention because patients will have the ability to prevent stresses that mimic those from childhood. And they will be better equipped to recognize and deal with such stresses if they arise. Finally, using art provides an

actual, healthy alternative to acting out on eating disorder impulses (Cooper and Milton 2003; Matto 1997).

Promoting problem-solving skills

When using the art experiences described in this book, patients will be confronted with unfamiliar materials and processes. With guidance and persistence patients will create meaningful images that aid self-expression. Therapists can reinforce the ways in which successfully using art media as a means of communication is a new skill that patients can be proud of acquiring (Cooper and Milton 2003; Makin 2002; Wiener and Oxford 2003). In Chapter 6 on problem solving, art experiences are intended to help patients become familiar with positive qualities that might have been denied. The art experiences will demonstrate to patients that they have profound inner wisdom with which to confront problems. They will find that stereotypical eating disordered responses are no longer necessary when healing responses are available. Patients will discover that the use of art can be soothing and put them in touch with internal calmness and serenity.

Specific skills which enhance problem solving and decision making can be taught through the use of the art experiences (Makin 2002; Matto 1997). A former patient, writing about the use of art in therapy, said that the use of art made her aware of new ways of coping (Warriner 1995). One challenge for patients in learning new coping skills is to embrace their emerging wisdom and not be frightened into denying it or attributing it to the therapist. Because images are created by patients, art can emphasize more strongly than verbal therapy that healing answers come from patients. Former patients also report that having someone believe in them and their ability to recover was one of the most motivating aspects of eating disorder treatment (Reindl 2001). Art can *show* patients that they can believe in *themselves*.

Reclaiming emotions

Assisting patients in recovery from eating disorders involves helping them become reacquainted with feelings that have been disallowed. The art experiences in Chapter 7 on reclaiming emotions will assist patients in beginning to understand how emotions might have been confused with one another or confused with physical sensations. Like most skills, understanding and responding to emotions (our own and those of other people) takes practice. The art experiences in this chapter will provide patients with practice in identifying emotions, discriminating among them, and learning not to judge or fear them.

The majority of art therapists writing about their work with eating disor-
dered patients have discussed the relative ease with which art helps patients,
often described as having alexithymia (Lusebrink 1990), regain awareness and
expression of emotions (Fleming 1989; Levens 1995b; Lubbers 1991; Makin
2002; Rabin 2003; Rust 1995). Art experiences in this chapter will encourage
patients to explore how feelings have been denied or repressed, and to help
them begin to accept feelings that they might have judged unacceptable in the
past.

A picture may best *explain* complicated emotions for which patients have no
words (Lubbers 1991). Art experiences also can *contain* emotion by

1. providing art materials with inherent structure internalized by
 patients (Lusebrink 1990)

2. providing experiences that encourage cognitive rather than
 emotional responses (Kagin and Lusebrink 1978; Lusebrink 1990)
 or

3. expressing feelings safely within the physical boundaries of the
 paper. For example, patients with bulimia nervosa can be
 encouraged to "purge on paper" rather than with food.

In addition, the use of symbolic content can aid in the development of higher
order coping skills which can replace the need for acting out in negative ways
(Cooper and Milton 2003; Levens 1995b).

Addressing body image issues

One of the hallmark characteristics of persons with eating disorders is disturbed
body image (Polivy and Herman 2002; Stice 2001). From the terror of weight
gain and the distorted body image that characterizes anorexia nervosa, to the
dismay or disgust at obesity seen in binge eating disorder, all persons with
eating disorders must confront their bodily sense of self. Art experiences in
Chapter 8 on body image are designed to illuminate family generational influ-
ences on body image as well as cultural and personal influences. Art experiences
in the chapter also demonstrate the importance of *action* in changing body
image. Body image does not change by thinking about it or talking about it
(Freedman 2002).

The first concrete steps toward changing negative body image can be taken
through art experiences (Matto 1997). Because it is a visual endeavor, art
therapy is uniquely suited to explore and alter body image perceptions (Fleming
1989; Lubbers 1991). Through the use of drawings patients can directly
confront body image distortions (Lubbers 1991; Makin 2002; Matto 1997;
Rabin 2003). Changes in negative body image cognitions and realistic accep-

tance can begin on paper. Finally, art experiences help patients realize and internalize that they are more than the sum of their physical parts. The experiences help patients look beyond the physical to embrace positive psychological and spiritual characteristics.

Enhancing self-acceptance

Many times eating disorders developed because people were taught directly or indirectly that who they were as a person was not adequate or acceptable (Andersen *et al.* 2000; Pipher 1995; Reindl 2001). Art experiences in Chapter 9 on enhancing self-acceptance make information available about unique aspects of self. The art experiences are meant to help patients learn about parts of themselves that have been split off, rejected, or denied. Art is uniquely able to contain the ambiguity inherent in human experience (Cassou and Cubley 1995; Jung 1969; Malchiodi 2002). Confrontation with the art image also helps patients recognize denied or repressed parts of themselves (Jung 1964; Levens 1995a). Because it has been rejected or denied, the information gathered from these experiences might be difficult for patients to confront. They should be guided to allow the information to arise and not immediately judge or censor it.

Therapists can model nonjudgmental and accepting words and behavior by demonstrating more interest in patients and their art than in the details of the food eaten or rejected. When therapists show more interest in patients and their artwork than in the physical details of the eating disorder, this reflects acceptance that will translate into self-interest and self-acceptance (Schaverien 1995; Warriner 1995). Having completed art experiences in Chapter 9 and in the previous chapters, patients are beginning to have a body of work, documenting therapeutic progress, that they can look back on and in which they can take pride (Lubbers 1991; Makin 2002). Pride in therapeutic accomplishments can translate into increased self-acceptance and increased self-esteem (McNiff 1981).

Fostering a spiritual connection

As has been mentioned previously, eating disorders often develop as children adapt to abusive or negligent situations. They learn to use food or food rituals to replace emotions and fulfill emotional needs. Eating disorder behavior evolves into an attempt to fulfill all needs at all times. Throughout this book, art experiences have been designed to help patients become aware of, and accepting of, positive qualities and innate healing wisdom. In Chapter 10 on fostering a spiritual connection, art experiences will explore spirituality as the origin of this innate wisdom. In addition, art experiences are designed to introduce ways that

art can be used to create and maintain a connection with the spiritual – the relationship that can truly fulfill. Art is uniquely suited to exploring the divine because it can put us in touch with personal and universal symbols of the divine presence within (Capacchione 2001b; McNiff 1981).

Regardless of religious orientation, patients will be asked to understand what spirituality means to them. They will be encouraged to use art as a means to nourish the soul (Azara 2002; Carey, Fox, and Penny 2002). Art experiences help emphasize that patients will feel most fulfilled when they are giving to others and how important the giving is – to the self and to others. These exercises more than any others in the book can be repeated at various times to deepen understanding and strengthen the spiritual connection.

Summary

Eating disorders are characterized by preoccupation with food, weight, and body image. All have been associated with significant physical, emotional, and spiritual consequences. Eating disorders develop in part because sensitive, caring, and intelligent children raised in troubled families meet the needs of others, but use to express their own feelings and meet their own needs. Food seems to help solve problems and numb psychic pain. Target areas for healing are directly related to the symptoms and problems seen in eating disorders such as reclaiming emotions, developing problem-solving skills, increasing self-acceptance, and improving body image. Art can be an effective tool in the treatment of eating disorders by helping break through denial. It can bring order out of the chaos of childhood memories and help structure the course of treatment and formulate treatment goals. Art can concretely illustrate and express complex feelings and relationships; it can embody ambivalence. Art can teach specific positive coping skills. Art can be the first step in making constructive changes, and a review of artwork done over the course of treatment can keep track of those changes.

Getting Started Using Art in Therapy

To wake the soul by tender strokes of art,
To raise the genius, and to mend the heart.

Alexander Pope (1688–1744)

Introduction

The German psychiatrist Hans Prinzhorn was one of the first persons to systematically study the art of the mentally ill. Prinzhorn, during the early 1900s, collected and analyzed the spontaneous artistic productions of institutionalized mental patients, mostly schizophrenics. In 1923, he published *Artistry of the Mentally Ill*, demonstrating parallels between pictures made by artistically untrained schizophrenic patients, children's drawings, and the artistic productions of primitive societies. From these observed parallels Prinzhorn concluded that there existed in all persons a universal creative urge.

The field of modern art therapy is founded upon the premise that there exists in all persons a desire or need to create and that "the creative process involved in the making of art is healing and life enhancing" (American Art Therapy Association 2005). There are numerous accounts of the spontaneous creation of art by trained and untrained artists affected by trauma. Art was used as a way of processing or coping with pain and suffering. For example, Alfred Kantor was imprisoned in Auschwitz and other labor and death camps during World War II. He risked his life to draw some of his experiences while imprisoned. Upon his liberation Kantor spent ten weeks drawing the events of his imprisonment as a way to begin to heal from the trauma (Kantor 1971). The pain and humiliation of being a Japanese American prisoner in an internment camp during World War II was drawn by Mine Okubo (Okubo 1983). *My Depression: A Picture Book* was written and drawn by Elizabeth Swados (2005) as a way to cope with the life-threatening effects of major depressive disorder.

Many more examples exist of persons spontaneously using art to heal themselves (e.g., Barry 2002; Henriques 1997; Tinker 1997) and in them, the authors write about how creating art helped them survive or thrive despite their difficulties. Psychologist Ellen Langer (2005) wrote about the life-enhancing

qualities of engaging in the creative process. Writer Natalie Goldberg wrote and illustrated a book about how painting has a synergistic effect on her writing. Goldberg (2002) wrote that engaging in painting infuses her writing with energy and life that it does not have when she is not painting.

The field of art therapy

Art therapy is founded upon the curative nature of the artistic process as well as the universal creative urge. The profession of art therapy developed along parallel lines in Great Britain and the United States. In the United States, from the end of World War II when a great many veterans required mental health services, until the 1960s and the deinstitutionalization movement, many artists and art educators were employed by large hospitals. Artists, under the supervision of psychiatrists, offered patients various types of therapeutic art services in American and British hospitals. The British Association of Art Therapists was founded in 1964 and the American Art Therapy Association in 1969 in order to bring together practitioners from diverse backgrounds and promote art therapy as a unified profession (American Art Therapy Association 2005; British Association of Art Therapists 2005). Currently there are university training programs in both countries where the earned master's degree takes two years of post-graduate study and registration in the profession requires supervised clinical practice (British Association of Art Therapists 2005; Junge and Asawa 1994). Art therapy education emphasizes the judicious application of media choices, therapeutic directives, and artistic interpretations when using expressive techniques.

There are a growing number of general psychological practitioners using expressive techniques in therapy. A recently formed division of the American Psychological Association focuses on creative arts therapies (Winerman 2005). One stated goal of the new division is to introduce more psychologists to the use of expressive arts in therapy and to provide training for persons who would like to integrate expressive techniques into their practices. According to Wiener and Oxford (2003), obtaining appropriate training in the use of expressive therapeutic techniques is important for several reasons. First, the techniques are action oriented, so using words alone to describe them is inadequate to convey their power. Second, without training or supervision practitioners might find first attempts to use expressive techniques unsatisfying and assume that they do not work or that it would take too much training to learn to use them effectively. Wiener and Oxford (2003) argue that the techniques *can* work for most able practitioners and that the amount of training required to employ them effectively is often exaggerated. The reader is cautioned that in order for the art experiences in this book to be used most successfully some training or supervised

clinical practice should accompany them. It would be considered practicing outside one's area of competency to call oneself an art therapist after reading a book or attending a seminar (APA 2002). However, most capable therapists can ethically incorporate the use of art media and expressive techniques with thoughtful preparation and supervision.

When embarking on the use of art media in therapy it is important to be familiar with the various materials that will be offered to patients. If patients are offered freedom of choice in materials and content, they are more likely to engage in a meaningful way with the art media (Ellenbecker 2003). In order to provide patients with choices therapists must be familiar with a wide range of media. Therapists' comfortable knowledge of the properties and uses of art media gives patients a sense of security. Cooper and Milton (2003) point out that it is expecting too much of inexperienced patients to express themselves with materials that are untried. In fact, some materials can be perceived as threatening because of the perfectionism often associated with anorexia nervosa, or because of shame about revealing personal information (Reindl 2001). Approaching an unfamiliar task with an attitude of shame or an expectation of perfection can be paralyzing. It is the therapist's responsibility to explore attitudes and expectations, and to make the media comfortable and thus an effective vehicle for the meaningful expression of thoughts and emotions.

High quality art media

The word "media" is used to describe the materials employed in the art experiences described in this book. Peter London (1989) the author of *No More Secondhand Art* observed that media comes from the Latin word for *middle* and that when making art, media are in the middle between imagination and expression. Media are in the middle between the hand and the paper. The art media are tools. A practical definition of media is "the means by which something is communicated" (DK Illustrated Oxford Dictionary 2003, p.508). Using the word media will help emphasize that art is being used as a tool to aid communication; patients are not making "Fine Art."

Many patients have not handled art media since they were in elementary school. In order for the art experiences in this book to be meaningful for patients and not feel childish to them, it is important to avoid purchasing poor quality media or the types of media that might too readily be associated with elementary school art class. For example, colored construction paper and small scissors will bring kindergarten, not recovery, to mind. In addition, expressive therapist Shaun McNiff (1998) explained that patients using poor quality media may attribute resulting poor quality images to themselves as beginners when the real culprits were the media. Poor quality media are difficult to use and produce

inferior products regardless of talent or experience. As an example, poor quality crayons seem to have a higher content of wax than pigment. A great deal of pressure is needed to make an image and the result is often dull and dissatisfying.

There are many good and even high quality art supplies available at discount arts and crafts stores or online at affordable prices. Good quality art media can make these art experiences both meaningful and enjoyable. The following is a list of media and supplies that would make a good starting "tool box" for the person just beginning to use art in therapy.

Paper

You will need an all-purpose, white art paper – heavy enough to absorb water for painting but smooth enough to provide a pleasant drawing surface. A 60–80 (89–118 gsm) pound all-purpose paper in a 12 x 18 inch (A3) size is a good starting paper. The larger size is recommended because larger sheets of paper can contain more – thoughts, emotions, and ambiguity. Half of a 12 x 18 inch paper is still a good size for some art experiences. Reams of this paper are available at affordable prices. If a large quantity of paper is available, patients are less likely to feel intimidated about "wasting" resources.

Another type of paper needed for some of the art experiences is colored tissue paper. Packages of 25 or 50 sheets of multicolored tissue paper can be found at most arts and crafts stores. Other types of decorative paper or used wrapping paper can be salvaged for use in collage. Colored construction paper, 12 x 18 inches (A3) like the white drawing paper, will make a good background for collages; patients can vary the color of background papers to emphasize a feeling, mood, or other characteristic of a collage.

A collection of old magazines will be necessary for making collages. An assortment of magazines can create a diverse collection of images. Trading magazines with friends or colleagues can help achieve this variety. Therapists often find the process goes more smoothly if they cut or tear images and have them available when patients wish to make collages. In this way, patients spend less therapy time looking through magazines. Adolescent patients in particular can get caught up in magazines and leave themselves little time for actual artwork. Having precut or torn images in a box encourages patients to use more *pictures* than *words* in their collages. In addition, torn images give patients permission to be less perfectionistic because they are not precisely cut. Torn images therefore induce a greater sense of freedom about their use (Landgarten 1994).

Scissors

Scissors can be used for collage and should be carefully monitored in groups and with patients who demonstrate a tendency for self-harm. There are scissors available with decorative edges that can add whimsy and be enjoyable to use.

Pens

Different colored gel pens often provide stimulation to write, or provide just the right small detail on an art image. Gold and silver gel pens are particularly effective for making an image special. In addition, permanent markers will be needed for labeling when other pens cannot penetrate the paper or drawing/painting medium.

Drawing media

Some of the art experiences will require that patients make diagrams or draw images. For these experiences, it is desirable to have a few different types of drawing media available. Markers are a good all-purpose choice. Provide thick and thin markers so that patients will have a choice depending on their preferences. Thick markers will more quickly and easily fill a 12 x 18 inch (A3) paper. Thin markers are useful for precise detail. Crayons are familiar and a comfortable choice for some.

Pastels are chalk or oil drawing media made with pure pigments of color that are ground into a very fine powder and mixed with a binding medium. Two types of pastels are recommended because of their different qualities and the blending effects that they offer. Soft chalk pastels are dreamy and dusty. Some people love them because the colors blend easily; other people dislike them because they smear too readily. If a patient chooses to work with chalk pastels, have some pastel fixative spray to set the completed images. Oil pastels are similar to wax crayons, but they have a relatively high oil content and thus can be easily rubbed, smudged, and blended. Again, some patients love to work with oil pastels because these media allow them to smear and blend colors with ease. Others greatly dislike the oily residue left on their fingers after use.

Colored pencils do not blend as easily as other media. Some people find great pleasure working with them because of the feeling of control that this more restrictive medium offers. Water-soluble colored pencils, or watercolor pencils, provide a compromise because they can be used for added control over the image, and patients who choose them can be encouraged in future sessions to use water to blend them. Regular lead pencils can be made available for sketching.

Paints

Paint is a medium that easily evokes emotion (Lusebrink 1990). Watercolor paint or tempera cakes may be the simplest kind of paint for the non-artist to use. More or less water can be added to the paint to increase or decrease flow. A simple rectangular pan of seven watercolor paints or tempera cakes can be effective. Good quality watercolor or tempera paints with deeply pigmented colors will help ensure satisfying results. A large number of color choices is not necessary because patients can mix colors to produce those that are not available in a set.

Modeling clay

One or two of the art experiences call for plasticine or some other type of modeling clay. Plasticine has a high oil content and does not dry out. Thus, it will be pliable at a later date if patients wish to revise their sculptures. Simple modeling clay can easily introduce patients to working in three dimensions and can be used in most types of settings. Sculpy™ is a type of modeling clay similar to plasticine, but it does not have such a high oil content. In addition, it can be baked in a conventional oven at a low temperature to produce a permanent, hard consistency. Model Magic™ is another affordable choice for small sculptures. Model Magic™ is lightweight and white; it dries hard when exposed to air, and when dry it may be painted with watercolor, tempera, or acrylic paint if desired.

Glues

Glue sticks work well for collage and gluing other thick papers. Glue sticks do not wrinkle paper when they dry like white school glue. However, a mixture of white school glue and water will make a good fixative for tissue paper collage when glue sticks would rip the thin tissue paper. Thus, it is recommended to have both types of glue on hand.

Media variables

For the therapist just beginning to use art media in therapy, the best way to understand the materials is to experiment with them. If the therapist has not had art training, experimentation will show the different ways the various media react with the paper. When exploring the media, spread and blend the colors. Try the flat sides and the tips of the pastels and markers. Try mixing two or three paints. Experiment with how the different types of glue work with different types of paper: glossy magazine pages, tissue paper, and others. Experience how the modeling clay responds to your touch and what seems like a good amount to handle. You might even want to get some ideas from a book about art media and procedures to inspire creativity. The book *ArtEffects* by Jean Drysdale Green

(1993) contains information about the effects of all sorts of art media and household products on various surfaces. The author gives suggestions about the implementation of various techniques and their anticipated results. It is a gorgeous book to look at, full of artful inspiration. The more you familiarize yourself with the media now, the better guide you will be for your patients when they begin the art experiences.

Another aspect of understanding the media is becoming familiar with the physical properties they possess and how these physical characteristics interact with information processing and image formation. The physical properties inherent in media can be classified along a continuum from fluid to resistive (Kagin and Lusebrink 1978; Lusebrink 1990) as is shown in Figure 3.1. Fluid media evoke emotion and resistive media evoke intellect. Resistive media are those that retain their structure when they are uncontained like wood, clay, and crayons. Fluid media are things like paint and chalk pastels that flow when they are uncontained. Fluid media are more likely to *evoke* emotions and aid patients in processing information in an affective way. Resistive media are more likely to *contain* emotions and help patients process information in a cognitive manner (Kagin and Lusebrink 1978).

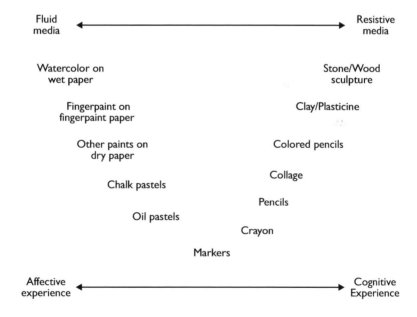

Figure 3.1: Media properties and affective experience

Thus, a patient feeling very depressed would benefit from using structured materials. The structure inherent in materials such as wood, mosaic, or even collage will help produce a sense of internal control and reduce affective responding (Lusebrink 1990). Conversely, a patient who has been very controlled in his or her expression of affect while using art may be encouraged to try a more fluid media in the hopes of accessing more emotion. As can be seen in Figure 3.1, the type of paper also interacts with the media to produce a fluid or resistive experience. For example, using finger paints on slick finger paint paper is a more fluid, and thus emotional, experience than using finger paints on regular drawing paper. All media properties must be taken into account when designing art interventions.

Setting the stage for the use of art in therapy

Adding music to the mix

As you experiment with the art media, see what happens if you play music. Play music of different genres and see what effect, if any, you feel on the art process. Different types of music can set the mood for different sorts of art experiences. Music with words could interfere with the creative process, so try playing music without words and see what effect that has. Many creative art therapists play gentle instrumental music to facilitate creativity. The book *Arts with the Brain in Mind* (Jensen 2001) contains comprehensive information about how music can set the stage for various creative and learning experiences.

Suspension of the inner critic

It will be necessary to help patients quiet the negative voice of the inner critic in order to proceed with these new experiences. In their book *Embracing Your Inner Critic*, Stone and Stone (1993) wrote that the inner critic is an internalized parental voice that was originally designed to *help*, not hurt. The original function of the inner critic was to save children from shame and embarrassment, especially when embarking on a new endeavor. However, in some people, the inner critic becomes such a strong voice that it hinders them because the mere thought of doing something new or out of the ordinary provokes thoughts of failure and feelings of embarrassment and shame.

The inner critic can be calmed with recognition of its original function and realistic self-assurance about new endeavors (Stone and Stone 1993). Therapists must openly discuss the role played by the inner critic and encourage understanding and acceptance of this voice. Patients can be reminded that the original function of the inner critic was protective and that it can still be protective if not

over used. The inner critic can have a say in the therapeutic session without being allowed to devastate the process.

Keeping patient artwork

At times the inner critic will command patients to destroy their artwork. Therapists should not allow patients to act upon this command in an unplanned fashion. Artwork can be destroyed as part of the therapeutic process, but the destruction should be discussed and planned after the valuable information contained within it is processed and recorded. In general, therapists using art as a therapeutic modality keep all art images in their original form until termination of therapy. In this way there exists a permanent record of patients' themes and processes in therapy. One of the last experiences in art-assisted therapy will be a review of all of the images created in order to trace the healing journey and project a future path. If the images were destroyed there would be no way to recreate the map of the healing journey that the images provide.

Impulses to destroy the artwork do not always come from the inner critic. At times the artwork brings up disturbing images that have long been unconscious and will not be easily remembered (Ball and Norman 1996; Levens 1995b). Trust developed in the therapist is essential for helping patients work through uncomfortable realizations, memories, and feelings brought up by the artwork. In addition, the therapist can support patients in finding non-eating disordered ways to comfort themselves. The art can certainly bring up disturbing thoughts and memories, but it can also become a significant way in which patients learn to soothe themselves and solve problems as will be demonstrated in Chapter 6.

In working with eating disordered patients I have noticed another way in which the art experiences are altered. Patients sometimes do not complete the art experiences as instructed, but alter them to fit their own needs. Sometimes these alterations are presented to therapists in a challenging fashion as if patients expect to engage in power struggles similar to those that they have initiated with food. Power struggles are not therapeutic. Rather than engage in a power struggle about art directives, I have patients explain how the altered art experience worked better for them than the one originally proposed. In this way patients are recognized and respected as knowledgeable about their own personal recovery.

Avoiding therapist errors

Due to personality characteristics such as perfectionism, feelings of ineffectiveness, and a desire to please, patients with eating disorders approach therapy seeking to please the therapist as they have attempted to please others all their lives. Patients might take on inappropriate weight gain or loss goals suggested

by an overzealous therapist or struggle with an inexperienced therapist for control. Therapists might focus too much on eating behavior and ignore emotional expression (Thompson and Sherman 1989). Using art in therapy can help therapists avoid these and other errors when treating patients with eating disorders.

According to Thompson and Sherman (1989) therapists should teach patients that normal eating is not perfect eating. I have seen that during the course of therapy patients will come to view eating mistakes as opportunities for learning. When patients report in their weekly sessions a larger number of serious eating mistakes, therapists do well not to get caught up in *behaviors*. Patients can use an art experience to explore what events and feelings made the eating disorder return with such intensity. Using art in this way focuses on the fact that the eating disorder behaviors can be viewed as *communicating* something to the patient. Eating mistakes are thus used as opportunities to learn about the special circumstances and emotions that trigger eating disordered behavior. The art responses made to discover these special circumstances provide permanent reminders of lessons learned.

Patients should be reassured that they are not in therapy to please the therapist. They will be taught that not thinking first of pleasing others will be a fundamental change in the way that they approach life. It should always be stressed that patients are making changes in order to help and please themselves, not for the therapist or anyone else (Thompson and Sherman 1989). The use of art experiences helps reinforce that changes are made by and for patients. Patients are not merely guessing at or parroting back what they believe the therapist wants to hear. The images' answers come from within patients and reflect their internal wisdom.

Thompson and Sherman (1989) report that patients can become turned off by talking too much about eating or not eating. They are reporting on their eating behavior to doctors, dietitians, and family members. The art experiences can help reduce the focus on eating and increase the focus on the cognitive and emotional components of the eating disorder where it will most benefit the patient. Using art experiences reduces the need for language and focuses on the underlying message of the eating disorder behaviors rather than strictly on the actions themselves. After some time in therapy patients begin reporting their thoughts and emotions rather than their eating disorder symptoms. Patients will be encouraged to freely express emotion through art and to experiment with expressing feelings that they have previously avoided. This is in contrast to the ways in which they report being raised where the direct expression of emotion was shunned.

When the direct expression of emotion is not allowed, patients develop issues with control, often substituting control or the absence of control over food for emotional control. Thompson and Sherman (1989) point out that therapists should not assume control over food when a primary treatment goal is for patients to control their own eating, emotions, and lives. Instead, patients should be actively encouraged to participate in treatment decisions, especially those having to do with eating and weight gain. When patients ask therapists directly how they should behave, therapists may fall into the same trap as ineffective parents by suggesting courses of action that are rejected. Image-based answers achieved through art experiences are not rejected because they come from within the patient and stem from their own internal wisdom. When patients ask for suggestions therapists can ask what they would like to do or are willing to do in a given situation. More importantly, therapists can refer patients to their own wise answers stemming from their art responses.

Relaxation before beginning

Relaxation is conducive to creativity (Benson and Proctor 2003; Dacey and Lennon 1998). Relaxation is incompatible with anxiety, an emotion that evokes the inner critic. Relaxation allows for thinking in new ways. The simple breathing exercise (described below) can induce a feeling of relaxation in patients. This or another simple relaxation exercise should be used before beginning each art experience. The goal is to do something that will quickly and reliably help induce a feeling of calm and allow for increased creativity.

The first art experience: Draw your eating disorder

Familiar drawing media have been chosen for the first few art experiences because familiar media can provide reassurance in new situations (Fleming 1989; Makin 2002). In addition, drawing media such as pencils and markers are likely to promote feelings of control and to encourage cognitive responses in patients who might be emotionally overwhelmed by the process of beginning therapy or a new type of therapy with unfamiliar media (Fleming 1989).

Relaxation instructions
"Sit comfortably allowing the chair to support your back and legs. Your arms are supported on the arm rests of the chair or in your lap. Your feet are placed flat on the floor for support. Take a moment to clear your mind of all of the concerns of the day. Close your eyes and take a deep cleansing breath; that is, breathe in deeply through your nose and exhale slowly through your mouth. Take another breath. This time, hold your breath for a few seconds. Let out your breath and as

you do, imagine that the cares of the day, physical and psychological stressors, are leaving your body. Keeping your eyes closed, repeat the process three more times letting go of more and more physical and psychological tension each time."

Media
One 12 x 18 inch (A3) sheet of white paper, familiar drawing materials (pencils, markers, crayons), collage images, scissors, and glue stick.

Art directive
Remind patients before they begin that art is merely being used as a form of communication. You are wondering if there is anything that this visual language can tell both of you about the eating disorder that has not been said in words. Emphasize again that together you are searching for meaning in the art; you are *not* searching for beauty.

Have patients use the drawing and/or collage media in any way they like to create an image of the eating disorder. Have patients choose colors, lines, and forms that best express what the eating disorder is and means. Given the length of the therapeutic session, a time limit must be set limiting the amount of time spent creating so that time can remain for verbal processing of the experience and the image. Remind patients when there are ten minutes left and five minutes left. When there are five minutes left you may tell patients to put the finishing touches on the piece. When the image is complete, have patients think of a title and put the title and date on their work. All images should be titled and dated. Thinking of a title for the image is one way to quickly summarize the information contained in the image. Dating the images keeps them in order for future review.

Viewing the finished product
When the picture is complete, allow the patient a few moments to silently reflect upon the image and the process of creating it. Stone (2003) writes that when an image is completed the creator becomes a viewer who must respond to the image like any other person looking at the art. She maintains that this process of viewing will sometimes lead to unexpected and unpredictable revelations about the self. Art therapist Mala Betensky (1995) developed a process called *intentional looking* to facilitate self-understanding by viewing one's created artwork. Intentional looking begins with clearing the mind and is followed by looking at the art product as if it were something never before seen. The artwork is first described in terms of its formal artistic elements (color, line, form) without using symbolic interpretations. According to Betensky symbolic interpretations are

avoided because they represent preconceived ideas and are unlikely to tell patients anything they do not already know. Betensky encourages therapists to help patients develop a new sense of their artwork by looking at the art intentionally with an unprejudiced view.

Thus patients can be instructed to look at their pictures as if they were seeing the images for the first time. After a period of intentional looking patients describe what they have seen in terms of the lines, colors, and shapes used. Metaphorical information derived from this process will help deepen understanding of the art product. For example, a patient suffering from bulimia nervosa saw the tangled mess of colors and lines in his representation of the disorder as "mud." He developed the metaphor by explaining that when engaged in the eating disorder, he could not think clearly; everything was mud. Mud became a shorthand way to refer to the debilitating cognitive and emotional consequences of bulimia nervosa.

Another way to respond to the image is to have patients say a list of words that comes to mind when they look at the image. They can be encouraged to respond quickly without judging or censoring what comes to mind in a manner akin to free association. Again, this reduces the likelihood that patients respond with preconceived ideas or symbols, but rather that they get fresh information from viewing the image. Therapists can write down the words and keep them for reference or later patient use.

Finally, patients can discuss the image, the process of making it, and the experience of viewing it. Therapists should allow patients to develop their own interpretations of images, colors, and words. Therapist interpretations are influenced by their own projections. Patients are the experts on their own creations. Patients must feel respected as the authorities on their use of the art media to communicate personal information.

Expected themes

In creating the image of the eating disorder patients have taken a significant step in recovery: they have separated the eating disorder from themselves. Patients have distinguished it by its size, shape, and color. They have separated the eating disorder and given it a name. This is the first step in patients realizing that they are *not* the eating disorder and an important first step in change. Many persons with anorexia nervosa and bulimia nervosa refer to themselves in terms of the disorder. It is common to hear a patient say of herself, "I'm an anorexic" in a manner that patients with other mental disorders do not. Putting the eating disorder on paper is the first step in helping patients recognize that *they are people not disorders*. They can begin to be aware of the eating disorder as a separate entity that can be dealt with effectively.

Persons suffering from eating disorders tend to think in black and white terms and thus it is likely that patients will attempt to represent the eating disorder as all bad. Therapists must help patients understand that the eating disorder originated as a purposeful activity (Pipher 1995; Schoemaker *et al.* 2002; Serpell and Treasure 2002). The eating disorder represented an attempt at problem solving that made sense to the patient when the disorder began. However, outside of the circumstances in which the eating disorder developed, it no longer makes sense and can be classified as self-defeating (Cudney 1983). A self-defeating behavior has an immediate payoff which can keep patients trapped in a negative cycle. One short-term payoff is a state of oblivion or "food coma" as some binge eaters call the sluggish state induced by overeating. There is also a long-term negative price for engaging in the eating disordered behavior. The price usually has physical, emotional, and spiritual dimensions that contribute to general malaise and depressive feelings. Therapists can emphasize that in the past patients used food, weight, and body image to cope with life's difficulties and with this first art experience they have begun using art as a new way of coping.

Homework and healing dimensions
Between therapy sessions patients have important work to do in changing their eating and exercise habits. Their physical health should be closely monitored by a physician, and they should be working in conjunction with a dietitian who can supervise diet and exercise. Art therapeutic homework can be assigned to strengthen and extend the learning that has taken place during therapy sessions. However, using art as homework is not always benign or helpful. Farrelly-Hansen (2001) asked some patients who had been sexually abused as children to stop making spontaneous images at home. She explained that these patients became too overly stimulated by the colors and flooded with emotions when unsupervised. The patients were left "too raw and too alone" (p.145) to effectively use the art experiences as homework. Thus, homework assignments should be carefully monitored to ensure that progress rather than regression is taking place.

Between sessions the majority of patients can be asked to amplify their responses to the art images they have created. Patients should be asked to keep a creative journal in which additional images are made that develop or deepen themes occurring in the sessions. The journal should be a spiral-bound tablet of heavy, unlined art paper. A spiral binding is recommended because it allows the journal to lay flat while patients are working. The creative journal should be at least 9 x 6 inches (A5); smaller sizes overly inhibit expression. Digital photographs can be taken of the images made in therapy and glued into this journal.

The photos can be responded to in writing. Therapists can give patients the lists of one-word associations that were generated by the images, and ask patients to use these words to further develop the images in poetry or prose. If patients do not like their handwriting or if they need lines to write, the words can be written or typed on separate pieces of paper and taped or glued into the journal.

Summary

A good working knowledge of the art media – their physical properties and the types of information processing they evoke – is an important foundation upon which the therapeutic use of art is built. When therapists feel comfortable with the media they are the most effective guides for patients using this new method of communication. The first way in which art can help patients communicate is to distinguish themselves from the eating disorder by making it separate and containing it on paper. This separation is a gift of the art – patients can quickly be in touch with themselves as people rather than as disorders. The next chapter begins the recovery journey by helping patients detail the impact of the eating disorders on their lives. Insights that come from this work will provide patients with motivation for change.

Effects of the Eating Disorder

Truth is the secret of eloquence and of virtue, the basis of moral authority;
it is the highest summit of art and of life.

Henri Frederic Amiel (1821–1881)

Introduction

An important first step in the healing journey is for patients to take an honest inventory of the effects of the eating disorder on their lives. The first task in therapy is to help patients acknowledge that the eating disorder is a problem and to break through denial of the associated difficulties and pain caused by it (Fleming 1989). The information gained in these experiences that examine the effects of the eating disorder will provide incentive for change. In addition, patients will be assured that the artwork can be used to contain and make concrete the pain that previously has been demonstrated through eating disorder behaviors and symptoms (Levens 1995b; Schaverien 1995).

Therapists should remain nonjudgmental when patients relate facts of eating disorder behaviors such as the extent of food restriction, the amount of food consumed in eating binges, or the number of purges in a day. Patients often experience great shame in sharing details of their eating disordered behavior. On the other hand, spending too much time talking about the details of restricting, eating, or purging can be a way for patients to avoid psychic pain. Therefore, the art experiences and discussions about them will be focused on the *impact* of the eating disorder, not the *details* of the disorder. The knowledge that patients allow themselves to gain during the art experiences in this chapter will provide the foundational motivation for change. When denial is broken through and patients are honest about the impact that eating disorders have had on their lives, the necessity for change will become apparent.

The art experiences in this chapter will provide permanent reminders of the impact of the eating disorder and motivation for change. These images can be referenced any time during therapy in order to strengthen patients' motivation for change. One young woman I worked with made a mask to demonstrate the effects of the eating disorder on her life. The mask was blindfolded and gagged.

She left the mask on a shelf in my office and we often referred to it during her treatment. Looking at the mask reminded her that she no longer wanted to be blind, deaf, and dumb – the sensory negating impact of the eating disorder on her life.

In Chapter 3 patients were aided in creating an image of their eating disorder. They were encouraged to detach themselves from their symptoms and describe the eating disorder as an entity separate from themselves. The first art experience to describe the *impact* of the eating disorder on patients' lives follows.

Eating disorder promises and reality

Media
One 12 x 18 inch (A3) sheet of white paper, colored construction paper, familiar and non-threatening drawing media (pencils, crayons, or markers), collage images, scissors, and glue stick. Remember to begin the art experience with a short breathing exercise and period of relaxation.

Directive
"Fold the paper in half, crease it, and open it back up. There will be two equal spaces on which to work. On the left side of the paper, make a collage or drawing of the *promises* that you believed the eating disorder held in the beginning: promises about coping and helping. Depict everything that you believed or hoped about the eating disorder with either a collage or a drawn image.

On the right side of the paper, depict the *reality* of the eating disorder and its functions. Think about what the eating disorder currently does to you and for you. Reflect upon whether or not the eating disorder fulfilled its promises. Think also about how your behavior changed over time. It is likely that there were positive aspects to the eating disordered behaviors in the beginning that became negative over time. When you are finished with the image, think of a title for it and date it."

Viewing the finished product
When the picture is complete, allow the patient a few moments to silently reflect upon the image and the process of creating it. Remember, patients should be instructed to look at their pictures as if they were seeing the images for the first time. After a period of intentional looking, patients describe what they have seen in terms of the lines, colors, and shapes used.

Patients can free associate a list of words that comes to mind when they look at the image. Therapists should write down the words and keep them for later use. Finally, patients will discuss the image and anything that they learned from the process of making or viewing the dual image.

Expected themes

The promises and reality of eating disorders are different for everyone, but some common themes are often noted. People with eating disorders commonly mention that the eating disorder seemed beneficial in the beginning. Men and women with anorexia nervosa mention believing that they would feel a sense of superiority as the eating disorder progressed (Knapp 2003; Way 1993). Instead, they report that they became too weak or too tired to feel anything (Goldkopf-Woodtke 2001; Rios and Rios 2003). If they had energy, it was often focused on counting calories, planning meals, or burning off calories. If patients are honest in their assessment, they will show themselves that they did not have a life outside of the anorexia nervosa.

Persons suffering from bulimia nervosa often mention the promise of "having your cake and eating it too." After a time, they discover that in reality, they "have their cake and *chaos* too" as the binge eating and purging behaviors become more frequent and the sense of being out of control more intense. The young woman who made the collage in Figure 4.1 depicted the promise of "having your cake and eating it too." The young woman pictured on the left-hand side of the collage was described as, "thin and able to eat whatever she

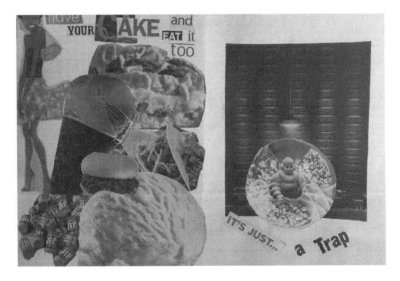

Figure 4.1: "Have Your Cake and Eat it Too" – Art separates the patient from the disorder

wants." The reality of the eating disorder for her was that she eventually felt trapped. She could not casually eat whatever she wanted and throw up afterwards; she became involved in a vicious cycle of throwing up after everything that she ate. Making the collage was a way to reinforce the discrepancy between what was promised by the eating disorder and what it actually delivered. Ironically, the young woman felt trapped and "as fat as the Michelin Tire man" when what she desired was to be thin and free. Other associations with the reality of the eating disorder were "isolated, lonely, and interrogated."

Binge eaters or compulsive overeaters talk about being vulnerable to the promise of oblivion. They report initially believing, "If I eat enough, I won't feel anything." Unfortunately, they state that the reality of the eating disorder is that they feel an increasing sense of shame as binge eating takes up more time and energy in their lives. In addition, the long-term consequences of all eating disorders are compromising physical conditions. In the case of binge eating disorder, one consequence is obesity. Aside from the physical health complications that permeate their lives, persons with binge eating disorder report that their lives are negatively impacted by the prejudice they feel from others at their being overweight (Gimlin 2002; Grogan 1999). Looking honestly at the promises and reality of the eating disorder and sharing this information with a therapist will help patients begin to change their lives and obtain the reality they want.

Helping patients understand the initial benefits received from engaging in eating disorder behaviors may help reduce their feelings of shame at later finding themselves trapped by those same behaviors. Patients can be introduced to the concept of a self-defeating behavior as mentioned in Chapter 3. According to Cudney (1983) a self-defeating behavior initially has short-term positive consequences, but over time develops a devastating long-term price. Patients can be helped to understand that they likely chose food because it was readily available to young people and because binge eating can have sedative effects or relieve boredom (Serpell and Treasure 2002; Thompson 1994). In addition, identification of the initial benefits of the eating disorder provides direction for future skills building. For example, if patients know that they used the eating disorder to calm themselves, then one necessary direction for future therapy is teaching self-soothing behaviors.

Response piece: Creating the reality you want

Media
One 12 x 18 inch (A3) sheet of white paper, colored construction paper, familiar drawing media (pencils, markers, or crayons), collage images, scissors, and glue stick.

Directive

Patients should first relax with a simple breathing technique. When relaxed, patients will be given the following directive: "Please think about the previously created image: *Eating disorder promises and reality*. Focus on the current reality of the eating disorder and whatever negative consequences you identified. Now think about how you would like to transform these negative influences. Focus on the life you would *prefer* to live. In what positive ways can the promises of the eating disorder be answered? How can you make yourself strong, and less vulnerable to eating disorder triggers? Use this paper to create an image of the reality that you want in the future – a future where you are strong and the promises of the eating disorder are met in healthy ways."

Expected themes

Patients should intentionally view the finished image and respond to it with a list of one-word associations. As was discussed in the first chapter, response pieces are meant to provide patients with corrective emotional experiences which change negative reactions to the original image, to more realistic or positive ones. The corrective emotional experience occurs through *Creating the reality you want* when patients depict a positive future. They must be reminded that the information came from within them. The therapist did not create the positive reality. Patients themselves hold the healing knowledge that they need and the images are a constructive way to illustrate that wisdom. In addition, the response piece can be explained as the first active step toward changing their reality. If it is possible to visualize a different reality, and to depict it on paper, then that reality is one step closer to occurring.

Homework and healing dimensions

Between therapy sessions patients should draw or write in their creative journals to deepen their understanding of the themes occurring in to the two *Promises and reality* art experiences. Patients can use the lists of words generated by the images to develop their written responses. Patients may wish merely to write simple lists of promises and realities of the eating disorder. These lists can again concretely demonstrate that there are more negative aspects than positive ones associated with the eating disorder. Patients can be asked to develop the theme of their preferred reality in a new image. This new image again makes definite that patients know the sort of life they would like and are closer to obtaining it with each image created.

Lifeline

Media

One or more 12 x 18 inch (A3) sheets of white paper, and markers. Depending on how large or small patients work, therapists may need to tape sheets of paper together to make longer pictures.

Directive

The patient is given the following instructions after a period of simple breathing exercises and the resulting relaxation.

"Draw a continuous line to express your feelings in relation to events and milestones in your life. Your lifeline should start at your childhood and continue to the present, starting from the left side of the paper and moving to the right. The line is to correspond to your feelings about changes in your life; it should climb up or slide down according to your emotions. Be as creative as you want with the line. You may change its intensity or color. You may include stair steps, steep curves, spirals, or any quality of line that helps express your feelings about the events in your life. Next, each important event or milestone is to be identified with a drawn picture or simple symbol. Milestones include any important events in life: friendships, births and deaths, beginning school, graduation, marriage, and divorce, to name a few. When the image is finished, please make a title for it and date it."

Patients should be encouraged to take some time to look intentionally at the lifeline. They can then be asked to think about when and how the eating disorder was represented in the lifeline. What twists and turns did the line make before and after the start of the eating disorder? Ask them to reflect upon how the eating disorder influenced other events and milestones in their lives. Patients should contemplate whether or not they were fully present (mind, body, and spirit) at all the events depicted. Patients will make note of surprising or unexpected findings. Finally, have patients generate a list of one-word associations to the lifeline which therapists record for later use. After contemplation, allow patients time to respond in words to the topics above.

Expected themes

Women and men with eating disorders report that when they look back on their lives, they are surprised to find that their memories of important events and milestones are poor. They remember that events took place – a wedding, a graduation – but often they do not remember details. This memory impairment occurs because a person suffering from anorexia nervosa may be too malnourished to think effectively and remember clearly (Bruch 1973). Also, if the disorder involves binge eating, a person might be so preoccupied with the food

involved in an event (for example, avoiding a buffet line, altering plans for going out to dinner) that the details of the event itself never register in memory. When patients look honestly at their lifelines, they may find that important events were not clearly remembered and that other events were altered or avoided because of the eating disorder.

In addition, a common theme among all patients with eating disorders is that feelings of shame about their bodies prevented them from fully engaging in activities. For example, patients stated that they would not go to the beach with friends because the thought of wearing a bathing suit provoked feelings of disgust or fear. Patients frequently claim that body shame promoted avoidance when what they really wanted was acceptance by and engagement with others. These types of realizations made concrete in images provide and sustain motivation for change.

Response piece: Future timeline

Media

One or more 12 x 18 inch (A3) sheets of white paper, and markers. Depending on how large or small patients work, therapists may tape sheets of paper together to make longer pictures.

Directive

After a brief period of simple breathing exercises and relaxation, patients can be given the following directions for the future timeline.

"Using the same process that you used in the lifeline, depict what you would like your life to look like *over the next ten years*. Use detail in line intensity, color, and direction to show the events and emotions that you would like to experience. Please use simple pictures or symbols to include the important milestones that you would like your life to include such as graduation, career milestones, marriage, and children. Be sure to depict what role you would like the eating disorder to have in your life during the next ten years. When the timeline is finished, please title it and put a date on it."

Expected themes

Patients can compare and contrast the lifeline and the timeline in order to emphasize the different information brought out by these art experiences. These may be the first glimpses of the desired life. Patients should be encouraged to remember that these image answers came from within them. They *know* what sort of life they want for the future. Patients recovered from eating disorders report that *hope* was one of the most important factors in facilitating recovery

(Goldkopf-Woodtke 2001; Reindl 2001). Envisioning a positive future provides hope and making it a concrete image on paper provides a permanent reminder that hope is alive.

For some patients deeply entrenched in an eating disorder, a positive future can be hard to imagine. These patients will require assistance envisioning life beyond the eating disorder. The timeline requires that patients work cognitively. In order to make a timeline patients must think, plan, and draft a line that depicts the future. Certain patients will be unable to *think* about a positive future, but they might be able to *imagine* it in a different way. One way for patients to do this would be to draw their future life as a simple fairy tale. Beginning with "once upon a time," a fairy tale can help patients get in touch with universal healing images, symbols, and themes. What they are unable to think about concretely, they may be able to imagine symbolically. Fairy tales are full of danger and darkness, but they end happily ever after. Again, hope is conveyed through the expressive work.

Homework and healing dimensions
Between therapy sessions patients can be asked to compare the lifeline and timeline in their creative journals. They can be instructed to respond to the similarities and differences in the images; they can create a new image as a response. As was mentioned above, digital photographs can be taken of images made in therapy and glued into this journal to stimulate written reflection. Therapists can give patients the lists of one-word associations that were generated by the timeline and lifeline and ask patients to respond by writing a paragraph or poem about what the two images represented.

Drawn defenses

Media
One 12 x 18 inch (A3) sheet of paper and familiar drawing media.

Directive
In this art experience patients are to draw their defense mechanisms. A simple explanation of defenses such as "the way(s) you protect yourself from emotional pain in the world and in relationships" is probably necessary. You may give an example like, "do you defend yourself by being smooth and absorbent like a sponge, hard and prickly like a cactus, or something else?" Patients need to understand that they do *something* to protect themselves (that everyone does to some extent) and that a complex set of behaviors can be symbolized in a picture. Patients can close their eyes and take a moment to imagine what their defenses

look like: their color, size, and shape. When the image is in mind, patients then can represent their defenses on paper.

Expected themes

Patients will take a few moments to study their image of defenses. They need to contemplate what the lines, shapes, and colors say about the way(s) they protect themselves. They also can think about how people typically have reacted to their defenses. Patients will generate a list of one-word responses to the picture of their typical defenses.

Thinking about defenses is probably unfamiliar to patients. Nonetheless, it is important for them to learn that as children, all of us adopt ways of thinking and behaving to protect ourselves from emotional pain in our childhood world. For example, some families of anorexic patients place extreme emphasis on academic performance. A child in an academically pressured environment may feel that knowing many facts is good protection. That child might develop an intellectualizing defense to guard against feeling unintelligent and therefore unloved. Often what worked in childhood is not as effective, and may even be harmful, under circumstances outside of the family. For example, the overuse of intellectualization as a defense can make an adult seem arrogant and unapproachable. Relationships may be lost due to over-dependence on intellectualization, or any defense.

Persons suffering from eating disorders often report that they were raised in families where they experienced an overemphasis on physical appearance (Davis *et al.* 2004). They claim that in their families of origin, *how they looked* was more important than *how they felt*. They report binge eating or food restriction developed in response to the pain of feeling emotionally neglected. Binge eating as a defense works in two ways: it assuages the immediate pain and it insulates against future pain. Immediate pain is alleviated by the numbness following the eating binge. Future pain is thought to be avoided by rejecting the parental value that looks are one's most important attribute. Usually persons with binge eating disorder easily see that the defense has become ineffective as social, emotional, and physical health problems develop.

Childhood abuse has been identified as a risk factor for the development of eating disorders (Schoemaker *et al.* 2002; Smolak and Murnen 2002; Stice 2001). Patients from abusive families need to be assured that their choice of food as a method of coping made sense. Food was readily available to young people and overeating provided the desired sedative effects (Thompson 1994). Identifying that the eating disorder originally had a purpose can aid patients in finding appropriate and adaptive ways to fulfill the purpose. Shame experienced about the eating disorder slowly dissipates. In addition, at this point or perhaps

during the body image experiences, patients will explore how changing their bodies by either making them too fat or too thin was a defense against further abuse.

Response pieces: Defenseless and different defenses

Media
Two 12 x 18 inch (A3) sheets of paper and familiar drawing media.

Directive
After a period of breathing and relaxation, patients will be given these instructions: "Think about what your life would be like *without* defenses. What would your life feel like and look like without defenses against the emotional and physical pain of the world? Depict what your life would be without the particular protection you have adopted. Do this in the same way you did in the previous drawing using lines, shapes, and colors. When the image is complete, date it and title it."

It is probably uncomfortable to contemplate life completely without defenses. In the next image, patients make a picture of defenses they believe will work differently and *better* for them. Patients do this in the same way they did in the previous two drawings using lines, shapes, and colors.

Expected themes
Patients should be encouraged to take some time to look at the images without talking or explaining. Before discussing the images, patients can make a list of one-word responses to the two images just produced. Next, with all *three* images – defenses, no defenses, different defenses – displayed before them, patients can take a few moments to compare and contrast them. Therapists should encourage patients to think about: What is life like with your current defenses in place? What would life be like without them? How are they similar and different? Does the third image represent a middle ground between the two or something entirely new?

Patients need to know that defenses help form necessary boundaries between them and the outside world. They need to be reassured that some defenses, used in moderation, are beneficial. They would not want to live a life completely without defenses. They would not want to tell everyone they meet everything about themselves, or allow people to walk all over them. Patients can be assured that people need suitable defenses that allow freedom to choose with whom to share and from whom to protect themselves. Patients can be taught that assertive behavior is an appropriate and useful defense. By behaving asser-

tively, patients can ask for what they need or set comfortable limits. In addition, they do not hurt other people by behaving aggressively, or hurt themselves by behaving passively.

Homework and healing dimensions
Patients will not be able to learn everything about assertiveness in one session. Increasing assertive responding takes focused attention and repeated practice of new skills. Patients should be provided with a book about assertiveness and asked to read it in sections and practice the behaviors described between therapy sessions. One practical book about assertive behavior is *Your Perfect Right* by Alberti and Emmons (2001). The book contains useful exercises and step-by-step procedures to gently increase assertive behavior. Patients should practice assertive behavior as homework and record their emotions and thoughts about the new behavior with images and writing in their creative journals.

Inner self/Outer self box collage
Media
Patients will need to find a box that they will use to represent themselves. In light of what was learned about defenses they need to make sure that they find a box with a way of opening and closing that feels right. Therapists will need to have some extra boxes on hand in case patients forget to bring one to the session. Patients also bring in found objects such as sea shells, dried flowers, and pine cones, as well as personal objects such as copies of photographs. Also needed are collage images, tissue paper, scissors, and glue.

Directive
Patients will use collage images, tissue paper, personal objects, and found objects to decorate the box self collage in the following way: The outside of the box is created to show the self that patients present to the outside world. This is how other people see them. The inside of the box is made to demonstrate the private self. This is how patients see themselves.

Expected themes
Before responding to the box patients should spend time intentionally looking at it, comparing outside and inside elements. Patients should contemplate what the similarities and differences between the inside and the outside of the box mean about them. Patients can generate a list of one-word responses to the box

self collage, answering quickly without judging or censoring what comes to mind.

In responding to the box self collage patients should be encouraged to explore family expectations about private self and public self. Again, the theme may arise that the public self was seen as more valued than the private self. Persons with eating disorders often report coming from two types of families (Root 1989). One type of family is characterized by open conflict – all negative feelings are reported all the time. Arguments are frequent and destructive. Patients have said about these families that it was necessary to look to the outside world that everything was fine, or that they were the "perfect" family. Again, the eating disordered individual received the message that how they *looked* on the outside was more important than what they *felt* on the inside. The private self was disregarded. The other type of family is the intrusive or overprotective family. In this sort of family, members report a high degree of emotional enmeshment. Children report taking on adult burdens with little privacy felt by anyone. Again, a "perfect family" presentation to the outside world is common (Root 1989). In either type of family, the tension between the private self and the public self is great. The following response piece is designed to be one way to lessen this tension.

Response piece: Abstract self-portrait

Media

One sheet of 12 x 18 inch (A3) white paper, colored construction paper, familiar drawing media or collage images, scissors, and glue stick.

Directive

After relaxation, patients will be given the following directive: "An abstract image uses line, color, pattern, and other elements of design to communicate ideas and feelings. Using design components from both parts of your box self collage create an abstract self-portrait. This picture of you should include something from the inner self portion – a color, a shape, a particular line – and something from the outer self portion of the box. The two parts of your previous work (or portions of them) will be integrated into a new image to create the abstract self-portrait."

Expected themes

Therapist and patient will spend some time reflecting on the image. Before describing what was intended by the image, patients should be encouraged to respond to the formal artistic elements of the abstract portrait. That is, they will

talk about the lines, shapes, and colors that they see. Patients can respond to the image with a series of one-word associations and the therapist will write these down for future use.

Patients should be encouraged to reflect upon and then talk about what the integration process was like: What parts of the box did they choose to include in the abstract self-portrait? What was omitted? They should reflect upon the *process* of choosing and integrating different parts of themselves into a new, cohesive whole.

This experience can be used to re-emphasize the importance of personal boundaries. Women and men with eating disorders often have not learned appropriate boundaries in their families of origin. They do not know that most people present only a part of themselves, a persona, to the world and reserve some thoughts and emotions as too private to share with others. They are incredulous to learn that, as with defenses, having different personas can be helpful. For example, having a professional persona for the workplace can help one function effectively. Writing private inner thoughts and feelings in a diary can reduce stress. This difference between inner and outer self is only problematic when the difference is so great that one begins to doubt the authenticity of either part. Patients with eating disorders often have told me that the outer, competent and achieving self presented to the world is not real. However, they are very quick to declare that the fearful, shame-filled private self is real. It is more accurate to say that *both* sets of feelings and behaviors are real. Patients can be taught that healing from an eating disorder involves acknowledging weaknesses *and* strengths, and learning from both.

Homework and healing dimensions

Patients have just completed the last art experience designed to help them understand the effects of the eating disorder on their lives. They need to understand that the self they present to others, and their private self, have both been impacted by the eating disorder. They have reflected on the process of integration. The process of integration can happen more readily by sharing what it means – patients' fears and expectations – and their plans for it. Patients should be assigned homework that helps extend integration and the valuing of both inner and outer self. They can make another image that shows they understand the importance of a private self and a public persona and that the conscious use of both can be adaptive. They can use the one-word associations generated about the box self and abstract self-portrait to write about, in prose or poetic form, the integration of inner and outer selves.

Summary

The art experiences in this chapter have required patients to look closely at their lives and the effects on them of the eating disorder. Patients have examined the early seduction of the eating disorder and the path their lives have taken because of it. They have seen the impact of the eating disorder on their relationships, and on their very being. Finally, patients have reflected upon how the eating disorder has shaped the way they present themselves to the world and even to themselves. It has been necessary to take this hard look at the consequences of the eating disorder so that patients will know and remember exactly why they want to change.

In the response pieces completed, patients have given themselves a first indication of the healing wisdom that they possess to restore themselves to health and happiness. Patients need to be reminded that the image answers came from within themselves. They were not told what to draw or how to respond. They have given themselves hope for the future in projecting a timeline into the next ten years. They have imagined a different sort of life and different relationships. Patients need to know that their therapists have faith that these things are possible. In creating these images, sharing them with a therapist, and reflecting upon them between therapeutic sessions, patients have taken the first steps toward change. The change is reflected in the concrete images created. A therapy session can be devoted to reviewing the art images made thus far. The images related to the impact of the eating disorder can reinforce motivation for change and the response pieces will provide hope that change is attainable.

CHAPTER 5

Understanding Childhood Influences

The childhood shows the man, as morning shows the day.
John Milton (1608–1674)

Introduction

Many factors are involved in placing young persons at risk for developing binge eating disorder, bulimia nervosa, or anorexia nervosa. Biological, hereditary, media, and individual personality features as well as family dynamics predispose young persons to develop eating disorders (see Polivy and Herman 2002 for an excellent review). The art experiences in this chapter will shed light on some of the factors converging in patients' lives that made them vulnerable, especially familial and media influences. While performing these exercises therapists also need to examine and explain biological and hereditary influences.

The art experiences in this chapter will examine family dynamics, the expression of needs in relationships, and interactions with food and nurturing. Therapists should emphasize the importance of this information for "lapse prevention." Fairburn (1995) suggests using the term "lapse" instead of "relapse" because lapse means a temporary setback whereas relapse means a return to the beginning. I emphasize with patients that they are never back at square one after a lapse because information gained from the art experiences has changed them. They are not the same as they were at the beginning of the therapeutic journey; they have more knowledge and more tools. When patients comprehend the influences that propelled them toward an eating disorder, they will be better prepared to resist similar stressors in the future. In some cases, they will be able to *prevent* similar stressors from entering their lives. Effective treatment for eating disorders incorporates information about lapse prevention from the outset.

Childhood family drawing

Media

Familiar drawing media; one sheet of 12 x 18 inch (A3) white drawing paper.

Directive
After a period of breathing and relaxation, patients will be given the following directive:

"Draw a picture of your family at the time the eating disorder started. Be sure to include each family member and draw your family engaged in an activity. Make sure that everyone is doing something. Also, indicate the time period and culture by including clothing styles, songs that you liked, favorite television shows, as well as books and magazines that influenced you. When the picture is finished, please title it and put a date on it."

Expected themes
Clues to important themes in family relationships come from the placement and sizes of objects and people in the family drawing, as well as activities pictured. Children use size to indicate age, but *size* can also indicate relative power and importance within the family. Larger figures are perceived as more powerful than smaller figures (Burns 1982; Furth 1988). The *placement* of figures relates to family relationships and emotional closeness. Also, the *types of activities* pictured can indicate emotional closeness of family members (Burns 1982; Furth 1988). Family members believed to be close often are pictured engaged in similar activities. Patients' use of colors, shapes, and symbols will add information as well. Cultural influences will be displayed in the television shows, songs, magazines, or other media influences pictured. Information about nontraditional cultures, levels of acculturation of family members, and cultural conflict might also be indicated.

Patients may be gently guided to understand that their drawings represent their *perceptions* of family dynamics and functioning. There are no universal truths about life in families. Nevertheless, patients were influenced by the way they experienced their family when the eating disorder developed. Patients need to be reassured that their views and the feelings evoked by them are valid. Though valid, perceptions of families can be revised in therapy to reduce stress and promote recovery. One common revision is to recast parents as loving but limited. Loving but limited parents were unable to express their love in ways that were fulfilling to their children. Parental and family limitations such as alcoholism, illness, cultural barriers, or emotional neglect forced children to live with less than they needed. Education about appropriate family roles and relationships can help replace negative childhood perceptions with healthier information.

Discussing family dynamics helps patients determine what influences they were responding to as they were growing up. By examining the family drawing, patients will gain clues to parental discord, sibling rivalry, sibling physical or

emotional illness, and other family influences that predisposed them to develop an eating disorder. The discussion can include information about how parental discord sometimes provokes symptoms in sensitive children who draw off attention from the discord onto themselves (Bruch 1973; Kinoy 2001). For example, a young teenager with anorexia nervosa with whom I worked looked at her tiny representation of herself between two huge parental figures and said that the smaller she became, the less they fought. She was encouraged in family therapy to use words and not her physical size to express her discomfort with her parents' marital problems.

Boundary issues of all sorts are expressed through family drawings. Ideally, each figure would be separate from the rest and have a moderate degree of space surrounding it to indicate appropriate physical and emotional boundaries (Furth 1988). Patients with eating disorders frequently do not know that having physical or emotional boundaries between family members is appropriate. Often they have lived in families characterized by enmeshment or physical, sexual, or verbal abuse (Reindl 2001; Striegle-Moore and Cachelin 2001; Thompson 1994). Parents violated appropriate emotional or physical boundaries and did not allow for their development. At times eating disorders develop as physical barriers when personal boundaries are not respected. Patients report believing, "if I get big enough, or if I am small enough, I will be left alone." Patients need to be educated about appropriate interpersonal boundaries in families and other relationships. When they set boundaries with words and actions, they do not have to embody the boundary. In the response piece that follows, *Ideal family collage*, patients can be encouraged to keep boundaries in mind when they are depicting what they would like in their future/ideal family.

Media influences need to be addressed. Research has shown that even short-term exposure to media messages affects body image perception in women and men (Becker 2004; Calogero, Davis, and Thompson 2005; Leit, Gray, and Pope 2002; Wiseman, Sunday, and Becker 2005). All young women are exposed to the media's flaunting of very thin figures, yet not all young women develop eating disorders. There is a decision-making model for some women in which media becomes a risk factor (Smolak and Murnen 2001).

Therapists treating eating disorders must be educators. The responsible standard of care must involve educating patients to become discriminating consumers of the media. By educating patients to be "media literate" (Levine and Smolak 2001; Wiseman *et al.* 2005) therapists help mitigate the effects of media as a future risk factor. Therapists should know what television shows patients watch, what websites they visit, what magazines they read, and what musicians and film stars they admire. Patients can be supported in changing or eliminating some of the media influences that are particularly negative. For example, I ask

female patients not to read fashion magazines. Male patients can be discouraged from reading body building magazines. Pro-eating disorder websites must be prohibited. These media sources feed the body image obsession rather than heal it.

Response piece: Ideal family collage

Media

One sheet of 12 x 18 inch (A3) white drawing paper; tissue paper in assorted colors, scissors, and white glue mixed half and half with water.

Directive

After breathing and relaxation, patients will be given this directive: "In this experience you will cut or tear tissue paper into forms to make an abstract family collage. This collage will represent the family that you would like to have: your ideal family. Try not to make paper dolls; instead use color, shape, and size to *abstractly* represent people, emotions, and other influences. See what happens if you let colors and shapes alone speak your truth. When creating your collage, make sure you deliberately change what felt uncomfortable in your childhood family: relationships, boundaries, and other family dynamics. Remember, you are designing an ideal family – the family that you *want* to have – make it work for you."

To attach the tissue paper pieces, patients will dip them in the glue/water mixture, wipe off excess on the side of the glue dish, and place the tissue on the white drawing paper. The wet tissue paper tears easily if it is too wet. Tissue paper is transparent and, when wet with the glue mixture, the colors will run like watercolor paint. This is probably an unfamiliar method; patients can experiment with handling the tissue paper and glue before making the final collage. Alternatively, patients can plan the collage, paint the white background paper with the glue/water mixture and lay the tissue paper on it.

Expected themes

Patients should take a few moments to reflect silently on the colors, shapes, and sizes that were included in the abstract family collage. After intentional looking, patients can generate a series of one-word associations to the image. Patients should respond to the images as *art*, not as family. See what information arises if patients respond to what they *see* not what they *think*.

Examining childhood family dynamics is an intensely emotional experience. The art process and product can direct and contain these powerful emotions. The power can be used constructively in a way that has been called by

psychoanalytic therapists "regression in the service of the ego" (McMurray and Schwartz-Mirman 1998, p.31). It is powerful to remember the negative dynamics that contributed to the development of the eating disorder. But it is equally empowering for patients to know they may change what they found uncomfortable or unpleasant. Patients have demonstrated with the ideal family collage that they possess healing knowledge about what they desire in a family. They might not know *how* to go about getting what they want, but the image they created showed them that it is within their grasp.

If patients still live in a negative environment, making the abstract family a reality might seem impossible. However, family therapy can help change negative family dynamics. If family therapy is not feasible patients can be encouraged to take small steps to change their behavior within the family to encourage improved boundaries or interactions. Therapists should guide changes to help patients avoid potential negative consequences such as increased verbal or physical abuse.

Homework and healing dimensions

Between sessions patients will create new images in their creative journals. They will especially benefit from further exploration of the media influences. For example, patients can design an advertisement for themselves. When making this advertisement patients should highlight qualities and characteristics other than the physical body.

Patients can respond in writing to the images that were created in the art experiences dealing with the childhood family. They can use the lists of one-word associations generated by the images to help them write about the issues raised in the art. The adolescent girl who made the abstract family collage in Figure 5.1 made a list of words about her ideal family collage. She was responding to the image as art, not as family, and she was encouraged to think about appropriate boundaries. Her list was: four circles, messy shapes, pretty colors, primary colors, blending colors, boundaries, symmetrical, blue, red, green, orange, space. The words stimulated her to write this paragraph about her ideal family:

> I would want a family where everyone had space. In my family now with seven kids no one has any space. Everyone would have a separate color too. Right now my mom usually mixes our names up so bad it seems like she doesn't really know which of us is which. I would have fewer kids — one boy and one girl. Everyone would get attention. They would have their own space, but be close.

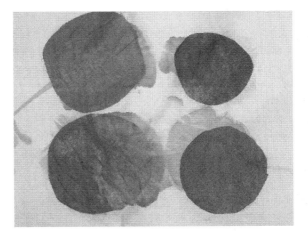

Figure 5.1: "Abstract Family Collage" – Art defines new hope for the future

Relationship/Needs drawing

Media

One 12 x 18 inch (A3) sheet of white paper and pastels – either oil pastels or chalk pastels. Pastels might be unfamiliar to patients. However, by this time, art experiences *are* familiar and patients should be ready for a new medium. Pastels are slightly more fluid than pencils and markers; their use will encourage a modest increase in the expression of emotion.

Directive

After a brief period of breathing and relaxation, patients will be given the following directive: "In this experience you will draw an important family relationship and your needs within it. Do not draw actual people. Different and perhaps deeper information is often obtained by drawing metaphorically. Please draw something that *symbolizes* an important family relationship and your needs within that relationship."

Age, developmental level, education, and brain functioning all converge to make patients more or less able to benefit from metaphor in therapy. There will be patients who are not able to work metaphorically; they will work concretely, not symbolically. When discussing patient images, therapists can teach the symbolic aspects of color, line, and form (see Lusebrink 1990, Chapter 4 for a comprehensive review). Examining these formal artistic elements of images can be a first step for those patients who do not naturally work metaphorically.

Expected themes

Symbolic language, like the figurative language of dreams, provides different information than the straightforward representation of a subject (Malchiodi 2002). For example, a 27-year-old woman with binge eating disorder, who was the mother of three young children, drew the bird's nest pictured in Figure 5.2 to represent an important family relationship and her needs in it. She explained that she saw herself as the "holder" and caretaker (nest) for her three small children (eggs). When asked about her needs in the relationship, she claimed that she did not have needs. For this woman, the responsibility of caring for three young children obliterated her own needs.

The theme of not having needs or not understanding needs comes up frequently in the treatment of eating disorders. As has been discussed previously, persons with eating disorders often are keenly sensitive to the needs of other persons and have worked since childhood to make sure that other people's needs are met. Frequently, they claim that merely thinking about their own needs makes them feel selfish and ashamed. The eating disorder is used as a means of suppressing awareness of needs. The anorexic is rigidly wrapped up in ritual and does not feel day-to-day needs. Binge eaters and bulimics binge eat to become oblivious to needs.

The majority of eating disorder patients need basic instruction about needs. If they are aware of needs at all, they mention that the body needs water, air, and food to survive. Their education should include information about other types of needs in addition to these biological ones. A sentence or two can introduce the concept of social, emotional, intellectual, and spiritual needs. Patients can be

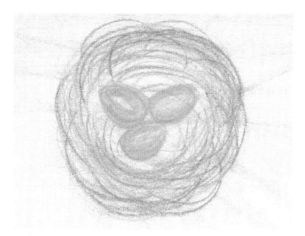

Figure 5.2: "Bird's Nest Drawing" – Art shows an important relationship and patient's needs in it

instructed that what they *need* is different from what they *want*. A *want* represents a desire, something that a person can live well without. A *need* is something that people feel propelled to fulfill – either biologically or psychologically. People cannot live healthily when needs are not met.

Patients can be introduced to Abraham Maslow's theory of human needs. They can be shown a diagram such as the one shown below in Figure 5.3. According to Maslow (1990), when lower level needs are met people begin striving to meet higher level needs. Starting from a very basic level, people need food and water in order to survive. Next, a sense of safety is essential in order to thrive and proceed to meet higher needs. When physiological and safety needs are met, people will strive for a sense of belonging, self-esteem, and self-actualization. Maslow's hierarchy helps explain my own observations that people are restless and dissatisfied when higher level needs are not fulfilled. I believe that this dissatisfaction motivates patients to seek psychotherapy. People want to *thrive*; they are not content merely to *survive*. The creation of art is one way to express higher level needs. Patients thrive when expressing themselves through art. Creative activity can facilitate self-actualization and help patients realize their highest level needs.

Often basic needs are intertwined and it is difficult to think of one without thinking of others. Children easily associate mother's love and food. Patients with a history of abuse will report not feeling safe and attempting to fill security needs with food (Thompson 1994). Maslow's hierarchy demonstrates that if patients do not feel safe, no amount of food will fulfill them. This is the vicious cycle of eating disorders: patients use food in an attempt to fulfill needs that

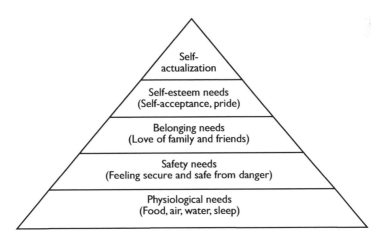

Figure: 5.3 Maslow's Hierarchy of Needs (from Maslow 1990)

food will never satisfy. Recovery involves learning what needs are and how they are most suitably met.

Response piece: Needs collage

Media
One sheet of white 12 x 18 inch (A3) drawing paper or colored construction paper, collage images, glue stick.

Directive
Patients look through precut collage images to find pictures that illustrate the diverse needs that they have learned about. They should be encouraged to represent as many needs as they can think of, including those that feel challenging or frightening.

Expected themes
Men and women with eating disorders often report growing up with parents who were emotionally neglectful, uninvolved, or openly critical. Shame develops about having needs, especially about having to ask others to fulfill them. The theme of experiencing shame for having needs occurs repeatedly in the treatment of eating disorders. As was identified in Chapter 2, patients may be involved with bulimia nervosa because binge eating seems to fulfill a need. The subsequent shame that accompanies the recognition of the need can be punished by purging (Pipher 1995; Reindl 2001). Culture will also influence which needs are acceptable and which are not, and if those needs are expressed directly or indirectly (Sudarsky-Gleiser 2004).

Time and again patients report having learned to take care of others and to deny their own needs. Upon further questioning they admit that a vague sense of resentment grows as other people's needs are met, and their needs are fulfilled only through the eating disorder. Women and men suffering from eating disorders often claim that relationships are unsatisfactory. They must be educated that relationships *are* unsatisfactory when their needs remain unmet. Since childhood, the eating disorder has been one main way to express and meet needs.

It is uncomfortable for patients to think about depending upon people to meet their needs. However, the therapeutic relationship can be the first reliable and helpful connection, and will set the stage for practice with others. Helping patients recover from eating disorders involves guiding patients in the development of an awareness of important needs. Patients will then learn how to satisfy those needs in positive, healthy ways, including forming relationships with others.

Homework and healing dimensions

Patients should be asked to spend time between sessions paying attention to their needs, especially when they feel the desire to act out using eating disordered behavior. This self-observation will demonstrate that patients often are trying to fulfill needs inappropriately with food. Patients can draw or write in their creative journals about discriminating among needs and meeting them more suitably.

In addition, the list of one-word associations generated by the images can be used to deepen the art experiences in writing. For instance, the young woman who made the bird's nest drawing in Figure 5.2 generated a list of rhyming words for her drawing and used the words to write this poem:

> Bird's nest
> I always do my best
> Sometimes kids are a pest
> I'd really like some rest
> When I'm put to the test
> I never head out west
> I stay and do my best
> That's hard to digest.

This simple rap helped clarify the message of the bird's nest drawing. The young woman understood that neglecting her own needs to care for her small children was complicating the eating disorder. She had a new awareness that she needed to pay more attention to getting rest as well as getting other needs met in order to recover from her eating disorder.

It is likely that some needs were left out of the *Needs collage*. These omissions can be discussed as areas for further exploration and growth. Patients should be encouraged to create new images in response to the needs that were omitted and to explore their meaning in writing.

In my childhood kitchen

Media

One sheet of 12 x 18 inch (A3) white drawing paper and oil or chalk pastels. Patients can be encouraged to try using a different sort of pastel than the one used in the previous drawing. Sometimes experimenting with a different medium yields a new way of looking at things and therefore fresh information.

Directive

After a brief period of breathing and relaxation, patients will be given the following directive for the *In my childhood kitchen drawing*. The image is best developed if patients remain relaxed with their eyes closed and imagine the scene as clearly as possible using all of their senses.

"Imagine for a moment, what it was like to be in your childhood kitchen when a meal was being prepared. Remember what the kitchen looked like, what it smelled like, what it sounded like, and what it felt like. Remember some of the foods that you have tasted there.

Indicate the major presence in the kitchen – your mother, father, or grandmother – whoever was the primary food provider. The kitchen is often referred to as the heart of the home. Attitudes about food preparation and presentation as well as rules about access to food can be metaphors for nurturing. That is, a person's attitudes about food sharing are often seen as metaphors for attitudes about caring. You do not have to draw an actual kitchen. You may use color, line, texture, and patterns to demonstrate the experience of being in your childhood kitchen in an abstract or symbolic way. Make sure that your image conveys the complexities of loving and giving that began in your childhood kitchen."

Expected themes

Childhood kitchen drawings provoke discussions of control and confusion regarding food and emotions. For example, persons with eating disorders often report that the expression of love and the consumption of food seemed one and the same. Patients talk about their mothers over-reacting to children not enjoying meals; food preferences being taken as personal acceptance or rejection. Patients relate stories of grandmothers who consistently prepared and fed them their favorite foods but never said "I love you." Food preferences become confused with the expression of love. The confusion of love and food happens to a greater or lesser extent in many families; it does not necessarily predispose children to develop eating disorders. However, the confusion of love and food seems to become a risk factor when combined with other predisposing factors such as an emotionally negligent or critical parenting style. Occasionally, patients report that, due to poverty, there was not enough food. Patients remember fighting for what they could get and going hungry, as well as parents being overworked and absent. In families affected by poverty, food consumption was often tightly controlled and parental support lacking.

In remembering their childhood kitchens, patients commonly report control of food, weight, and body image. For example, they report having mothers who rigidly controlled what food was in the cupboards, when it was eaten, and by whom. These patients claim having little control over what they

ate until the eating disorder developed. Patients report having fathers who weighed their over- or underweight children publicly, curtailed their food choices, and vigilantly monitored their intake. Many report being placed on diet pills as early as elementary school ages. Frequently they report sneaking, hiding, and hoarding food in response to rigid control over their food intake and weight.

This imposed or implied control of food, weight, or body image does not in and of itself cause an eating disorder. But as was stated above, over-control becomes a risk factor when it is combined with a critical or emotionally neglectful parenting style. In addition, control becomes a risk factor when it occurs in families where there is no emotional communication or where conflict is frequent and unresolved. Many patients show in their childhood kitchen drawings that meals were characterized by conflict. Sometimes the conflict was about food, eating, or table manners, but often the family meal was merely the arena where everyone gathered and thus became a forum for airing grievances (Bullit-Jonas 1998).

Response piece: Kitchen of my dreams

Media
One sheet of 12 x 18 inch (A3) white drawing paper and oil or chalk pastels.

Directive
"In this experience you may design the kitchen of your dreams. How would it look? What would it feel like? What sounds would you hear? What would it smell like? What needs would be met and how? Make sure that you address the kitchen influences that you believe contributed to the development of your eating disorder. What would the rules be about access to food, its preparation, and its presentation? Use color, line, pattern, and texture to represent the experience of your future kitchen: the kitchen of your dreams."

Expected themes
After being confronted with potentially disturbing images, thoughts, and feelings in the previous drawing, the *Kitchen of my dreams* drawing gives patients the freedom to make something positive. Patients express the desire for their kitchen to be free of conflict or anxiety. They describe places where needs are met in appropriate ways. In addition, they talk about desiring that family meals be peaceful and characterized by open communication, laughter, and sharing. The *Kitchen of my dreams* art experience may be the first step toward establishing new and healthy food rituals. Patients who create new and healthy rituals about

family meals are likely to have more satisfying future experiences than those who do not (Roberts 1999). Art makes the ritual visible and therefore more likely to be effectively employed.

Homework and healing dimensions

Patients must recognize the difference between eating to provide fuel for the body and eating for emotional reasons. Between sessions they can use their creative journals to record the circumstances prompting eating episodes. After recording these events and the eating episodes that follow, patients are often able to recognize the confusion of food and emotion. They are often surprised to discover how relatively infrequently they eat in response to hunger cues, and how often they binge eat in response to emotion. After the pattern is revealed, it is easier to help patients eat in response to hunger and to fulfill emotional needs in appropriate ways.

Patients can be asked to expand on the similarities and differences between the two kitchen drawings. They can use their creative journals to write a paragraph or poem to help consolidate the learning. The two kitchen drawings by an adolescent girl who suffered from anorexia nervosa are displayed in Figure 5.4. This girl placed a digital photo of the combined drawings in her creative journal. The side-by-side kitchen drawings helped her compare and contrast her thoughts and feelings about them. She responded to the image with the following words:

> I loved imaging how my ideal kitchen would look in comparison to my mother's, because it made me feel that food did not always have to be presented in a messy, chaotic situation. The kitchen I pictured for myself was immaculate, spacious, well-lighted, and inviting because nourishing myself should be a positive experience, not an anxiety provoking one. The dining table is right in the middle because I wish that meals could be about connecting with family and friends and coming together, instead of simply eating.

The young woman who made these drawings has a permanent reminder of what she will create for herself in the future. Patients can be encouraged to think beyond themselves and write about how they would like to *prevent* eating disorders in the next generation. They can write about avoiding struggles with food, not using food as a reward or punishment, and finding non-food ways of nurturing in the kitchens of their dreams.

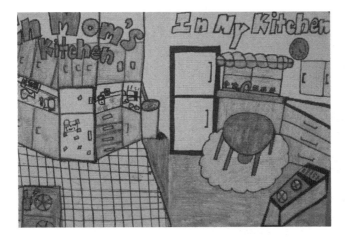

Figure 5.4: Kitchen drawings demonstrate and clarify confusion of nurturing and food

Hopes, wishes, dreams drawing

Media
One sheet of 12 x 18 inch (A3) white drawing paper and oil or chalk pastels.

Directive
After a brief period of relaxation, patients will be given this directive: "Close your eyes and imagine yourself before the start of the eating disorder. Remember what your important wishes, hopes, and dreams for the future were at that time. Think about where you imagined you would live, who you thought you would live with, and what sort of work you wanted to do. When a picture is in mind, portray it on paper. Please date and title the finished image."

Expected themes
Frequently the theme that arises from this drawing is of the hopes and dreams that were put on hold or lost due to the eating disorder. Patients should not be allowed to consider their hopes and dreams lost. They can be recovered along with other aspects of the life they are planning for themselves. Sometimes patients report feeling they have spent so much time and energy on the eating disorder that they do not have time to pursue their dreams. The response piece following this art experience, *Making dreams come true*, will be a starting point for recovering what patients felt was postponed by the appearance of the disorder.

Response piece: Making dreams come true

Media

One sheet of 12 x 18 inch (A3) white drawing paper, colored construction paper, collage materials, oil or chalk pastels, scissors, and glue stick.

Directive

After breathing and relaxation, patients will be given the following directive: "Choose one portion of the previous drawing that you would like to focus on. The focus will be on making *one part* of the previous childhood dream a reality. Cut or tear out one segment of the drawing and glue it to a new background paper. Choose collage materials or pastels to make a background that is conducive to making the dream become a reality."

Expected themes

Patients often report difficulty getting started with this mixed media art experience, but once is it completed, they claim a sense of relief knowing that their dreams can come true. Difficulty getting started is likely related to patients being confronted with the fact that the eating disorder has prevented them from having what they wanted in life. Sadness at the realization of this loss is natural. In addition, patients often feel overwhelmed when they believe all losses have to be addressed at the same time. By focusing on *one part* of the image above, therapists demonstrate that tasks are manageable when they are broken down into small steps. This is not to say that the whole of the childhood dream cannot be recovered, merely that only one part at a time is the focus of attention.

Patients also are faced with the necessity of changing their lives in order for their dreams to come true. Fear of the unknown makes change difficult even when patients believe that a healthy life is more desirable than an eating disorder. Art can be a way to overcome fear of the unknown. For example, the young woman who made the collages shown in Figures 1.4 and 1.5 demonstrated to herself that the chaos of bulimia nervosa had to change in order for her to have the calm and celebratory life that she wanted. As in Figure 1.5, the *Making dreams come true* image does not require patients to have a concrete plan for change. The creative *process* has demonstrated that dreams can come true; this fact is reassuring regardless of the details of the plan.

Homework and healing dimensions

Patients can be encouraged to use their creative journals to further explore the *Hopes, wishes, and dreams* image. They can use the same process of choosing one piece of the original image and incorporating it into a new drawing to see what

information it contains about making dreams come true. Patients can be encouraged to write a paragraph or poem about renewing hopes, wishes, and dreams or having renewed courage to make their dreams come true. Patients may need to develop new skills in order for meaningful change to take place. In the next chapter problem-solving skills are taught which can help patients transform their lives.

Summary

The art experiences in this chapter demonstrated that eating disorders develop in response to many factors. Patients benefit from understanding the complex and multi-determined development of the eating disorder. Understanding this complexity helps reduce the shame associated with the disorder. In addition, this understanding can eliminate the likelihood of externalization of blame and provide more internal motivation for change. In this chapter complex childhood family dynamics were made visible through art experiences. Patients learned about appropriate boundaries and needs. Art helped clarify confusion relating to food and nurturing. Patients began to understand needs and to unravel the confusion about meeting needs. Art demonstrated that eating disorders delayed dreams for the future and showed that dreams can be reclaimed. Patients have taken the first steps toward designing their futures, free from eating disorders.

Promoting Problem-solving Skills

Fine art is that in which the hand, the head, and the heart go together.
John Ruskin (1819–1900)

Introduction

Men and women with binge eating disorder, bulimia nervosa, and anorexia nervosa often depend solely on eating disordered behaviors to soothe themselves in times of emotional distress (Freeman and Gil 2004; Schoemaker *et al.* 2002; Serpell and Treasure 2002). Because of the overuse of these behaviors, skills and confidence do not develop in positive problem-solving behaviors. One young man I worked with depended on restricting caloric intake with a religious-like zeal. He became so emaciated and weak that no other problem-solving skills were possible; he could not think about or do anything except starve himself. I have witnessed the same process, though perhaps to a lesser extent, in most patients with whom I have worked. Eating disordered thoughts and behaviors become the near-exclusive ways in which life is approached.

The art experiences in this chapter will demonstrate that alternatives to eating disordered thoughts and behaviors exist. Patients need to know that eating disorders become overused because they become habits. One purpose of the art experiences in this chapter is to show that positive skills also can become familiar and habitual. Already patients' positive experiences with art media have required new problem-solving skills. And patients' success with the media has begun to foster a sense of mastery and control that is not based on the eating disorder. In addition, concrete skills have been taught and practiced that will guide patients to healthier ways of coping.

Through the use of art experiences and homework assignments in previous chapters, patients have been encouraged to practice assertive behaviors which should have increased positive interpersonal relations. They have been encouraged to be aware of their needs and to start meeting needs in healthy ways. Patients have recognized that eating has not always been initiated by hunger; other desires have sometimes provoked eating, either because they have been confused with hunger, or because patients wanted to avoid acknowledging

those needs. Patients have begun to track this confusion and sort it out, and they have begun to eat more in response to physiological hunger cues and less in response to feelings and needs.

Through the specific art experiences in this chapter, patients will learn that they have the ability to soothe themselves when upset and that art will facilitate this practice. Art can be used to combat anxiety and enhance the relaxation response. In addition, patients will have an opportunity to learn a unique art-based problem-solving technique that reveals they already have solutions within them. Art experiences will help patients understand ambivalence about change and chart a course for recovery.

Safe place painting

Media

One piece of 12 x 18 inch (A3) white drawing paper, folded in half, creased heavily, and gently torn in half. Only one of the resulting 9 x 12 inch (A5) pieces of paper will be used. Watercolor paints, water, and brushes. Watercolor paints will be introduced in this chapter to help evoke more emotion. Paint is a fluid medium and its use is associated with the greatest level of emotional involvement (Fleming 1989; Kagin and Lusebrink 1978; Lusebrink 1990). Patients should be challenged to use new art media. As was stated in the previous chapter, a new medium may yield new types of information. In addition, the use of a new medium challenges cognitive distortions such as, "I have to be perfect in everything I do" or "I must have absolute control over everything I do" (Matto 1997). Patients can be talked through their discomfort into experimenting with unfamiliar materials and processes. In addition, patients' self-talk should be monitored and changed so it is more accepting and soothing. Therapists actively model and teach realistic and reassuring self-statements during the art experiences (Matto 1997).

Directive

After a period of breathing and relaxation, the following directive will be given: "While you are relaxed and comfortable, close your eyes and bring to mind a place where you have felt, and would continue to feel, calm and safe. It may be indoors or outdoors as long as you would feel secure and serene there (pause 5 seconds). Think about how the place looks: the colors and sights you would see there (pause 15 seconds). Imagine what sounds you would hear (pause 10 seconds). What pleasant, relaxing aromas would you smell (pause 10 seconds). Imagine sensations the place would evoke; would it be warm and windy or cool

and still (pause 10 seconds)? Take a few moments to relax in this safe, calm place (pause 20 seconds).

 With this image firmly in mind, please paint a picture of your safe, calm place. Paint it with as much detail as possible in line, color, and form. When you look at the picture in the future you will need to see so much detail that you will be able to easily recall the relaxed state you experienced when you began to paint. When the painting is finished, please date it and choose a title that reflects safety and serenity."

Expected themes

Patients should spend time intentionally looking at the image. During this period of intentional looking, patients should be instructed to recreate the experience of relaxation they felt when first imaging the safe place. Eating disorder patients report stress as a trigger for food preoccupation and binge eating (Fairburn 1995; Vanderlinden *et al.* 2004). Patients often report feeling as though they will be carried away by strong emotion and that the only way to stop feeling the emotion is to binge eat, or engage in some other eating disordered behavior. Patients should be taught that relaxation is a state of being that is physiologically incompatible with stress, anxiety, or other strong emotions. Using relaxation as a tool, they can cope positively with strong emotions. Eating disordered behavior gave the *illusion* of control; relaxation is a tool that can be used to establish *true* control over mood states or mind states. The image forms a tangible reminder of the ability to use the new skill of relaxation.

 A woman who suffered from binge eating disorder painted a seaside sunset as her calm, safe place. She wrote the following simple verse as a way to remember that she could create within herself a feeling of relaxation:

> Safety and serenity
> I have it all in me.
> It's as simple as this:
> Follow your bliss.
> Sunset on the sea
> I have it all in me.
> Wind, sun, salt, and sand
> Calm in the palm of my hand.

This woman learned she could recall these relaxing feelings when she was upset and wanted to feel calm. When she was able to evoke a feeling of relaxation she was much more in charge of her emotional well-being than when she felt at the mercy of the eating disorder.

Response piece: Reduced reminder

Media

For this experience patients buy a small picture frame. It can be either magnetic to put on the refrigerator, or have a stand to place on a table. Therapists need access to a color photocopier.

Directive

Therapists reduce the original *Safe place painting* to a size that will fit in the frame. Patients place the framed painting where it will be viewed regularly.

During the week, patients are instructed to use their framed *Safe place painting* as a reminder of safety and serenity. They will call to mind, as many times as possible, the feelings of calmness and safety that they experienced when making the original painting. Patients should be instructed to try to relax when they are not feeling particularly stressed or emotional. After some practice, they should be encouraged to use this relaxation response *in place of* eating disorder behaviors whenever possible. This experience builds upon the skill previously developed of noticing that eating disorder urges occur in response to feelings and needs, not merely to physiological hunger cues.

Expected themes

Patients often respond to this experience by saying that it was unusual to feel so relaxed. Some will fall asleep during the relaxation. The theme to be developed with patients is that they have positive control over distressing feelings by using the relaxation response. This can be a freeing and yet a frightening proposition to those who have felt out of control with binge eating, or rigidly controlled with caloric restriction. This aspect of positive control should be emphasized and the skill practiced until it feels comfortable.

Some patients will contend that they could not think of a safe place, that they have never felt safe, or that they could not relax. In this case they should be encouraged to construct in their minds what they would *like* to experience as a safe, calm place. Again, they should be helped to develop the image of this calm place with as many of their senses as possible, and when it is developed to paint a picture of it. Patients *can* create the relaxing reality they wish to experience.

Homework and healing dimensions

Patients should be asked to record their attempts at practicing relaxation in their creative journals. They will put down in images or words their thoughts and feelings about taking themselves to the calm place they created. Patients should

be encouraged to write in detail, especially about the times they chose to use relaxation rather than the eating disorder when they felt upset or emotional.

Road to recovery

Media

One sheet of 12 x 18 inch (A3) white drawing paper, watercolors and brushes, or drawing media.

Directive

After a short period of breathing and relaxation, patients are asked to paint or draw a "road to recovery." In this problem-solving experience they are asked to predict what sort of road they will find and what obstacles remain in their way. Some patients will make an actual gray road with a yellow line down the middle, others will depict the road abstractly. They can be encouraged to include such things as: construction sites, road blocks, pot holes, detours, tolls, bridges, and any other obstacle or advantage that they imagine. Patients will also indicate their location on the road.

Expected themes

Patients should take time to silently view their image and to generate a list of one-word associations in response to it. The *Road to recovery* drawing often suggests the "superwoman" stereotype. The superwoman stereotype is described as the socio-cultural pressure to achieve in multiple different roles as well as to be thin. Thinness, perfectionism, and independence seem to interact in such a way that the result is felt as pressure to do it all, and to do it all without help, while looking great (King 2001; Smolak and Murnen 2001). Research has shown that young girls who internalize the superwoman stereotype are more likely to develop eating disorders than those who do not. Smolak and Murnen (2001) add that achievement striving per se is not problematic, "rather the lack of *intrinsic self-confidence* and motivation and the *loss of connection* in combination with attempting to achieve in multiple roles are associated with an increased risk of eating problems" (p. 96, italics added). Therefore, it seems that problems with the superwoman stereotype lie in disconnection from intrinsic motivation and the loss of support that comes from healthy interconnectedness.

Most women with eating disorders whom I have met adhere to the superwoman stereotype. They report feeling as though they must manage the home and housework, a job outside the home, their children and other family responsibilities. They feel pressure to be beautiful and to appear as if balancing their myriad tasks did not bother them. A popular novel by Allison Pearson, *I*

Don't Know How She Does It: The Life of Kate Reddy, Working Mother (2002), drew tremendous kudos as well as scathing book reviews for exposing the trials of women pulled in too many directions (Maslin 2002; Warner 2002). Some women seemed relieved to have the stress of trying to be superwoman exposed while others were angry.

I have talked with many men as well who feel pressured to fulfill an ever expanding number of multiple roles. Younger men especially claim confusion about what is wanted from them socially and emotionally. There is pressure to be successful and accomplished in their careers, as well as strong and determined, while at the same time being emotionally vulnerable with their girlfriends or spouses. They state that they must be successful at their profession during the week and then tackle the "honey-do list" on the weekends. They feel pressure to take their wives on Saturday night dates and be at the ballpark on Sundays. They report that when trying to be all things to all people, there is no time for decompression, no personal time. These men report using food to combat the ever increasing stress in their lives.

Another expected theme from the *Road to recovery* paintings is that of supporters and saboteurs. When patients begin to examine obstacles to optimal health, they may find that people make up some of those barriers. Patients must look honestly at the persons in their lives and assess whether or not they will be supportive of health or whether they will sabotage efforts at wellness. Patients ought to be counseled to reinforce connections with persons who support recovery and to modify, reduce, or eliminate relationships with those who do not. Patients in families where they do not perceive support need extra care and attention. Family therapy, marital therapy, or individual therapy can be recommended for difficult family members.

Response piece: The road less traveled

Media
One sheet of 12 x 18 inch (A3) white drawing paper, watercolors and brushes, or drawing media.

Directive
After relaxation patients are asked to respond to what they learned in the previous art experience. They will represent a road or create an abstract design, but patients should be encouraged to add or change something in this picture that they learned from the previous image. Examples include the addition of new construction or bridges, or the elimination of a detour or toll booth. Maybe there are pot holes that need to be filled. As much as possible, therapists will use

patients' metaphors to encourage them to change and add to their road drawings to make full recovery from the eating disorder a greater possibility.

Expected themes

Patients should compare and contrast the first and the second road images. Similarities and differences will be noted along with what these mean for recovery. After spending time with the two images patients may write a list of one-word associations to the second image or about the contrast between the two. Themes to be discussed are that

1. tremendous learning has occurred
2. recovery from the eating disorder is within reach
3. challenges will continue to occur.

Therapists help patients celebrate the learning and changes that have taken place thus far. The road images are not meant to show patients how far they have to go, but rather to emphasize how far they have come. Patients need to be reminded that on a difficult journey, every small success should be celebrated. Because many persons suffering from eating disorders have not worked from an intrinsic motivational base, they still look to the outside for validation. Therapists can validate progress; and point out how the images show it as well. The second image makes recovery more real because patients have delineated some necessary components for change. In addition, therapists can introduce metaphors that reinforce the idea of continuing to meet new challenges. For example, the evolution of the road as needs change over time, or pacing oneself for a marathon rather than sprinting to the finish.

Homework and healing dimensions

In the time between sessions, patients may use the one-word associations generated by the *Road to recovery* paintings to write a paragraph or poem entitled "What I have learned along the road to recovery." They should be encouraged to include what they have learned from the recovery process so far and to assess the difficulties they will face in the future. Patients can be challenged to project and develop in writing the type of life they would like for the future.

Patients can be assured that when they write about what they expect for the future it is more likely to happen as they imagine it. Patients can be introduced to a book by Henriette Klauser called *Write it Down, Make it Happen: Knowing What You Want and Getting it* (2000). In her book Klauser gives practical advice and anecdotal evidence about how writing helps people change their lives. She tells about ordinary people changing their lives by writing in everyday journals.

Writing a desire in the creative journal makes it more tangible and the outcome more possible.

I have often given star stickers, similar to the stars used on elementary school homework assignments, and asked patients to use them to decorate pages in their creative journals where they list the concrete steps they have already taken on the road to recovery. Patients should be encouraged to notice and record their progress on this difficult journey. They should not be allowed to forget that it *is* a difficult endeavor and they should be encouraged to celebrate each success as a way to sustain motivation in treatment.

Mandala painting

Media
One sheet of 12 x 18 inch (A3) white drawing paper, pencil, dinner plate, watercolor paints and brushes, water.

Directive
Mandala is an ancient word meaning "sacred circle" and it is a drawing or painting made in the form of a circle. According to Cornell (1994) the mandala drawing mirrors an illuminated state of consciousness through a symbolic pattern – making the unconscious conscious and drawing the creator and viewer into an encounter with healing energy. The purposes of the mandala drawing are to integrate different parts of the self, to create calmness, and to help the creator feel centered and whole (Cornell 1994; Jung 1969). Therapists facilitate circular drawings by tracing the outline of a dinner plate in the centers of some papers and having these templates available for use.

Therapists should explain that mandala drawings help confront ambiguity in a healing way. They can instruct patients to contemplate for a few moments conflicting thoughts or feelings causing them tension. Often patients feel ambivalent about the recovery process itself. Part of them desires wellness and part of them desires the familiar, even if it is unhealthy. After some thought, patients will be instructed to begin their mandala painting with a central image that summarizes the dilemma. They then add around that center point colors or symbols that characterize the uncertainly or contradictions requiring reconciliation. Patients should keep adding to the circular painting with colors, shapes, and lines until it feels complete. When the painting is finished, patients write a title for it and date it.

Expected themes

Before talking about the mandala, patient and therapist should take time to intentionally view it. Patients can be instructed to make sure they contemplate the message about unity that the image offers. After a period of contemplation patients can generate a list of one-word associations to the mandala painting.

Many times patients deny or disown what they do not like in themselves or what they believe others do not like. Disowning parts of themselves cuts patients off from potential personal power. This art experience shows patients that as they embrace and understand what they find undesirable in themselves they can gain strength from working toward wholeness. The woman who created the mandala in Figure 6.1 was trying to find a balance between what she called the light and dark sides of herself. Through her hard work in therapy, this woman discovered she had tremendous courage and strength. This mandala painting helped her understand that she wanted to develop her mountain-climbing skills rather than deny the physical strength that was not acceptable in females in her childhood family. This was the "dark side" which was considered too masculine in her family of origin. This woman realized she had been living her life in extremes by denying her strength and overemphasizing stereotypical feminine characteristics (the light side). She understood that rather than living her life in this way, she could find a comfortable middle ground. The mandala painting helped her begin her journey to the center of herself.

Many young men and women with eating disorders find themselves living life in extremes. Sometimes they refer to a process of black and white thinking where nothing is moderate: Things are black or white, good or bad. Reality is

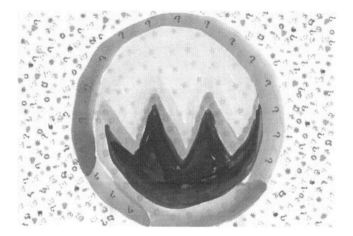

Figure 6.1: Mandala painting aids integration of opposites

that events and people have both good and bad qualities. Forcing events and people into extreme categories is artificial and increases tension. Images provide an effective way of confronting this cognitive distortion of black and white thinking. Often images plainly show the artificiality of the division and the desired middle ground When patients learn to live with the dual nature of things, people, and especially themselves, they live more peacefully.

Response piece: Recovery mandala

Media

This art experience requires one sheet of 12 x 18 inch (A3) white drawing paper, pencil, dinner plate, watercolor paints and brushes, water.

Directive

Therapists prepare for the mandala painting by drawing a circle in the middle of a paper. After a period of breathing and relaxation, patients will be given the directive:

"Think about your recovery and the contradicting forces pulling you in opposite directions. This could be an instance of black and white thinking in which you would like to find some gray. It may involve ambivalence about wanting to give up the eating disorder. You may want to try integrating opposing parts of your personality. Start your painting in the center, adding symbols, colors, and patterns to represent the problem and possible courses of action. Keep working around the center filling more of the circle until it feels whole."

Expected themes

Integrating opposites is not an easy or comfortable process for many; it takes time and conscious effort to accomplish. Patients may report that it feels artificial to think in this integrative fashion. It is not important to name the opposing forces or give words to the work that the mandala represents. Patients can be encouraged to respond to the mandala as a work of art rather than as a representation of a problem and potential solutions. They should reflect on how the mandala assisted them in looking at recovery in a different way.

Patients will benefit from an open discussion of the ambivalence that characterizes change. They must be reassured that it is common for persons in recovery to have mixed emotions about change. Although they truly want to be rid of the eating disorder, it is the reality with which they are most familiar and therefore will be very hard to give up. Patients need to know that therapists understand and empathize with their fears of change and the unknown. At the

outset of therapy, wellness is the unknown. Patients will benefit from this direct discussion of what they expect and fear about life without the eating disorder. In addition, patients may be encouraged to express their fears through art.

Homework and healing dimensions
Drawing or coloring mandalas reduces anxiety and increases physical and mental relaxation (Curry and Kasser 2005; Malchiodi 1999). Between therapeutic sessions patients can use the mandala painting as a way to decrease tension and increase relaxation. Patients should be instructed to paint a mandala at least once during the week in the place of eating disordered behavior. They will experience the mandala as nurturing in ways that food has never been.

If these healing designs particularly appeal to patients they can be encouraged to do further reading about mandala paintings. There are books about the history and interpretation of the mandala (e.g., Fincher 1991) and even mandala coloring books such as Mariane Mandali's *Everyone's Mandala Coloring Book* (1998), which contains preprinted designs for coloring and contemplation. Patients also can create their own complicated mandala images with a child's Spirograph toy. A Spirograph allows a circular image to be formed by rolling a circle inside or outside another circle. Spirographic images may be colored with colored pencils for relaxation.

Problem-solving collage

Media
One sheet of 12 x 18 inch (A3) white drawing paper, colored tissue paper, and a half and half mixture of glue and water.

Directive
After a brief period of breathing and relaxation, patients will be given the following directive in steps:

1. Think of a problem you would like to resolve
2. Break the problem down into three to five essential elements
3. Write a list of the elements of the problem
4. Assign each part a color and write it on the list
5. Put away the list
6. Cut or tear pieces of colored tissue paper to match the colors chosen

7. Use the tissue paper, in the colors chosen, to make a picture. The picture can be an abstract or representational, whatever feels authentic.

8. Dip the torn tissue paper in the glue-water mixture and lay it on the background paper to form your image.

Expected themes

Patients should take some time to reflect on the image. They can be encouraged to think about how the image contains the solution to the problem that was proposed. Patients may make a list of one-word responses to the image for later use.

The woman who made the image in Figure 6.2 found clarification of a problem in the reflection of the setting sun. The woman was a successful attorney, married with two children, who reported being under a great deal of stress. She engaged in daily binge eating and purging behavior to "deal with the stresses" of working full time and leaving her children in full-time daycare. The elements of the problem were 1. money, 2. the well-being of the children, 3. career satisfaction, 4. marital harmony, and 5. free time. When the image was complete, the answer that came to her was:

> I don't want my children in daycare from sun up to sun down. The extra money is not worth the extra stress and guilt that I feel. I can get career satisfaction and have more marital harmony and time with my children by working part time.

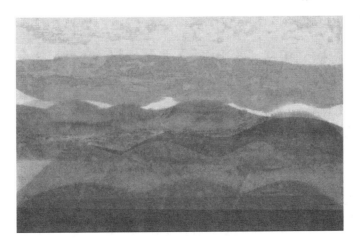

Figure 6.2: Problem-solving collage – Art shows patients that healing answers exist within them

The idea of working part time was not new, but this was the first time it was articulated and made concrete. Seeing the picture and discovering what it meant made part-time work a realistic possibility for this woman. The problems and solutions in this experience are secondary to the lesson that patients hold healing answers – answers that are right for them – inside their heads and hearts. The important lesson is for patients to develop confidence in their own inner wisdom.

Response piece: Decision-making collage

Media

One sheet of 12 x 18 inch (A3) white drawing paper, colored construction paper, collage images, and glue stick.

Directive

Patients will be encouraged to think of a different problem or a decision they would like to make. The problem should be clearly written as a statement for which the pros and cons can be examined. Patients will be instructed to fold their paper in half, open it back up, and they will have two equal halves on which to work. The problem should be written across the top of the paper. The two halves of the paper will represent the "pros" and "cons" of the problem/decision. Patients will be instructed to place collage images on each side of the paper representing the positive and negative aspects of the decision/solution.

Expected themes

Patients should contemplate their image and the process that they went through in making it. Persons with eating disorders have stated that they do not feel confident about making their own decisions. In fact, they report not making personal decisions, but rather doing what other people tell them to do. Additionally, they report experiencing uncertainty and delaying decision-making until in effect, a decision is made for them. They explain that the anxiety involved in thinking about and delaying a decision provokes eating binges or extreme food restriction. When patients have no firm knowledge of themselves – their beliefs and values – decision making is especially difficult.

Through this art experience patients will gain understanding of one aspect of decision making. They will see through their own practice that problems can be carefully thought through in order to reach rational decisions. Patients will begin to learn from these experiences that they can trust their internal wisdom and draw upon it in future problem-solving and decision-making situations.

Homework and healing dimensions

Between sessions patients should be encouraged to use the problem-solving technique or the decision-making collage in order to solve a dilemma facing them. They will choose decisions or problems they feel capable of tackling on their own. After engaging in these activities, patients will record them in their creative journals. They will be certain that there are healthy and helpful problem-solving alternatives available to them. Patients will have increased confidence that solutions to difficult problems exist within them, the answers merely need a vehicle for expression.

Summary

The art experiences in this chapter have demonstrated that patients can soothe themselves with art by using the *Safe place painting* and the *Mandala painting*. They can learn the relaxation response through calling to mind a safe, calm scene using all of their senses. The relaxation response is physiologically incompatible with anxiety, anger, and other strong emotions. When patients become practiced at creating relaxation, they have the power to make themselves calm in the face of stress or strong emotions. Patients can choose to practice relaxation rather than eating disordered behavior. The mandala drawing also can be used for self-soothing. As was mentioned, research has shown that engaging in this specific circular creation induces mental and physical relaxation. Patients can use the mandala to relieve stress and tension.

Finally, the art experiences demonstrated that patients can use the power of their minds and the written word to create the life they want. With conscious effort and hard work they can solve problems without resorting to eating disordered thoughts or behaviors. Patients have learned a unique art-based problem-solving technique that reveals solutions already within them.

They have seen that healthy alternatives exist *right now* within them. Sharing these vital realizations with therapists and practicing them through homework assignments helps clarify and solidify the new skills.

Reclaiming Emotions

It is the glory and good of Art that Art remains
the one way possible of speaking the truth.
Robert Browning (1812–1889)

Introduction

At very young ages children learn which emotions are allowed expression in their families and which are not. Generally speaking, feelings deemed unacceptable are ones that cause parental discomfort. Children regulate and change their emotions in order to maintain important attachment relationships (Cassidy 1994). If father has alcoholic rages and mother cries or hides because of them, children learn that rage/anger makes mother uncomfortable and soon avoid expressing their own anger. Anger is contained to maintain a relationship with the mother. Both the suppression of anger as well as the experience of chronic anger have been related to the development of eating disorders (Waller *et al.* 2003). For children, emotions can feel so powerful that they seem dangerous and unacceptable. If the experience of emotion is not clarified, all feelings can be driven underground in confusing ways.

Sometimes emotions are suppressed because sensitive children perceive that parents are too preoccupied to attend to them. For example, a teenaged girl with whom I worked was eleven years old when her mother became pregnant with a half sister in a new marriage. When the baby was born, medical complications required an apnea monitor which caused stress in all family members as the alarm sounded and everyone rushed to see if the baby was breathing. When she was twelve years old, this young girl started her menstrual period and was unprepared for it; no one in her family had talked to her about menstruation. In addition, she started middle school and was anxious about the increased academic and social demands. Finally, the girl was asked to tutor her younger brother who was having difficulty in school. This young adolescent met all of these challenges without help or complaint. She never knew that she was feeling *any* emotion – she just stopped eating.

During her treatment for anorexia nervosa this young girl pieced together the influences on the development of her eating disorder. And when she did, lack of emotional expression was a major contributing factor. She was angry with her mother for abandoning her when she needed her greatly, and angry with herself for not knowing how to ask for what she needed. The girl and her parents worked hard in family therapy and developed more open ways of communicating about emotions.

Art experiences in this chapter will reveal how emotions may be suppressed altogether, confused with one another, and also confused with physical sensations. One goal of this chapter is to help patients learn to discriminate among their feelings. Patients will learn to distinguish one emotion from another, and emotions from physical sensations. They will learn that emotions are signals that help guide communication and behavior. This knowledge, combined with skills learned earlier about self-soothing and relaxation, will increase behavioral choices. With more choices available, the eating disorder will decrease in importance as a response to emotions.

When patients first come for psychotherapy they often tend to describe their eating disorder symptoms in minute detail as a substitute for emotional expression (Krueger 1989). When asked how they feel patients often reply, "I feel fat"; because they have avoided emotions for so long they do not have words to describe their feelings. Patients who have avoided emotions since childhood need to understand that they will not be overwhelmed by their emotions when they begin to experience them again. Bullit-Jonas (1998) wrote that for patients with eating disorders, the capacity to fully experience emotions has "been asleep," similar to a limb that has become numb from pressure. Beginning to experience emotions again may feel like the pins and needles that occur after numbness: painful at first, later annoying, and finally disappearing.

It is not only patients' numbness and suppression of feelings that therapists are attempting to modify. To recognize and experience emotions patients must overcome our "emotion phobic" societal norm which values rational thought over emotion (Greenspan 2004). According to Greenspan, patients have been socialized to endure emotions in silence and to value stoicism over the expression of emotions. Men might have an especially difficult time overcoming "normative male alexithymia" (Levant 2003). Most men in western cultures do not have words to describe their emotions and might not even know that they are experiencing emotions. Therapists must explain that socially sanctioned stoicism must be overcome by men and women so that emotions can be invited back into patients' lives. Recognition of feeling states allows considerable choice over how emotions are expressed.

Mood states/Mind states

Media

Three sheets of 12 x 18 inch (A3) white drawing paper, watercolor paints, paint-brush, water, and pencil. Write out the following words for reference: Angry, Anxious, Calm, Curious, Depressed, Excited, Fearful, Guilty, Happy, Helpless, Innocent, and Sad.

Directive

Instruction #1: Therapists prepare for the art experience by sharply creasing and gently tearing three sheets of 12 x 18 inch (A3) white drawing paper into four equal rectangles. When finished, there should be twelve small sheets of paper, approximately 6 x 9 inch (A5) each. Patients write the name of each mood state or mind state from the list above, one on each sheet of paper. These labels will be on the *back* of the papers so that when the images are viewed from the front, the names written on the back will not be visible. After a period of breathing and relaxation, patients use colors, shapes, and patterns to *abstractly* demonstrate each mood state or mind state. They paint one mood state or mind state on each paper referring to the label on the back, but not making the name visible. When finished there will be twelve separate small paintings.

Instruction #2: In this session if there is time, or in the next, patients will sort the paintings into piles based on the abstract images. They should *not* refer to the written labels. They will use only elements of the visual image (line, shape, color, and pattern) to sort the images; thus, the groups will make sense *visually*. When finished, patients may have four piles of three pictures each, two piles of six, or some other combination of images. There is no right or wrong way to sort the pictures.

Finally, with the pictures sorted, patient and therapist refer to the labels on the back. Lists should be written of mood states and mind states that were grouped together.

Expected themes

Often patients are surprised to see which emotions were grouped together. Patients and therapists can explore how the emotions grouped together by image might be experienced or confused in life. For example, they might see that anger is confused with excitement or anxiety. Patients and therapists can examine patterns of emotional expression in families to determine how confusion might have been learned or modeled. As noted earlier, parents might not have had words to describe their own emotions or perhaps they never expressed emotions in front of their children. Their children would be raised without an

emotional vocabulary and would not learn to openly express emotions (Espina 2003). Some children might have witnessed their mothers cry when angry. These children would grow up confusing anger and sadness. Therapists also can explore how patients' religious, ethnic, or cultural background influenced the expression of mood states and mind states.

Therapists should explain that similar autonomic nervous system reactions accompany certain emotions (Stemmler 2004). For example, anger, anxiety, and excitement are characterized by increased heart rate, shallow breathing, and increased sweating. If a child decided that he or she was not going to feel anger, the child might confuse other emotions that are physically similar such as excitement or anxiety. Later in life, the child might suppress all emotions with the same physiological substrate.

It has been well documented that persons with eating disorders have difficulty identifying emotions from other people's facial expressions and vocal cues, and difficulty finding words to describe and express their own emotions (Hayaki, Friedman, and Brownell 2002; Kucharska-Pietura *et al.* 2003; Sim and Zeman 2004; Zonnevylle-Bender *et al.* 2004). It has been hypothesized that difficulty discriminating among emotions leads to difficulties interpreting emotional signals and understanding how to act on the basis of them (Ekman 2003; Pollak *et al.* 2000). Recovery from eating disorders must involve relearning what the basic emotions are, how they feel, what might provoke them, and what is appropriate to do about them. Research shows that there are emotion-specific facial cues and subtle autonomic nervous system variations that provide a foundation for teaching patients how to differentiate and respond to emotions (Ekman 2003; Israel and Friedman 2004).

Response piece: Four basic emotions

Media
One sheet of 12 x 18 inch (A3) sheet of white drawing paper, watercolor paints, paintbrushes, and water.

Directive
After breathing and relaxation, patients will be given this directive: "Fold your paper in half two times, and then unfold it. The large piece of paper will contain four smaller rectangular areas defined by the folds in the paper. In each rectangle write one of the following words: Mad, Sad, Afraid, and Happy. Remember a time when you felt each of these emotions. As you remember the circumstances in which the emotions were experienced, also try to recall the thoughts and bodily sensations that went along with them. You are purposely trying to expe-

rience the emotions as *different* from one another. Feel them differently in body and mind, and relate them to different events and outcomes.

With the labels in plain view, paint an abstract picture of each of the four basic emotions. Use color, form, line, and pattern to make the images as different as possible from one another."

Expected themes

Patients should spend time intentionally viewing their images before creating a list of one-word associations about them. Therapists and patients can discuss the process of discriminating among the four basic emotions, as well as the resulting images. The young man who made the picture in Figure 7.1 worked hard to show himself the differences between emotions. He reported that being able to focus on the different lines, shapes, and colors when making the pictures helped emphasize the differences among the emotions that he was learning to feel differently in his mind and body. During recovery, the young man could refer to the *Four basic emotions* image to help clarify confusing feelings. Images such as these or a chart explaining emotions are often a focal point in eating disorder treatment programs because they aid patients in becoming aware of emotions and discriminating among them. In order to triumph over an eating disorder patients need continued practice with the experience and expression of basic emotions (Becker-Stoll and Gerlinghoff 2004).

Figure 7.1: Four basic emotions drawing – Art helps patients discriminate among their emotions

While educating patients about the recovery of emotions, it is important to teach them that emotions are merely signals. The mind and body work together to inform us, through emotions, about significant circumstances in our lives. For example, anger is a signal that we did not get something that we wanted, or that we got something we did not want. Anger fuels behavior to put things right. Sadness signifies loss and the importance of sharing grief and being taken care of in times of need. Fear signals threatened danger. A natural response to fear is the fight/flight mechanism. If we feel threatened, we fight or flee. Happiness is a response to pleasure, satisfaction, or joy. Happiness makes us smile and laugh, and increases our chances of experiencing more pleasure in the near future. Patients need to recognize that emotions are important signals for directing and motivating behavior (Ekman 2003).

Patients also must learn that like most signals, emotions are temporary. Although they are intensely felt, when circumstances provoking emotions are removed, emotions fade away. Patients can be taught that emotions are like waves: they rise, crest, peak, and recede (Reindl 2001). The temporary nature of emotions can be reinforced through a review of patients' art work or creative journals. The review will show that over the course of time various strong emotions were felt. The same intensity of emotion will not be felt during the art review process. A strongly felt emotion is an important signal that recedes with time as its signaling function is no longer necessary.

Homework and healing dimensions
Creating art can function as a bridge between experiencing emotions and learning to express them spontaneously. Painting or drawing intense feelings helps patients experience, understand, and ease emotions. Patients can be instructed to paint or draw in their creative journals feelings experienced between sessions, and also to write about what the emotions signaled. The young man who drew the four primary emotions in Figure 7.1 used markers to make sketches like the one in Figure 7.2 in his creative journal to help *clarify* what he was feeling.

The sketch in Figure 7.2 represented anger, a previously unfamiliar emotion. Drawing his anger helped this young man clarify what he was feeling and know that it was safe to experience and express it. Drawing his anger also helped him define its parameters; when he could see the anger on paper it was concrete and less threatening. Responding to drawings in writing helped this young man learn from his anger rather than be intimidated by it.

Lubbers (1991) suggested that therapists ask eating disordered patients to draw six feelings that they experienced during the previous week. She proposed that the language of this art experience would help patients understand that it

Figure 7.2: Drawing of anger from patient's creative journal – Further discrimination of emotions

was acceptable and expected that patients feel many emotions. In addition, the art experience allows patients to express their emotions in a constructive manner. This art experience can be assigned as homework to give more experience discerning and expressing emotions.

Body feelings map

Media

One piece of 12 x 18 inch (A3) sheet of white drawing paper, black permanent marker, watercolor paints, brushes, and water.

Directive

To prepare for this art experience:

1. Therapists orient the paper vertically and draw an outline of a human body with the black permanent marker, making sure that head, neck, shoulders, arms, torso, abdomen, pelvis, legs, and feet

are included. The outline should fill the paper; it will serve as patients' map of the human body.

2. Therapists make a legend for the map at the bottom or side of the outline by writing the four basic emotions: Mad, Sad, Happy, Afraid, and one blank line for patients to fill in an emotion of their choice.

3. Next to each written emotion therapists make a square box that is filled in with color.

After breathing and relaxation patients will be given the following directive: "This body map will represent your body and how you experience these emotions. Please choose a color for each feeling listed here and fill in the square next to the name with that color. Where you see this line, write in the name of another emotion and choose a color for it too. When you have chosen a color for each feeling, paint the parts of your body where you feel each emotion."

Expected themes

Patients should take time to contemplate the *Body feelings map*. After silent contemplation, they can make a list of one-word associations about it. Therapists can promote discussion of how the feelings represented are experienced in the painted body parts. They might find for instance, that anger is related to headaches, or sadness to an empty feeling in the abdomen. Patients can reflect on how these physical manifestations of emotion are related to the eating disorder and other bodily concerns. Patients will benefit from learning that physical conditions at times are related to the stress of holding unexpressed emotions in the body. Therapists can teach that stress causes certain hormones to be secreted, muscles to be tightened, heart rate to be increased, and other physical processes that can exacerbate or cause physical conditions such as migraine headaches or ulcer (Lovallo 1997; Robert-McComb 2001). When emotions are more clearly understood and more openly expressed, stress-related physical conditions decrease in frequency, intensity, and duration.

Figure 7.3 is an example of a completed *Body feelings map*. The woman who made the map in Figure 7.3 suffered from binge eating disorder. She discovered that anger and fear were experienced as sensations in her stomach and that these emotions influenced her desire to binge eat. Eating binges are triggered by negative emotional states (Fairburn 1995; Kjelsas, Borsting, and Gudde 2004; Vanderlinden *et al.* 2004). If therapists help patients identify emotional triggers and handle them effectively, patients will be less likely to use eating disordered behaviors in response to emotion. Common triggers have been identified as stress, boredom, and loneliness (Fairburn 1995; Vanderlinden *et al.* 2004).

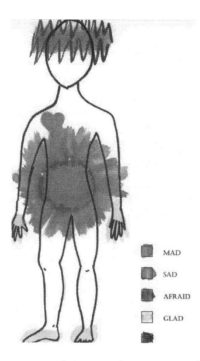

MAD

SAD

AFRAID

GLAD

Figure: 7.3: Body feelings map — Art shows patients how emotions can be related to physical conditions

Patients can be taught that emotional triggers have physical, emotional, and cognitive components that can, with practice, be identified and responded to in healthier ways.

Response piece: Listening to the body

Media
One piece of 12 x 18 inch (A3) sheet of white drawing paper, black permanent marker, watercolor paints, brushes, and water.

Directive
Therapists prepare a body outline as they did for the previous art experience. No written legend is required. After a brief period of relaxation, patients will be given the following directive adapted from a workshop I attended given by Lucia Capacchione:

"Close your eyes and review your body for pleasant and unpleasant sensations. What feels relaxed, well, and good? What creaks, aches, or gives you pain?

Now focus only on the *negative sensations* and choose one place in your body that you would like to concentrate on in this experience. Imagine *one place* in your body where an ache or pain is located, and use color, size, and shape to define it. For example, the pain might feel yellow and orange like fire, or blue like an icy knife. When you have an image in mind, paint it on the body outline provided."

When they are finished with the body painting, the next part of the experience involves a dialogue with the chosen body part. Patients should write or say their answers to the following four questions:

1. What are you?
2. How are you feeling? Focus on physical sensations and emotions.
3. Why do you feel that way?
4. What can I do to help you?

Expected themes

Moore (1992) writes that in the United States we have been inundated with information about healthy lifestyles, but we have never been so out of touch with the natural wisdom of the body. It has been my experience that most patients with eating disorders can recite countless facts about nutrition and exercise, but they lack the ability or wisdom to apply the knowledge meaningfully in their own lives.

A young woman suffering from bulimia nervosa and a chronic foot injury from excessive exercise wrote the following responses to the four healing questions:

1. What are you?	*I am the foot that tries to slow you down.*
2. How are you feeling?	*I feel put upon. Stabbing, burning pain. Notice me!*
3. Why do you feel that way?	*I hurt because you do not slow down. You are always working out. You are always "on your toes."*
4. What can I do to help you?	*Slow down. Take care of yourself. Take care of me.*

A fifth healing question may be added: *What are you here to teach me?* This question was not required in the previous example because as often happens, it was answered in the responses to the first four questions. After completing this

art experience, the young woman discussed above reported that she was willing to listen to her wise inner voice telling her to slow down and take care of herself. She wanted more out of life than exercise and injury. All patients suffering from eating disorders must relearn the skill of listening to and regaining trust in the wisdom of their bodies.

Patients from diverse cultures will benefit from therapists' understanding that emotions are sometimes not expressed directly, but expressed through physical symptoms. In this case, working metaphorically through art images will help culturally diverse patients express what they may not have words to describe. In addition, working with images may promote positive feelings and an appreciation for the distinctiveness and wisdom of patients' cultural backgrounds (Aviera 2002; Henderson and Gladding 1998; Ying 2002).

Homework and healing dimensions

In the previous two art experiences patients learned that emotional signals, if they are not expressed directly, may be expressed through illness, physical symptoms, or eating disorder behaviors. Patients can take cues from their bodies and listen to physical symptoms as messages of hidden conflict or stress. In the time between sessions, patients can be encouraged to paint or draw in their creative journals about their experiences listening to the natural wisdom of their bodies. They should be cautioned to be especially attentive to messages from their bodies about stress and unexpressed emotions. These messages are likely to be present when patients feel like acting out with the eating disorder.

Pride/shame/joy circles

Media

Three sheets of 12 x 18 inch (A3) white drawing paper, collage images, drawing media, glue stick, and scissors.

Directive

To prepare for the session, therapists draw or trace on each sheet of paper a circle large enough to fill the center. After a brief period of breathing and relaxation patients will be given this directive: "Label one paper Pride, one Joy, and one Shame. Inside each circle, please represent achievements, personal characteristics, and experiences that you feel proud of, joyful about, or of which you feel ashamed. You may use paint, drawing media, or collage materials."

Expected themes

Patients should take some time to intentionally view the circles and then write a list of one-word associations about them. One theme that comes out of the *Pride/Shame/Joy circles* is that the amount of time spent with emotions influences mood. The more time spent feeling ashamed, and thinking about past shame, the more likely it is that patients will be depressed. The more time spent being proud and joyful, the more likely people will be content with life. Patients will benefit from learning how thoughts and emotions influence mood, and from receiving further education about how they can *change* their moods. Moods are influenced by emotions, but unlike emotions which are temporary, moods are longer lasting states. Patients need to understand that moods can be influenced by thoughts and behaviors. Conscious positive focus will more likely lead to a positive mood.

Patients should be taught about common cognitive distortions such as black and white thinking, magnification of the negative, and minimization of the positive. They can learn how changing these errors in thinking can result in fewer mood swings (see Burns 1999 for an excellent review). Also, therapists should discuss how the flow of self-talk influences mood and performance on any type of task (Burns 1999; Tamres, Janicki, and Helgeson 2002). Challenging negative self-talk can be introduced as a coping skill for dealing with eating disorder urges.

Response piece: Changing pride/shame/joy

Before the next session and art experience, therapists will instruct patients to make a conscious effort during the week to *increase* the amount of time that they spend each day feeling pride and joy and *decrease* the amount of time that they feel shame. Patients increase pride by focusing on their accomplishments, no matter how small. They increase pride and joy by celebrating positive steps in recovery. Joy also comes from noticing beauty and kindness in the world. Patients should be encouraged to illustrate and write in their creative journals *specific things that they did and thought* which increased the amount of pride and joy in their lives. In addition, patients are asked to make an effort to *decrease* the amount of time that they spend focusing on things that make them feel ashamed.

Media

Three sheets of 12 x 18 inch (A3) white paper, colored construction paper, collage images, drawing media, glue, and scissors.

Directive

Therapists prepare for the session by drawing or tracing a circle large enough to fill the center of each paper. After relaxation patients are given the directive: "Label one paper Pride, one Joy, and one Shame. Please refer to your experiences from the previous week about consciously increasing joy and pride and decreasing shame. Fill in the circles by painting, drawing, or gluing images of things that made you feel pride, joy, and shame."

Expected themes

When finished, patients can compare the images from the previous week with the current images to discover how the circles were transformed with conscious effort. They can write a series of one-word associations about the circles, the process of trying to change mood, or the comparison. Patients often are surprised that change involves such hard work. Because human beings are creatures of habit, it takes tremendous conscious effort to do things differently. Therefore, keeping track of and deliberately changing shame into pride and joy was probably effortful the first week. Patients will notice though that as increasing pride and joy becomes more habitual it also requires less effort.

When patients complain of the hard work of therapy I reply that they are familiar with hard work and therefore I am sure that they will succeed at recovery. I remind patients that the self-starvation that characterizes anorexia nervosa is excruciatingly difficult to maintain. Binge eating is uncomfortable and purging is painful. Dealing with societal pressure when one is obese takes great fortitude. Eating disorder patients are not strangers to hard work. With time they will recognize their tremendous efforts to maintain the disorders, and apply equal efforts to recovery.

Homework and healing dimensions

Now that they have had some of their first experiences influencing mood, patients can be introduced to the work of David Burns and other cognitive behavioral therapists. In his book, *Feeling Good: The New Mood Therapy* (1999), Dr. Burns explains how making a conscious effort to change thoughts changes mood. He gives specific examples of cognitive errors, called cognitive distortions, and how to combat them. Patients can be given parts of *Feeling Good* to read which include cognitive behavioral exercises for influencing mood. Patients can keep track of their success in altering their moods by drawing and writing about their experiences in their creative journals. A similar book containing valuable cognitive behavioral exercises for influencing mood is Greenberger and Padesky's *Mind Over Mood: Change How You Feel by Changing the Way You Think* (1995).

Collage of faces and feelings

Media

One or more sheets of 12 x 18 inch (A3) white drawing paper, assorted collage images of faces showing different moods, scissors, glue stick, and a black permanent marker.

Directive

After breathing and relaxation patients will be given the following directive: "Please select pictures of faces showing a wide range of emotions. These pictures will be glued on the white drawing paper with enough room around them to write labels and other comments. When you have one or two papers filled with various faces, please write underneath each face the emotion being expressed. You may also add comments about what the person pictured would say if she or he could talk."

Expected themes

Patients should take a few moments to reflect on the *process* of identifying emotions and the resulting collage. They may generate a list of one-word associations about the collage. A discussion of the various emotions depicted can follow. Patients sometimes report feeling that it was easier to distinguish the pictured emotions today than to figure out their own emotions in the *Mood states/Mind states* paintings. Conversely, some patients might experience frustration that they were not more aware of what emotions were being expressed. Of course, others report that it was much easier to differentiate emotions on paper than in real life. Nonetheless, all patients should be reminded that each experience represents progress in learning to discriminate among emotions as well as learning what different emotions signal.

Patients' written comments about what the person is thinking or about to say can be used to examine beliefs, cognitive distortions, and self-talk. Again, the importance of positive and realistic self-talk in coping with eating disorder urges can be reinforced. Cognitive distortions such as black and white thinking, magnification of the negative, and minimization of the positive (Burns 1999) can be challenged and more rational thought processes taught.

Response piece: Cause and effect collage

Media

One or more 12 x 18 inch (A3) sheets of white drawing paper, many collage images of faces showing different moods, scissors, glue stick, and a black marker.

Directive
After relaxation patients receive the following directive: "Select pictures of faces showing various emotions. The pictures will be glued on the white paper with enough room around them for writing. Please write underneath the picture which emotion is being expressed. Also, write on the *left side* of each face what event(s) have led up to the emotion pictured. On the *right side*, write what you predict will happen in the next few moments in response to the emotion depicted."

Expected themes
After intentional viewing and word association, patients can discuss the processes that they went through in deciding the causes and consequences of the emotions depicted. Each time patients think through emotions and their consequences they gain valuable practice in understanding cause and effect thinking. They reinforce for themselves through this process that emotions inform and guide human relationships and interactions. The ability to discriminate and act on the basis of emotional signals is a hallmark skill of adulthood. When patients are clear about what it is that they feel, they experience less confusion about how to act in response. Patients need to learn that being better able to distinguish emotions and act on the basis of them will improve relationships in their lives (Ekman 2003). In addition, patients will no longer feel that they have to turn to food because they feel conflicting or confusing emotions, or when they are unsure of how to respond to an emotion.

The *Cause and effect collage* also challenges cognitive distortions (Burns 1999). When patients demonstrate cognitive errors such as magnification of the negative, minimization of the positive or all-or-nothing thinking, therapists gently redirect thought processes in more rational directions. For example, patients could describe one of the faces as experiencing anger at himself or herself for not being perfect. A necessary discussion of the harmful effects of perfectionism, or all-or-none thinking, can ensue. Any number of cognitive errors can be addressed in a similar manner and patients helped to develop more rational and productive thought processes.

Homework and healing dimensions
Patients respond positively to homework that involves continuing the process of evaluating emotions from pictures of faces. They can be encouraged to cut out more faces from magazines and place them in their creative journals. These faces should be labeled with emotions along with cause and effect references. Patients who especially enjoy drawing can draw three-panel cartoons of the causes and consequences of various emotions. This type of practice will reinforce patients'

abilities to discriminate among, and appropriately respond to, emotional signals in their relationships.

Summary

Through the art experiences in this chapter, patients have learned to listen to the physical sensations that the body sends daily, and to discriminate among emotional signals. An important message of this chapter was that emotions are *signals* that help guide behavior. If patients learn what emotions they are experiencing, they will better predict how people might act and what behaviors will work best in response. Patients learned that although people cannot control their emotions, they can to some extent control and change their moods. By focusing on pride and joy patients experienced increased positive moods.

Through the art experiences in this chapter patients will have shared their emotions with therapists in ways they might not have before. With therapist support, patients can learn not to negatively judge the emotions they feel or to get caught up in them in an obsessive way, but merely to accept them as signals.

Addressing Body Image Issues

All great art is the work of the whole living creature, body and soul,
and chiefly of the soul.

John Ruskin (1819–1900)

Introduction

Body image concerns are characteristic of persons with eating disorders. In general, body dissatisfaction means that perceived body image is larger than ideal body image. Sometimes for boys and men, perceived body image is smaller or less muscular than ideal (Kashubeck-West and Saunders 2001). Body image dissatisfaction exists in a large number of children by the age of eleven years, and in adolescents it is related to the development of eating disorders (Presnell, Bearman, and Stice 2004; Smolak and Levine 2001). Body image drawings are a powerful way to assess and help patients begin to deal with body dissatisfaction (Gillespie 1996). From the obsessive fear of fat that characterizes anorexia nervosa to the disgust and self-hatred associated with obesity and binge eating disorder, body dissatisfaction must be addressed so that successful treatment of eating disorders can take place.

Many women with body image concerns report having heard their mothers talk about their own body dissatisfaction (Fisher and Birch 2001; MacBrayer *et al.* 2001). They remember watching as their mothers tried many different fad diets, performed punishing exercise routines, or underwent plastic surgery. The indirect effects of mothers modeling body image dissatisfaction, weight preoccupation, and dieting, as well as direct negative comments by mothers about children's weight, have a tremendous influence on the development of body dissatisfaction (Polivy and Herman 2002; Smolak and Levine 2001; Way 1993). Fathers and siblings influence body dissatisfaction as well, usually by emphasizing thinness or teasing (Davis *et al.* 2004; MacBrayer *et al.* 2001). By elementary school age boys and girls express body image concerns similar to those voiced by their parents such as fear of becoming fat and perceptions of ideal body image. Girls want to be thin; boys want to be thin but moderately muscular (Grogan 1999).

Much like eating disorders, body dissatisfaction develops not merely as a result of family influences, but in response to a multitude of factors (Presnell *et al.* 2004; Shisslak and Crago 2001; Smolak and Levine 2001). In addition, body image disturbance seems to be influenced by different sets of issues depending on ethnicity (White and Grilo 2005) and gender (Presnell *et al.* 2004). Overall, among the strongest factors impacting body image dissatisfaction are media influences and the internalization of a thin body ideal. By late elementary school girls ages eight to eleven years old compare themselves to media images and feel inferior (Smolak and Levine 2001). Exposure to thin models has a negative effect on adolescent boys and girls; they judge their own bodies more negatively after exposure (Grogan 1999; Wiseman *et al.* 2005). Teasing, which is sometimes a precursor to sexual harassment, has been related to body dissatisfaction in girls but not boys (MacBrayer *et al.* 2001; Smolak and Levine 2001). Child sexual abuse has been associated with significant body dissatisfaction in both males and females (Connors 2001).

Freedman (2002) has pointed out that body image is multifaceted: it is visual, because a picture of the body exists in the mind's eye. In addition, body image involves thoughts and feelings about the body. Body image is kinesthetic because it involves feedback about body movement. Finally, body image is historical; it develops over a lifetime. The art experiences in this chapter will use visual input to help patients explore the origins of their body dissatisfaction, challenge negative beliefs and feelings about the body, and help promote a more neutral stance toward the body. A neutral stance is emphasized because many patients initially are more agreeable to making body image neutral than they are to making it positive (Stewart 2004). According to Stewart successful body image treatment must continually emphasize that patients are not their bodies. The art experiences in this chapter will celebrate internal qualities as well as physical capabilities. They will help reinforce that patients are much more than the physical bodies they inhabit.

Bodies through the generations

Media
Three sheets of 12 x 18 inch (A3) white drawing paper and drawing media. Remember to use breathing and relaxation prior to beginning.

Directive
This experience will consist of three separate, but related images. On the first piece of paper, patients are instructed to draw a picture of their *parents' and grandparents' bodies*. Each person should be labeled with his or her name and relation-

ship to the patient. Around the six figures, patients will add words and phrases they have heard their parents and grandparents say about their bodies. On the second sheet of paper, patients draw *their body as it is currently experienced*. Patients add words and phrases they say about their own bodies and, with a different colored marker, things patients have heard parents or grandparents say about patients' bodies. Finally, patients are asked to make a drawing of the body that they would like to have: *their ideal body image*. They will complete this ideal body drawing with positive written affirmations about their body parts, physical capabilities, and physical strength.

Expected themes

Patients are asked to consider the first two images. After drawing bodies from three generations and writing frequently heard remarks, they often wonder whose body they inhabit. Patients can be encouraged to talk about inherited body parts (e.g., grandmother's thighs; father's height) or learned attitudes about their bodies (e.g., my mother always talked about wanting to lose ten pounds [4.5kg], now I always talk about wanting to lose ten pounds). Patients are often unaware of genetic and family influences on body image until they are depicted in drawings such as these. After family influences are named they can be evaluated for their truth and usefulness

Therapists should educate patients about genetic influences on height and weight, set point theory, and energy balance (Allison and Weber 2003). Because of hereditary and biological factors, the body may not be as changeable as they previously believed. Over the course of treatment this information will be repeated many times by many different practitioners: therapist, nutritionist, physician, and it will form the basis for *body acceptance*. Patients will be guided to accept the bodies that they were born with rather than fighting to alter what is not so easily modified (Stewart 2004). Patients will be encouraged to confront behavioral and cognitive features of body dissatisfaction that they can change such as: body checking, mirror gazing, social comparison, and reassurance seeking (Reas and Grilo 2004). These behaviors will be fully addressed later in this chapter.

Generational drawings increase awareness of negative body evaluations and self-talk that originated in families. Patients report that when they see comments made by their parents and grandparents in this dramatic way it begins to reduce their impact. Patients might tell themselves that the words belong to other people from other generations; the words are not useful to them in the present time. Patients' learned self-talk should be evaluated for evidence of cognitive distortions (Burns 1999). For example, there could be evidence of magnifica-tion of the negative with such self-statements as, "being five pounds [3 kg] over-

weight means I am an unforgivable slob." Overgeneralization is frequently seen in body dissatisfaction with statements such as, "I am fat, I will always be fat, and I will never be happy." Another cognitive distortion, all-or-nothing thinking, is seen in a statement like, "if I am not at my perfect weight I am a failure." Body image drawings help patients identify cognitive distortions that influence body dissatisfaction. Once the distortions are identified they can be refuted with objective evidence and replaced with more rational and realistic ways of thinking.

Related to cognitive distortions are maladaptive behaviors that subtly maintain eating disorders. Patients with bulimia nervosa and anorexia nervosa frequently engage in *body checking* in which they pinch a portion of their body and decide that it is fat. They seek out mirrors and judge themselves as overweight (*mirror gazing*). Patients with binge eating disorder usually avoid mirrors (*mirror avoidance*). Patients of all types compare their body size with same gender persons and feel good or bad depending on how they judge themselves in relation to the other (*social comparison*). Finally, many patients also repeatedly *seek reassurance* about their appearance from friends and family although they often discount the veracity of the reassurance obtained. These behaviors: body checking, mirror gazing and avoidance, social comparison, and reassurance seeking, are related to patients' learned attitudes about their bodies and serve to maintain body dissatisfaction and eating disorders (Reas and Grilo 2004).

Ask patients to be aware of these behaviors and establish baselines for their prevalence by counting the number of occurrences in a given time period. After baselines are determined, patients begin to reduce their frequency and intensity. Changing problematic behaviors and thoughts such as these is ongoing work throughout treatment.

As the last component of this art experience, patients should consider the drawing of their ideal body. Without judging the image, they can intentionally view it. The image will tell patients how they would like to feel in their bodies and what they would like their bodies to be able to do. Patients have made an image of their ideal body which will give them a concrete, visual goal to work toward. In addition, they have included neutral or positive comments that they can use for self-affirmation.

Response piece: Talk back to the mirror

Media
Sturdy cardboard, aluminum foil, collage images, scissors, and a glue stick.

Directive

Patients are asked to imagine the sorts of things that they say to themselves when they look in the mirror. As was explored in the previous experience, they have probably adopted many negative comments heard from previous generations. These types of negative comments will be changed to neutral and positive ones in the present art experience. Patients will be encouraged to talk back to the mirror in the most affirming way possible. They will frame a mirror in positive statements about what their bodies do, how they would like to feel, and the body parts that they accept and admire for their positive functions, not their appearance.

Patients first make a large mirror by cutting cardboard into any shape that they wish and covering it with aluminum foil. They will choose collage words and images representing positive comments and body affirmations as a frame. Patients are reminded to talk back in a positive way to the mirror that has repeatedly generated negative internal commentary.

Expected themes

Patients can generate a list of one-word associations about the mirror. When patients focus on what their bodies *do* rather than on how they *look*, they immediately have a more neutral or positive body image. Just as patients separated themselves from the eating disorder in the initial art experience, they must separate themselves from their physical appearance. Feelings of self-worth are rightly based on assessments of deeds, and wrongly based on appearances. Patients can be asked to imagine a person disfigured in an accident. Physical disfigurement does not change the worth of the person, merely the external appearance. The same applies to persons with eating disorders. Patients need to accept themselves on the basis of their actions and internal qualities, not on the basis of their outward appearance.

The following poem was written in response to the *Talk back to the mirror* art experience by a young woman who was suffering from bulimia nervosa. This verse was the beginning of body image change.

> I want the mirror to be my friend
> I want the insults to come to an end
> I will see what others see
> A friendly girl, that girl is me
> I won't see fat I won't criticize
> I will see myself through other's eyes
> I will accept that I am me
> I will accept
> I will be free.

Homework and healing dimensions

Patients should use their creative journals to write their own poem or paragraph about body image. They should challenge themselves in writing or drawing about how they believe behaviors such as body checking, social comparison, and reassurance seeking help them. They may write or draw about what they *want* the behaviors to do – reassure them – and about whether or not the behaviors actually function in that way. Chances are patients will realize that behaviors like body checking and social comparison do *not* reassure them, but actually *increase* anxiety and obsessive thoughts about their bodies. Patients can be counseled to consciously think about what they are doing rather than behave mindlessly. With mindful effort patients can reduce the frequency of behaviors that previously maintained body dissatisfaction. Patients can provide themselves with accurate reassurance that they are addressing their body image and getting appropriate treatment with statements such as, "Eating well and exercising moderately will help me maintain a healthy weight for my height." Patients may use their creative journals to record their intentions, track changes in behaviors, and reinforce healthier outcomes.

Societal messages: Fat is … Thin is … drawings

Media

Two sheets of 12 x 18 inch (A3) white drawing paper, any drawing or painting media.

Directive

Patients are asked to make two separate drawings, one which details thoughts and feelings about "fat is," and one that demonstrates feelings and thoughts about "thin is." They may make representational or abstract drawings, adding titles or other words of explanation (Bilich 1983).

Expected themes

These drawings will bring up familial, societal, and personal definitions of body type and size. Usually fat is associated with negative connotations such as lazy, out of control, and ugly. Thin is viewed as the opposite: attractive, effective, and in control. This experience can reveal to patients how they have blindly accepted other people's standards for beauty. Patients can be shown how standards of beauty have changed over time by viewing an art history book. It was not until the flappers of the 1920s that thinness became idealized as the preferred body type for women. It is probably not a coincidence that the first

mass-produced fashion magazine became available at the same time (Grogan 1999). Many women have been dissatisfied with their bodies ever since.

Rather than view women as helpless victims of internalized societal beauty norms, therapists should help patients remember times when they have rebelled against cultural beauty ideals. Patients can be empowered to repeat those experiences in broader contexts. For example, Gimlin (2002) points out that many women do not blindly accept hair stylists' suggestions about appropriate haircuts or colors. Just as they decide for themselves the best hairstyle, they can decide what would be a better body type. Reducing body image dissatisfaction means first becoming aware of, and then reducing, blind acceptance of current beauty standards. As patients practice assertively stating their feelings and needs, they become less dependent on having their bodies talk for them.

Patients often realize in therapy that they have used their bodies to set boundaries that they did not feel comfortable asserting verbally. *Fat is . . . Thin is . . . drawings* will touch upon patients' feelings about personal boundaries and sexuality. For example, a woman I worked with who was suffering from binge eating disorder drew charming cartoons of a party in response to the *Fat is . . . Thin is . . .* directive. In the *Fat is . . .* picture she drew herself in the kitchen away from the party. She wrote on the drawing "Fat me in the kitchen with the cat. So where do they keep the cat treats Kitty?" The *Thin is . . .* cartoon showed an alluring woman in the midst of the party. She wrote, "Thin me . . . I'm looking good, but I'd rather be in the kitchen with the cat." In discussing her images the young woman said that she did not trust how other people would treat her if she was thin. Upon reflection, she stated that she did not know if she could trust *herself* if she was thin.

The young woman had been sexually abused as a child and began binge eating as a way to cope with her emotions. Slowly she gained weight and either by design or by coincidence the abuse stopped when she became overweight. The woman was afraid that if she lost weight she would somehow *cause* sexual abuse to happen again. Many women report believing that when they made themselves less attractive, either by losing or gaining weight, the abuse that they were suffering stopped (Reindl 2001; Rust 1995; Thompson 1994). Whether actual or coincidental, the end of the abuse provides a foundation for the belief that controlling body image controls other factors in life. The successful treatment of eating disorders must address the facts that

1. Children are not responsible for sexual abuse.

2. Obesity and/or weight loss may have been used as physical barriers against unwanted sexual advances.

3. Assertive behavior is a healthier way of setting boundaries and expressing other needs.

Fat is ... Thin is ... drawings often illustrate attention bias and selective interpretation bias which are two information processing errors that maintain body dissatisfaction. Persons with eating disorders overvalue physical attractiveness and thinness as central features in determining self-worth (Williamson *et al.* 2004). Eating disorder patients attend to and selectively interpret information about the physical body. They pay more attention to body-related information that *supports* their distorted body image than to information that contradicts it (Williamson *et al.* 2004). When a person with an eating disorder hears "you look healthy," the information is selectively interpreted to mean "you look fat" (Stewart 2004). These sorts of selective interpretations and attentional biases must be identified and changed in order for meaningful body image transformation to take place.

Response piece: Mirror self-portrait

Media
One sheet of 12 x 18 inch (A3) white drawing paper and drawing or painting media. In addition, a full-length mirror will be needed to facilitate mirror viewing.

Directive
Patients are asked to view themselves in a full-length mirror and then create a self-portrait. On the picture they are asked to write a list in one corner of disliked body parts, and in another corner to write a list of body parts that they like or tolerate (Matto 1997).

Expected themes
Patients' first attempts at drawing their own bodies may be distorted, poorly detailed, or regressed (Gillespie 1996; Pipher 1995). These drawing styles indicate the body distortions that patients feel. As treatment progresses, self-drawings change to reflect greater self-awareness and body acceptance. However, the first crude drawings can make body image distortion visible to patients and provide a starting point for treatment. As was mentioned earlier, control over the body often assumed importance for setting boundaries. Bodies spoke for patients who did not feel they had adequate words. Successful treatment must challenge this illusion of control. Patients initially believed that the eating disorder provided control over their lives, but upon closer examination realize that they do *not* control the negative thoughts and behaviors that drive body dissatisfaction.

When patients look in a mirror, they are confronted with negative thoughts and overwhelming emotions about their bodies. Therapists can use this emotional energy to bring to light cognitive distortions affecting the way that the body is viewed and valued (Matto 1997). Repetition of information about cognitive distortions is necessary because body image dissatisfaction is maintained by distorted views and it is a difficult area to change. Body image seems to be one of the last areas of change in eating disorder treatment, and lack of change in body image predicts relapse (Rosen 1990).

Patients typically focus on one or two areas perceived as fat. They often *generalize* from those disliked areas that they are overweight and therefore awful people (Krueger 1989). This type of reductive reasoning must be challenged and a more holistic view developed. Often the mirror self-portrait will bring about a long list of disliked body parts and a very short list of body parts that patients like. This large discrepancy can be used to illustrate the cognitive distortions of *magnification* of the negative and *minimization* of the positive. Views must shift toward a more balanced view of the body. Many patients will be unable to list body parts that they like. They can begin by listing body parts that they can *tolerate*. Tolerance leads to a neutral and nonjudgmental stance about the body.

Homework and healing dimensions
The work of changing body image feelings and beliefs must be supported through homework exercises. Patients should use their journals to track negative beliefs, refute them, and replace them with more rational beliefs about their bodies. They may use their creative journals to draw or write about occasions when they rebelled against established beauty norms or experts. They can celebrate their independence from arbitrary and one-size-fits-all definitions of beauty. Patients can be asked to draw one self-portrait per day for the week and compare and contrast the resulting images. It has been my experience that the images become more positive in just one week.

In addition, patients should be asked to practice looking at themselves in the mirror in a new way. Rather than using mirror gazing to check and affirm negative body image, patients can be asked look at themselves in the mirror while relaxed and accepting. The mirror can be used to increase self-acceptance. Rita Freedman's book *Bodylove* (2002) contains specific and useful instructions for both using the mirror in affirming ways, and for challenging cognitive distortions. Patients can be given passages to read and exercises to perform as homework. Mirror work has been identified as an integral part of successful body image treatment and it must continue for some time before a more neutral body image emerges (Key, George, and Beattie 2002).

Animal self

Media
Some type of modeling clay: plasticine, Model Magic™, or Sculpy™.

Directive
Patients should be directed to take a piece of clay in their hands. They will probably find it cool and perhaps a bit hard because it has not been used. Patients will hold the clay, press it, roll it, and work it until it feels warmer and more pliable. Patients should be directed to close their eyes and imagine themselves as an animal. While rolling the clay in their hands, they allow the mental image of the animal to become clearer and begin to sculpt it in clay.

Expected themes
Patients should intentionally view their small sculpture. They can write down a list of one-word associations about the animal's characteristics. Patients can then discuss these characteristics and how they share characteristics with the animal they created. When they imagine themselves as animals, patients imbue themselves with physical strength or other abilities that they perhaps do not consciously know they possess. Patients might discuss how the animal is already a part of who they are. For example, do they identify with the loyalty and love demonstrated by a favorite family dog? Can patients claim for themselves the intelligence and freedom of a dolphin? Patients need to embrace rather than fear the parts of themselves that seem wild and instinctual. Recovering a pleasurable relationship with one's adult body requires reminding patients of their animal selves, of their instinctual responsiveness to both pleasure and pain, and of their wildness (Farrelly-Hansen 2001).

Patients sometimes first discuss a negative characteristic of the animal they have made, but with encouragement will recognize positive qualities as well. For example, an adolescent girl I worked with fashioned herself as a mouse. She explained that she was as nervous as a mouse, always running here and there. Upon reflection she remembered that she had had a mouse as a childhood pet and it was curious and industrious. The patient realized that she had characterized herself as nervous without giving herself credit for being curious and industrious.

Patients can be encouraged to think about the relationship between the animal that they have chosen and its environment. A field mouse may be overwhelmed in a barren environment or nurtured in an abundant one. Patients may reflect on how their own environment is either hostile or nurturing for them. They might decide to make some changes in their environment to better support themselves.

Response piece: Baby animal self

Media
One piece of 12 x 18 inch (A3) white drawing paper, drawing media or paint, and modeling clay.

Directive
After a period of breathing and relaxation, patients are asked to draw, paint, or sculpt themselves as a baby animal. This baby animal should be different than the animal in the previous art experience.

Expected themes
Patients can spend time intentionally viewing the image and write a series of one-word associations about it. They then describe their attraction to the partic-ular baby animal that they have chosen. Patients can be guided to talk about how the animal is nurtured by its parents and later encouraged to become inde-pendent. In previous art experiences patients have confronted the fact that they used food to nurture themselves emotionally. In this discussion they will talk about how they would prefer to be nurtured. The topic can be expanded to include a discussion of how patients will provide physical and emotional nur-turing for their own children and how they will support their children's independence.

Dependence verses autonomy is a central conflict for patients with eating disorders (Rehavia-Hanauer 2003). Examining the push toward independence evident in most mammals can help patients understand that separation and indi-viduation are natural processes that all species undergo. Patients can be taught that individuation involves the excitement of finding out their own unique pref-erences and values. Rather than acting to please others, patients can be guided to please themselves in ways that do not involve food. In addition, patients can be instructed that art can be used as a way to remain connected as they develop independence and healthy interdependence on others (Levens 1990). Images can remind patients that they are not alone as they become more able and willing to experience the world on their own and through healthy relationships.

Patients from diverse cultures may experience and express issues of separa-tion and autonomy differently than the majority culture. They should not be forced into a definition of independence that does not fit. It is the therapist's responsibility to help patients define separation and independence within the context of their culture and discover ways to express these ideas that do not increase cultural conflict within patients' families and within patients themselves.

Homework and healing dimensions

Have patients use the list of one-word responses generated by the animal sculpture and/or drawing to form a paragraph or poem about their animal selves. Writing will help reinforce qualities of their animal selves. In addition, patients can be encouraged to use their creative journals to draw and write about discovering their preferences in many areas of their lives. As a way of structuring the experience, patients can draw in relation to the five senses. For example, they may draw things that are pleasing to look at and the sorts of sounds that are pleasing to their ears. They may draw about pleasant aromas and favorite foods. Lastly, they can draw objects that are pleasing to touch. Focusing on sensory preferences provides patients with a foundation to develop a view of themselves that is separate from past influences. Patients later can build upon sensory preferences to include activities, beliefs, and values. With time patients will develop a view of themselves that is separate, whole, and free.

Body tracing

Media

Butcher paper, tape, markers, collage materials.

Directive

A piece of butcher paper large enough to accommodate the patient is cut and taped to the wall. After a brief period of relaxation, patients are asked to draw an outline of their body. They are asked to be as realistic as possible when estimating their size. After they are finished, the therapist traces patients' *actual* outlines with a different colored marker. Therapists should be sure to trace as accurately as possible especially if loose clothing interferes with tracing.

Expected themes

Generally patients grossly overestimate their size. The outline of their actual body almost always fits well inside their perceived body outline. Thus, body tracings are a powerful way to confront perceptual distortions. Perceptual distortions often originate from media images. The media portrays both men and women in ways that cause discomforting comparisons (Gimlin 2002; Wiseman *et al.* 2005). Women perceive themselves to be fatter than they are partly through comparing themselves with ultra-thin female models. Men become dissatisfied with their physiques after viewing thin but muscular male models (Wiseman *et al.* 2005).

As stated in Chapter 5, patients must become discriminating consumers of the media. They must be taught that often what they see in the media is illusion

created with sophisticated airbrushing techniques and digitally enhanced images. Patients must accept that aspiring to media illusion will always lead to frustration. It can be reiterated that bodies are not as changeable or malleable as they once thought. And given the perceptual distortion evident in the body tracings, most patients can begin to accept the body they have when they see concrete evidence that it is not as large as they previously had thought.

Response piece: Ideal self

Media
Long butcher paper, markers, paints, collage images.

Directive
Patients are instructed to draw a life-sized body outline and to decorate it. They may pose against the paper taped to a wall and have therapists trace around them, or they may draw a body outline freehand. Patients will decorate their life-sized figure with markers, paint, and collage images in a way that celebrates their ideal self. The colors, lines, and collage pictures will celebrate internal qualities that are made visible through words and actions. The *Ideal self* can be explained as everything that patients have learned about themselves that is not related to their physical bodies. They might include animal traits and newly found likes and dislikes.

Expected themes
As patients decorate this life-sized ideal self they truly begin to see themselves as separate from their physical bodies. This focus on personal qualities will set the stage for self-acceptance, which will be discussed in the next chapter. In addition, the *Ideal self* collage often brings up spiritual themes that will be explored more fully in Chapter 10.

Homework and healing dimensions
Patients should use their creative journals to draw and write about media influences on body image. They can use drawing and collage to dispute the accuracy and truth of media images and to create healthy alternative messages. Print advertisements and television commercials can be subjected to detailed examinations of truth or illusion. Continued practice with "media literacy" that analyzes media content and encourages activism and advocacy will increase awareness and knowledge of media manipulation in the future (Levine and Smolak 2001; Wiseman *et al.* 2005).

Summary

Art experiences in this chapter were designed to confront perceptions, attitudes, and behaviors that maintain body dissatisfaction. Disturbances in perception were addressed through body tracings. Problematic behaviors and cognitive distortions were confronted in processing all of the art experiences. Patients often have valued their physical appearance as their most important feature. The art experiences emphasized that patients are *more* than the physical bodies they inhabit. In order to reinforce this view patients were asked to focus on internal characteristics and personal values. Therapists must caution patients that if perceptions and attitudes that maintain body dissatisfaction do not change, it is unlikely that lasting change in eating disorder symptoms will occur. Patients can be guided to use their creative journals more frequently to work on changing the behaviors and cognitive distortions that in the past maintained body dissatisfaction and eating disorder symptoms. Patients should become informed consumers of the media so that illusory images no longer rule body image perceptions and feelings.

Enhancing Self-acceptance

Art is man's nature; nature is God's art.

Philip James Bailey (1816–1902)

Introduction

This chapter is deliberately called enhancing self-acceptance, not raising "self-esteem" or increasing "self-worth." The focus is on self-*acceptance* because acceptance is an essential first step toward gaining self-confidence and self-esteem. If patients do not first accept themselves there can be no esteem. Self-acceptance has been identified as a protective factor against the development of eating disorders (Shisslak and Crago 2001). The focus is on self-acceptance because a sense of *self-rejection* characterizes many men and women with eating disorders (Reindl 2001; Thompson 1994; Way 1993).

Self-rejection might come from patients having struggled as children with adult burdens and inappropriately labeled themselves as failures. It could stem from critical body image comments made by relatives throughout a lifetime, from childhood teasing (Smolak and Levine 2001), or unrealized perfectionistic strivings. Self-rejection might originate in patients closing themselves off to emotions and needs, and relying solely on eating disorder behaviors to meet needs and solve problems.

Recovery from an eating disorder must involve examination, acceptance, and affirmation of personal qualities. One young man whom I worked with was described by those who knew him as concerned about people and the environment, intelligent, and hardworking. He was unaware of these positive qualities that were so obvious to everyone else. When this young man, who was described in Chapter 3, thought about himself the negative voice of the eating disorder took over and everything was dark, dirty "mud." Mud was his word for the tangled mess of negativity provoked by the eating disorder. Mud was a fitting name because, under the influence of the eating disorder, thoughts and feelings were so muddled and muddied it was impossible for him to think clearly or positively.

As was mentioned in Chapter 3, one of the first things that this young man did in treatment was to make "mud" separate from himself in art and writing. This separation provided initial clarity that *he was not the eating disorder.* Following this separation, his positive personal qualities slowly began to emerge. With continued therapy and support, this young man was finally able to accept himself and to see himself in a positive light. Eventually he was able to see himself *as a positive light* in the recovery of others. He shone so brightly that others could not help but follow his well-lighted path to their own recovery.

Before there can be such shining self-esteem, there must be self-acceptance. Self-acceptance comes from honestly knowing oneself and understanding that all personal characteristics add depth and interesting dimensions to one's persona, including having recovered from or being in recovery from an eating disorder. The art experiences in this chapter are designed to help patients know themselves in ways that they have not before. Through previous art experiences, patients have realized that they have great depth of emotion and remarkable resources for problem solving. In addition, they have separated themselves from the eating disorder and they have started to realize that they have some unique positive qualities. Using scribble, collage, mandala painting, and miniature sculpture patients will demonstrate to themselves that *they are acceptable just as they are.* Patients will use art to express all parts of their personality. When using art, verbal defenses do not immediately censor previously unexpressed material.

Scribble drawing

Media

One sheet of 12 x 18 inch (A3) white drawing paper and whatever drawing media are comfortable.

Directive

1. Patients use a marker or pastel to make several large, random "scribbling" marks on the paper. Make sure that some lines cross each other, but do not allow patients to plan a picture. The idea is to have a moderate amount of intersecting lines on the paper when the scribble is finished.

2. Patients look at the scribble from all directions. They may turn the paper around to see it from different angles. They continue looking at the scribble until they perceive an image formed by its lines.

3. After patients have found an image, they use drawing media to complete the picture. They may add or ignore lines, fill with color, or emphasize outlines.

4. When the image is complete patients write a title for it.

Expected themes

Allow patients some time to intentionally view the image that emerged from the scribble. After silent reflection, patients can be encouraged to think about the title and meaning. Created ambiguous forms take on characteristics of the maker and allow the expression of those traits (Kramer 1971; Naumberg 1987). The scribble drawing invariably evokes ideas and issues that are unique to and meaningful for the artist. Many times what emerges is a healing message that tells the artist about a quality that must be acknowledged or integrated in order to recover from the eating disorder.

Figure 9.1 shows a chalk pastel scribble drawing done by a young woman recovering from anorexia nervosa. The message of the dove depicted was "And peace shall come in the form of a dove. PEACE. Be still and know that I am God." The young woman realized through the scribble drawing that she was reassuring herself that she would always be loved by God. This reminder of God's love was a first step toward self-acceptance. After all, she explained, why would she be harder on herself than God? If God could love her she could at least accept herself. In addition, the scribble drawing informed her that she would find the peace that she wanted. The second part of the message was that she had to *be still* to know God and find peace. The young woman interpreted "be still" to mean that she just had to *be*, to exist. She did not have to fill her life with activities, accomplishments, and perfection to find acceptance.

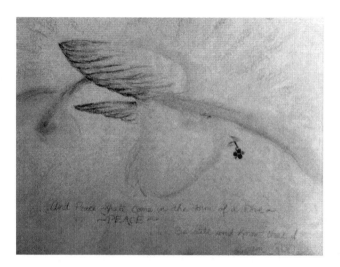

Figure 9.1: Scribble drawing – Important thoughts and feelings come to the surface in a simple set of lines

The subject of perfectionism must often be addressed to ensure successful treatment of eating disorders, especially the treatment of anorexia nervosa. Individual perfectionism, or obsessive-compulsive personality traits, when combined with other factors may increase risk for the development of eating disorders (Polivy and Herman 2002; Stice 2001). Perfection sometimes develops in response to the modeling of high standards and expectations of perfectionism in families. A perfectionistic façade may develop in response to family pressure and become reinforced through achievement and success (Way 1993). It is possible to help patients understand that they do not have to forgo high expectation in order to recover from eating disorders. Striving for perfection is not necessarily a risk factor as long as *acceptance of imperfection* is part of the equation (Lundh 2004). The use of the scribble drawing technique provides opportunities to discuss the acceptance of imperfection. Chances are that the lines of the scribble were not exactly right, but patients made the image fit as best they could. They accepted imperfection and gained meaningful information.

The message of the scribble drawing may not be one of achievement and perfection. But whatever it is, patients will decide what significance the image holds. The image brought forth a quality or conflict that needed attention in order for recovery to proceed. The scribble drawing demonstrates that true concerns come to the surface, even in a simple set of lines. We enhance our patients' sense of self-acceptance when we respect, value, and learn from what is included in that simple set of lines.

Response piece: Blot paintings

Media

One or more sheets of 12 x 18 inch (A3) white drawing paper, watercolor paints, sponge/rag, water, brushes, and drawing media.

Directive:

1. Patients should *lightly* wet their paper by painting a thin layer of water over it with a damp sponge, large paint brush, or wet rag.

2. When the paper is wet, they will use a paintbrush to randomly drop paint on the paper. Usually it is best to limit the number of paint colors to two or three.

3. Next they will fold the paper in half, rub it gently, and open it back up.

4. Finally, patients will look at the painting from all directions, turning the paper to see it from different angles, until they see an image formed by the paint.

5. When an image is found, and the paint is dry, patients may use drawing media to complete the picture. If it feels necessary they may add or ignore lines, fill in color, or emphasize outlines. Sometimes no additions seem necessary.

Expected themes

Patients should spend some time looking at the image that emerged from the paint blots. They can be encouraged to think about how the colors arranged themselves and what significance is contained within the picture. This is what the unconscious mind brought to awareness. Many times the blots present themselves as "monsters." The patient who made the blot painting in Figure 9.2 described it as an "Anger Monster." She went on to explain that when she became angry it felt as though a monster overcame her and she was not herself. She said that she often did not remember what she said or did "when the anger monster was in charge." The therapeutic work in this case involved helping the patient understand that anger was a part of her and that she did not have to dissociate her feelings and actions from the experience of the emotion. Anger had previously been too frightening to acknowledge or to accept. Patients will be taught that self-acceptance involves allowing all emotions to be acknowledged and appropriately expressed.

Figure 9.2: "Anger Monster" – The ambiguous forms of blot paintings show important thoughts and feelings

It is expected that the unconscious will perceive images whose acceptance is necessary for recovery. Therapists should be prepared to help patients process and accept negative or threatening images as well as positive ones. Both negative and positive must be integrated in order for healing to occur. Patients need to recognize that when they honestly know themselves, admitting both strengths and weaknesses, they have greater potential for healing than if they deny traits perceived as negative. Further, most characteristics have a dual nature: there are situations in which almost any particular characteristic has the potential to be either helpful or harmful. During therapy patients will understand that previously held beliefs will be re-evaluated and might change, like the belief that anger is frightening and must be avoided in the previous example.

Homework and healing dimensions
Patients can use time between sessions to write in their creative journals about the traits or issues evoked by the scribble drawings and blot paintings. The task must be explained as pure exploration without judgment attached. Small-scale scribble or blot paintings may be added to creative journals. Examination of traits and conflicts with additional scribble drawings or blot paintings continues the advancement toward honest self-exploration and self-acceptance.

Masculinity/Femininity collage

Media
One 12 x 18 inch (A3) sheet of white paper or colored construction paper, collage images, scissors, and glue stick.

Directive
Patients are instructed to look through collage materials to find images that express their views of the masculine and feminine parts of themselves. They should be instructed to choose some pictures that appeal to them even if they are not sure why; and also to choose some that they are certain describe them. Patients should try to convey as many masculine and feminine abilities as possible, including traits that are not well developed. Traits are considered not well developed when patients are attracted to them but unsure if they are fully expressed in themselves. Patients might want to put all of the masculine traits on one side of the paper and all of the feminine traits on the other side. Or they might find some other configuration that works well.

Expected themes

Patients should spend some time silently viewing the completed image. They might not have thought before that opposite gender traits exist within them. Before they reject the idea outright, it should be explained that all of us possess traits traditionally ascribed to the opposite gender. Research by psychologists, sociologists, and anthropologists has shown that opposite gender traits may not be as well developed within us as same gender traits, but they exist (Jung 1964). The most well-rounded and successful people are those that acknowledge and express traits of both genders. Androgyny has been negatively correlated with eating disorder symptoms (Hepp, Spindler, and Milos 2005). Extreme femininity has been shown to be a risk factor for the development of eating disorders (Smolak and Murnen 2001).

Female participation in the types of sports typically engaged in by males such as soccer and basketball has been identified as a protective factor against the development of eating disorders (Crago, Shisslak, and Ruble 2001). Participation in sports where a lean body or attractiveness is emphasized such as gymnastics or dance can be a risk factor (Shisslak and Crago 2001). Successful therapy for eating disorders will include an evaluation of stereotypical gender role behaviors and education about embracing and expressing both masculine and feminine traits.

Response piece: Harmony drawing

Media

One sheet of 12 x 18 inch (A3) white drawing paper, pastels, or watercolor paints.

Directive

This art experience may be done in a circle as a mandala, or it may be done on a rectangular sheet of paper. The goal of the harmony drawing is to emphasize unity of masculine and feminine traits. Patients may choose to incorporate some of the symbols from the previous collage, or they may choose to create something entirely new. Patients should be encouraged to take some time to think about what successful integration of masculine and feminine traits would mean to them.

Expected themes

Patients should be instructed to reflect on their harmony image and write a series of one-word associations to it. Figure 9.3 is an oil pastel picture created by an adolescent girl recovering from anorexia nervosa. This picture was completed near

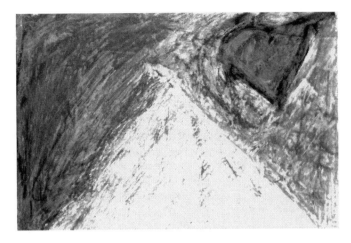

Figure 9.3: Harmony drawing – Art can help patients embrace masculine and feminine traits

the end of the teen's intensive outpatient therapy program in which she worked hard to integrate many opposing forces in her personality. The mountain represents masculine traits and the heart symbolizes feminine traits. The young woman integrated both traits beautifully into the image without prior thought as to meaning. Upon reflection she thought that the mountain was tough, resolute, and capable. These were the qualities she liked most about herself.

The young woman viewed the heart as a sun that warmed the mountain. She said that the heart was warmth, sensitivity, and caring. These were qualities that the teen did not demonstrate when she was consumed by anorexia nervosa. Talking about her *Harmony drawing*, she explained that without a heart, the masculine qualities would be too hard and uninviting. Without a mountain, the feminine qualities would be too soft and not hold up in difficult times. This 16-year-old girl realized that she needed to accept both feminine and masculine qualities in order to be successful in life. She recovered from anorexia nervosa and graduated at the top of her high school class – a capable student body leader and caring friend.

Patients can be taught that one goal for recovery is that the masculine and feminine traits they possess will be equally developed and exist within them in harmony. Patients will not fight what they believe is too feminine or too masculine. They will accept the traits they possess and grow, just as the girl who made the mountain-heart drawing flourished when she accepted both her masculine and feminine traits. Patients will become whole and well-rounded when all traits are accepted and developed.

Homework and healing dimensions

Between therapy sessions patients should be encouraged to draw or write in their creative journals about their responses to the *Masculinity/Femininity collage* and *Harmony drawings*. They may use the list of words generated by each image in order to organize their thoughts into a paragraph or a poem that emphasizes the goals of integration and acceptance. Patients will benefit from further image making to enhance traits that feel less well developed. Those who especially like to draw could make cartoons of the development over time of nascent personality traits. Patients might choose traits that they wish were more firmly developed in themselves and paint what their strong expression would feel like.

Self symbol in clay

Media

Some type of modeling clay: plasticine, Model Magic™, or Sculpy™.

Directive

Patients will take the clay in their hands and press it, roll it, and work it until it feels warm and pliable. Patients should be directed to close their eyes and imagine creating a self symbol. This small sculpture will represent something important about them. Patients may make something representational, a real object, or they may make something abstract. As patients work the clay, the symbol will take shape in their hands.

Expected themes

When patients are finished with the symbol, they should be encouraged to spend some time intentionally looking at it. In addition, they can take a digital photo of it or make a quick sketch of the sculpture in their creative journals and include a name for it. Without overanalyzing the symbol, patients can make a list of one-word associations to it. Therapists should inquire about the *process* of working with the clay.

Chances are patients have not worked with clay since elementary school. During the process of creating the self symbol in clay, patients sometimes make disparaging remarks about themselves and their abilities to work with this medium. Feelings of ineffectiveness are often brought to the surface as patients handled the unfamiliar substance. Therapists should take the opportunity to challenge thoughts and feelings of ineffectiveness and demonstrate how patients persisted, despite discomfort, to complete the task.

Ineffectiveness is a central theme for men and women with eating disorders. They often describe themselves as not being able to do anything well. In honest

moments patients with anorexia nervosa and bulimia nervosa will admit that the eating disorder was perhaps the first task at which they ever felt completely competent (Way 1993). Thus, the concrete experience of working with the unfamiliar clay and creating a meaningful self symbol will reinforce that, in a similar way, other skills can be learned and mastered that will reduce feelings of ineffectiveness. In addition, patients often are surprised by the richness of what emerges even at a beginning level of "competence."

Therapists should have a basic understanding of a number of common universal symbols to ensure that the experience of creating the self symbol is meaningful. If patients are at a loss for words about their symbol or its meaning, therapists use their knowledge of universal symbols to broaden or deepen the discussion of patients' self symbol sculptures. Sharing knowledge of universal meanings decreases patients' feelings of isolation and increases feelings of personal acceptance and power. Many symbols can be interpreted with positive or negative associations (Jung 1964). Either in this or the next experience, patients will explore both the positive and negative associations of their symbols. Exploring and accepting both will facilitate the quest for integration and self-acceptance.

Response piece: Self symbol companion

Media
Modeling clay: plasticine, Model Magic™, or Sculpy™.

Directive
Patients will take a piece of clay and warm it in their hands by kneading it and working it until it becomes pliable. As they are warming the clay in their hands, patients should be directed to close their eyes and imagine a companion symbol for the first self symbol they made. They can be encouraged to think about what would make the first symbol feel more complete. What would make a good companion for it? Patients will work the clay and fashion the companion piece as it comes to mind.

Expected themes
Patients should silently reflect on the self symbol companion. They can make a quick sketch of the companion or take a digital picture of it to include in their creative journals. The expected theme will be one of balance. Patients can be encouraged to think of themselves as having many complementary characteristics which, when developed, work together with one another to produce a well-functioning individual. Patients' perceptions of what was needed to

compliment the original self symbol can be used in a dialogue about personal abilities or traits that they might believe need strengthening in themselves. Patients frequently resist talking positively about themselves. They say that it feels self-centered or selfish to spend time thinking and talking about their good qualities.

Eating disorder patients often depend on other people to mention how well they are doing academically or how nicely they performed an activity. They do not feel a job was well done unless it is complimented by someone else. Patients need to recognize that when they depend on external sources for reinforcement they put themselves at the mercy of other people's preoccupations and moods. In fact, patients often misinterpret parents' or friends' preoccupation as dislike or disgust. Patients must learn the skill of trusting their own judgment in evaluating their abilities and achievements. As was mentioned in Chapter 6, artwork validates achievement and progress. When they become more able to admire their own work, patients' thoughts and feelings of self-acceptance become more stable. Self-acceptance is no longer based on the whims of others.

Homework and healing dimensions
Patients should draw and write in their creative journals about the significance of their self symbol and its companion. They can explore what the art experiences have taught them about their ability to accept themselves and *all* of their personality traits. In addition, patients can be encouraged to think about an art medium or technique with which they demonstrated persistence and overcame feelings of ineffectiveness. They can use this medium or technique in their creative journals to remind themselves that with practice they will become competent with activities outside of the eating disorder. If the medium is clay, patients may continue to make small sculptures and add sketches or digital pictures of them to their creative journals.

Mask making
Media
One sheet of 12 x 18 inch (A3) white drawing paper or colored construction paper, or cardboard if it is available. Other materials may be used as well; one man I worked with made a mask out of a plastic milk jug that he cut in half. Also needed are drawing media, collage images, found objects, and white glue.

Directive
Before patients begin making their masks they should be directed to write in their journals, or on another piece of paper, a list of three persons whom they

dislike. Underneath the names, patients should write three qualities of each person that they find disagreeable. Keeping these qualities in mind, patients will make a mask that demonstrates them.

Expected themes

With their masks in front of them, patients will write a series of one-word associations to it. They can be encouraged to describe the mask physically and psychologically, and use the one-word responses as the basis for creating a poem or paragraph about the mask and its meaning.

A woman recovering from bulimia nervosa created the mask in Figure 9.4 and named it "Stella." The following is her journal response that helped identify traits that were denied in herself and projected onto the mask. The journal writing also illustrates how this woman took an important step toward accepting the rejected qualities.

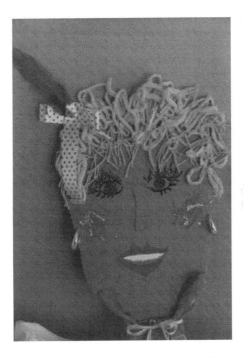

Figure 9.4: "Stella" – Mask making supports patients in embracing all personal qualities

Stella needs a lot of attention, and attracts lots of negative attention. She has on way too much blue eye shadow (the sparkly kind that people can see from miles away). She has on bright red lipstick and a bit of it has

rubbed off on her teeth (and is attracting more negative attention). Stella has on gaudy cheap jewelry that rattles and clanks. She thinks that the bow in her hair is attractive to men, but it really makes them laugh at her. Stella laughs a lot – too much in fact. She believes that her laugh is self-depreciating and endearing. Actually, there is a tremendous amount of rage hidden just behind those lipstick-stained teeth. She is extremely angry but she can't say it.

She tries to use her femininity to get things from men, and sometimes she succeeds. In relationships with men she is dependent. She needs them desperately to tell her that she is worthwhile and desirable. She believes that she is a star, but she needs men to help her shine.

Stella is extremely emotional – especially around the time of her period. She needs people to help her solve her problems. Stella has always depended on the kindness of strangers to help her through hard times. In fact, she uses people to get what she wants and is sometimes successful (when people aren't laughing at her). She feels justified in using people because she needs so much help.

Dependency, emotionality, neediness … all qualities that I avoid admitting I have. I would rather binge and purge that ask anyone for help … Hmmn … I know that I am not Stella. Maybe I could ask for help without being a buffoon.

The journal response describing "Stella" helped this bulimic woman see how she denied qualities that she did not feel comfortable with in herself. She realized that she made the traits of dependency and emotionality obnoxious to herself so as to never exhibit them. She projected these qualities onto other women whom she disliked because she could not bear the qualities in herself. This woman also understood that she made neediness and dependency so repulsive that she would rather have an eating disorder than express them. Finally, she realized through her response to the art experience that there might be ways to convey neediness and dependency without becoming her own worst nightmare.

Masks uncover unconscious material that can be uncomfortable and even shocking if not dealt with sensitively (Janzing 1998). When I introduced a series of mask making sessions to an ongoing art therapy group, attendance waned when it had previously been strong (Hinz and Ragsdell 1990). Perhaps extending the mask making over sessions left too much material unprocessed. I have used mask making more effectively in closed-ended group sessions in which all group members had an opportunity to share information. Patients can be gently educated about what Carl Jung called projection of the shadow self (Jung 1964). They can be guided to learn how the disagreeable character that

they created may be a projection of qualities that they do not like in themselves. Shadow traits may be exaggerated into characteristics that anyone would dislike. When patients look beneath the surface, they can be encouraged to determine whether or not the shadow represents qualities that they have been *afraid* to express. The shadow also contains positive qualities – basic instincts and creative impulses (Jung 1964).

Response piece: Companion mask

Media
The same media and materials that were available for the first mask making experience.

Directive
Before beginning the mask, have patients write in their journals a list of three persons whom they *admire*. After they have written the three people's names, patients should make a list of qualities that these people have that make them held in high regard. Keeping these traits in mind, patients should make a mask that demonstrates the admirable qualities.

Expected themes
Patients should intentionally view their new masks. After contemplation, they may write a list of quick, one-word associations about the mask.

This mask represents another type of projection. Qualities that patients admire in others are qualities that they also possess but have not realized or acknowledged. Self-acceptance will involve finding ways to allow these admirable traits to be expressed so that patients recognize them, claim them, and embrace them. Patients should not be surprised if accepting the positive is just as hard, or harder, than accepting the negative. Often, because a false sense of self has developed, patients may not feel that all of the qualities they possess are "real." They must be taught that recovery from an eating disorder involves accepting all of their personality traits. When these traits are acknowledged and expressed, they will emerge as a whole, well-rounded person.

Homework and healing dimensions
Patients should be encouraged to use the lists of characteristics and the lists of one-word associations generated by the masks to write about them. They can be encouraged to put on clothing that enhances each mask and *act out* both characters to see if there is more to learn about unacknowledged positive or negative

qualities. These experiences can be detailed in their creative journals with either illustration or writing.

Summary

Many people with eating disorders have split off parts of themselves and labeled them "bad" based on past experiences. These labels, learned in earlier times, will not change without conscious effort. Through the art experiences in this chapter, patients have learned that the conscious effort of enhancing self-acceptance begins with respecting that which comes to mind, even in a simple set of lines such as a scribble, and working with those ideas and images. In addition, self-acceptance involves recognition of the split off and rejected parts of themselves. These are characteristics that patients have made horrible, as well as those that they have deemed "too good" to be true parts of themselves. When these qualities are recognized, the work of integrating them begins. Through art experiences, life experiences, and homework exercises patients can embrace what they previously were not aware of or shunned. After they have embraced these internal qualities, patients will begin to affirm them through their thoughts, words, and deeds. Patients will be on their way to becoming whole and capable persons. When patients feel whole they will have more to give in relationships, in work, and to the community. The next chapter explains the importance of developing and maintaining a spiritual connection in order to have a foundation for giving of the self.

Fostering a Spiritual Connection

The spirit is the true self.

Cicero (106–43 BC)

Introduction

Spirituality is difficult to conceptualize and define, but necessary for therapists to understand. Not only must they understand the concept, they must also appreciate the place of spirituality in psychotherapy in order to best treat their patients (Lewis 2001; Mann 1998). Patients frequently come to therapy with negative images of God, feelings of spiritual unworthiness or shame, and the feeling of being abandoned by God (Richards *et al.* 1997). Our perception of God may influence how we see everything in life. If we see God as a harsh judge finding fault with all of our sins, then we live life in fear. If we view God as love, then our life is characterized by communication, unconditional love, and peace. My purpose in addressing the topic of spirituality in therapy is to help patients understand that they are not alone; they are accompanied on their life journey by a benevolent God, the spirit of the universe, or some power greater than themselves. Understanding that they are not alone helps reduce anxiety and infuses patients with energy to recover. Finally, it is my belief that spirituality is a personal quality that helps patients find a sense of meaning and purpose in life.

Eating disorders can represent an attempt to find meaning and purpose in life along with an acceptable identity, as patients struggle with a desire for perfection and the reality of their imperfection (Lewis 2001). Moore (1992) stated that psychological and physical symptoms are expressions of yearning for spirituality, and that spirituality is a valid concern in psychotherapy. He gave the specific example of the self-starvation and food rituals of anorexia nervosa representing a "pseudoreligion and symptomatic spirituality" (p.205). He explained that anorexia mimics religion in its rituals and discipline, so the patient is actually stating a need for spirituality where ritual and restraint have important roles.

Spirit has been defined "as the vital animating essence of a person; the soul" (DK Illustrated Oxford Dictionary 2003, p.800). Occhiogrosso (1991) pointed

out that the word "spirit" comes from the Latin word meaning "to breathe," so that spirit connotes an invisible life-enhancing energy. Spirituality can refer to the notion that there exists in people an unseen realm that functions as the animating, life-giving force. Religion is different than spirituality in that religion refers to precepts and rules. These precepts can fuel spirituality but are not equivalent to it. Spirituality is conceived of experientially, a connection with a higher power that gives life to the individual (Wuthnow 2001). Through the art experiences in the present chapter patients will find ways to fuel the spirit and successfully renew the life-giving force. Creativity is a natural way to express spirituality. Being involved in the creative process is energizing and fills the creator with inspiration and motivation for new projects. In addition, because spirituality involves things that have no physical presence yet are real, art is a way to give form to the spirit (Azara 2002; McConeghey 2003). Art can help describe, delineate, and display the mystery that is spirituality.

Patients will learn that forging a spiritual connection is important because spirituality is a foundation for giving and connection. When patients realize that a divine presence is with them on their journey, they experience less anxiety and feel more energy. They have more energy to give to themselves, to loved ones, and to the community. I have worked with many eating disorder patients who claimed, early in their therapy, that they had never "felt full." It has been my experience that patients who do not have a spiritual connection will seldom feel full. No amount of food consumed, food restriction, or food ritual will ever fill the hungry soul. Until patients establish a spiritual connection – whatever that means for them – they will always feel a certain level of emptiness. The opposite is also true. When a spiritual connection is in place, patients feel fulfilled. With hearts, minds, and souls filled, patients have a foundation for giving of themselves in relationships: they can comfortably fulfill their own needs and those of others.

Given the inappropriate demands that many patients were subjected to as children, it is not surprising they have reported feeling that life energy was being drained out of them as they met the needs of others in their families and denied their own. They have described themselves as children as being very fearful, believing that they were alone in the world. Sometimes patients sensed a need for protective energy and mistakenly turned to food for the body when what they really needed was food for the spirit – something larger than themselves to meet their needs and care for their souls (Bullit-Jonas 1998). The art experiences in this chapter will help patients start to forge a spiritual connection and develop an awareness that they are not alone in the world. Patients will begin to know that they are accompanied at all times by a power greater than themselves – a presence that infuses them with life-giving energy. Knowing this

presence will make it easier for patients to loosen the reins of control over food, weight, and body image.

Spiritual presence

Media
One sheet of 12 x 18 inch (A3) white drawing paper or colored construction paper, and whatever media patients want to work with: drawing, painting, or collage. Remember to use breathing and relaxation prior to beginning.

Directive
Patients fold their paper in half, crease it, and unfold it. They will have two equal sides to work on. On the left side of the paper, patients will represent what their world would look like if they do not feel a spiritual connection. On the right half of the paper, patients will represent what they believe a nourishing spiritual life would look like. Patients can be reminded that they may use metaphor in their drawing; the image does not have to be representational.

Expected themes
Patients should spend time intentionally viewing the dual image. They can respond by writing a series of one-word associations about it. The *Spiritual presence* drawings demonstrate a diverse assortment of images depicting spirituality. What patients find meaningful must be honored, and therapists will help patients access those concepts of spirituality and make them useful. A woman I worked with said she believed that God was present in the ocean waves. It was my task to help her define what she meant by "God in the waves," to help her access the waves for spiritual purposes, and to realize the life-giving energy that comes from honoring God in the form of ocean waves.

Another theme that arises in response to the *Spiritual presence* directive is that spiritual practices infuse patients with creative energy. The young woman who made the collage image in Figure 10.1 stated that she sometimes used meditation as a way to enhance her spiritual life. She explained that the collage image helped her appreciate that if she regularly followed the practice of meditation she would feel calm and centered. When she did not make time for meditation she felt mounting stress. Although this young woman was not an artist, she explained that meditation helped her feel calm and creative in her everyday life. She stated that when she was infused with the quiet spiritual energy that she achieved from meditation she felt motivated to spend time gardening or creating bead jewelry. When she engaged in regular spiritual practice this young woman had more life-giving energy to be "everyday creative" (Cornell 1990).

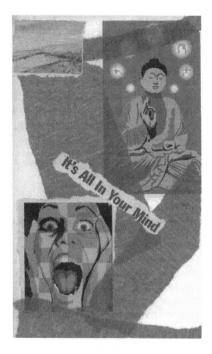

Figure 10.1: It's All in Your Mind" – Collage reveals importance of regular spiritual practice

Therapists should be aware that some religions such as Muslim and Orthodox Judaism prohibit making images of God because it is considered sinful to attempt to represent their supreme being. Before embarking on a representation of the *Spiritual presence* therapists should clarify patients' thoughts and feelings about this type of representation.

Response piece: Bridge to divine power

Media
Patients will need the previous image and one additional sheet of 12 x 18 inch (A3) white drawing paper or colored construction paper. Patients may use whatever media they would like: drawing, painting, collage, or clay.

Directive
After breathing and relaxation, patients will contemplate their *Spiritual presence* picture and decide upon a bridge that would best connect the two worlds. The bridge does not have to physically connect the two worlds it merely has to demonstrate a way to join them. Patients may draw the bridge, paint it, or make it in

three dimensions. After the bridge is completed, patients will create a self symbol and place it on the bridge in a spot that feels right.

Expected themes

If patients have used clay, they may make a sketch or take a digital photograph of the bridge and self symbol for their creative journals. Then they should take a few moments to silently reflect on the bridge and self symbol and create a list of one-word associations about them. Patients can be encouraged to think about what the bridge is made of and how it is connected to both worlds.

The bridge construction stimulates discussions of patients' beliefs about accessing a spiritual presence in their lives. Bridges are powerful symbols of connection. The bridge construction will emphasize that in recovery patients are focused on accepting and incorporating all of their personal characteristics. They are trying to reconnect with and recover essential qualities. Patients can be guided to understand that many people struggle with obtaining and maintaining a spiritual presence in their lives. Art makes spiritual struggles visible and helps patients transform these struggles into goal-oriented, life-enhancing strivings. As was discussed in the previous chapter, focusing on integration and connection will reduce the amount of energy spent on denial or repression of "negative" parts of the personality. Feelings of shame or spiritual unworthiness dissipate more readily when patients discover that integration does not involve elimination of all that is negative.

Bridge drawings also reveal that patients often resist the spiritual as much as they resist learning about the shadow sides of their personalities (Cassou and Cubley 1995). They might believe that in order to embrace a spiritual presence in their lives they will have to become some sort of religious fanatic and change their whole way of being. It has been my experience that patients will not necessarily voice these concerns outright, but will more likely subtly resist spiritual experiences. It is necessary to teach patients that having a spiritual presence in their lives will not fundamentally change them, but will fulfill them in new ways. A spiritual presence will not restrict their freedom, but *add* freedom as well as creative energy to their endeavors.

Homework and healing dimensions

Patients should develop their ideas about the bridge to the divine by drawing or writing in their creative journals. They may use lists of one-word responses generated by the images as the basis for a poem or paragraph about 1. not having a spiritual connection but wanting one, 2. having a weak spiritual connection and wanting to strengthen it, or 3. what bridging the gap means to them. The

images brought forth by the words will give clues to what is wished, feared, and hoped for about a spiritual presence. The bridge connecting the two worlds will help patients understand how to make the spiritual connection work. Patients can use their creative journals to develop further images of integration of the divine presence into their present world.

The gift of inner blessings

Media

This experience requires assorted magazines, one sheet of 12 x 18 inch (A3) white drawing paper or colored construction paper, scissors, glue stick, and gel pens.

Directive

This art experience requires faith that a healing message will emerge from an ordinary image. Patients are instructed to close their eyes, shuffle through a stack of magazines, and pick one without looking at it. Still with their eyes closed, patients thumb through the chosen magazine until they come to a stopping place. Without looking at it, patients rip out one whole page. After the page is separated from the magazine patients look at it. The images and words contained on the page represent a *gift* to patients from the divine presence inside them. Patients are asked to examine the page and decide what the gift is. The gift may be contained in the images or the words. Patients decide what the gift is, trim the paper with scissors if necessary, and glue the image to the paper.

The second part of the experience calls for patients to write a poem or a paragraph about the gift. Patients often write the poem directly on the paper surrounding the gift image.

Expected themes

In *Care of the Soul* (1992), Thomas Moore points out that the root word for symptom and symbol are similar and that symptoms often are symbolic of underlying diseases, and especially of a lack of attention to matters of the soul. Often people in recovery from serious conditions such as eating disorders come to look upon both the condition and the recovery process as "gifts" from the spirit (Koenig 1999). Patients recovering from life-threatening conditions say that they will not go back to living their lives the way they were before. They explain that the disease and recovery process prompted necessary changes and provided new meaning in their lives (Ganim 1999).

In response to *The gift of inner blessings* art experience patients should write about how the eating disorder or the recovery journey has been a gift that has

impacted their lives in fundamental ways. Patients have mentioned that the process of recovery from the eating disorder has helped them become more aware of the enormous value of life and the necessity of not wasting it. Patients report feeling free after their recovery: Free from their previous obsession about what others might have thought about them. Free from the obsessive thoughts and compulsive behaviors that characterized the eating disorder. Free from the tyranny of dieting and trying to look like media images.

I have participated in *The gift of inner blessings* art experience many times, and each time have found that there is revealed a pearl of healing wisdom. The simple instructions provide just enough encouragement for patients to get in touch with the presence of the divine inside themselves. Healing wisdom has existed all along; the spiritual focus at this point in the journey allows patients to be confident of their healing wisdom and reclaim it.

Response piece: A greater gift

Media
One sheet of 12 x 18 inch (A3) white drawing paper or colored construction paper, a large stack of assorted magazines, glue stick, and gel pens. Remember to use breathing and relaxation prior to beginning the directive.

Directive
Patients close their eyes, shuffle the pile of magazines, and pick one from the stack. They thumb through the magazine and take out a page. Keeping their eyes closed, patients tear a *square* shape from the magazine page. With their eyes still closed, they pick up the next magazine from the pile, tear out a page, and tear a *triangular* shape from the magazine page. They do the same things for the third magazine in the stack, but this time tear out a *circle*. Patients repeat the whole process, keeping their eyes closed. They will end up with six shapes: two squares, two triangles, and two circles.

These six shapes form the basis for a gift collage. Patients consider the images and words, integrate the information, and decide what message has been disclosed. This time patients do not have to trim the images with scissors. Patients glue the irregular shapes to the background paper. Patients then compose a poem that states the healing message of the gift collage.

Expected themes
The young woman recovering from bulimia nervosa who made the gift collage shown in Figure 10.2 was pleasantly surprised by the inspiration she found in the simple torn images. She had suffered from bulimia nervosa for most of her

teenage years, but was making great progress in intensive outpatient treatment. The progress she had made in recovery was evident in the words of encouragement that she wrote for herself in response to her gift collage. In response to her collection of images, the young woman wrote the following:

> If I can climb this mountain, though it may be hard and take a long time, when I reach the other side, I will have found what I am hungering for, and finally I will love the person that I am.

She explained that she was "hungering for" a spiritual presence in her life. She said she wanted to feel, as she had heard in Sunday school, that God loved her. She wanted to love herself. The theme of unconditional love often arises in the recovery process. Patients often perceive themselves as having been loved *conditionally* as children. They claim they felt loved only if they behaved or looked certain ways. Patients report that they have lived their lives trying to do what other people wanted. They long to feel unconditional love; to be loved just for being, not for doing. Patients can be counseled that the love they want to feel begins with the faith that unconditional love is offered by God. They must begin to love *themselves* unconditionally. Patients can also be encouraged to find a church or other spiritual community where they experience unconditional love.

The *Gift* art experiences require faith that a meaningful message will be revealed. Patients must have faith that healing knowledge exists within them and that this uncomplicated exercise will help it emerge. The process of finding meaning from the simple images reinforces what professional artists acknowl-

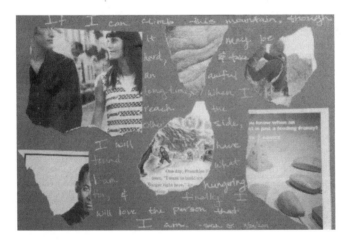

Figure 10.2: Gift collage – Art can help patients make something of what they are given

edge: they are not wholly in control of the creative process (Stone 2003). The subconscious – the muse – or divine inspiration – adds elements of surprise and pleasure that give further depth to the created image. The writer Dorothy Sayers (1970) proposed that all people would live more peacefully if they learned to live like artists. That is, if they gave up trying to "master their material" and rather "cooperated with it in love" (p.186). She explained that rather than defining life in terms of "problems" and then struggling to find solutions to those troubles people should, like artists, try to create something out of what they are given.

In the *Greater gift* patients created something out of what they were given; the whole of the image was much greater than the sum of its parts. Patients integrated words and images into a gift of spiritual wisdom. The power of the spiritual gift coming from within cannot be overstated. Patients need to gain confidence in their own inner wisdom and this experience is one that greatly reinforces it. These integrative experiences emphasize the process of emotional alchemy. Greenspan (2003) writes that alchemy has become a metaphor for the process of spiritual transformation. Alchemists are no longer trying to turn base metal into gold. *People* are looking for ways to turn their emotional experiences into "the gold of spiritual wisdom" (p.13). Emotional alchemy does not require the elimination of negative emotions. This type of healing uses negative emotions as tools for learning about spiritual transformation.

Homework and healing dimensions

These two *Gift* art experiences will help patients reflect on what it is to have faith and to rely on faith in healing. This faith is very different from the struggles with control that characterize eating disorders. Faith forms the foundation for maintaining a spiritual connection. Patients must know that a spiritual connection and the faith that underlies it is the essence of staying in recovery and preventing relapse. Patients should make a new drawing in their creative journals that integrates the messages of the two *Gift* images. They may create new images that help them reflect upon living in such a way that absolute control of the events in their lives is unimportant and they are relying on faith for answers in their lives.

One type of painting that illustrates faith is created by using watercolor paint on wet paper. Patients can protect other pages in their creative journals with paper towels and plastic wrap. One page can be wet and watercolor dropped or splashed on randomly. The paint will run and colors will blend together in ways that cannot be predicted or controlled. When the painting is dry, words may be added to enhance the message about the faith revealed (Carey *et al.* 2002).

Outer blessings

Media

This art experience requires patients to take a walk outside and gather natural materials. The found objects will reflect the natural beauty of the places patients live. Patients should collect an assortment of things: sticks, leaves, feathers, stones, etc. Other materials needed: natural colored twine, string, or colored yarn (preferably made from natural fibers), and craft glue.

Directive

After breathing and relaxation, patients begin to think about how they will arrange the found objects and other materials to form a sculpture that reflects and reveres the beauty and blessings of the natural world. Patients will arrange the materials in a way that feels right to them and affix them with craft glue or string.

Expected themes

Patients may make a sketch of the sculpture or take a digital photograph of it for their creative journals. They can respond to the found object sculpture by writing a series of one-word associations about it. Patients will learn from this art experience to expand their horizons. Eating disorder patients are often so absorbed in the small world of food and food rituals that they miss the beauty of the world around them. In recovery patients become more attuned to their world. They will marvel at each natural treasure that they are now open to seeing as indications of divine blessings in their everyday lives. Patients will be more likely to perceive and wonder at God's simple creations: an intricate pinecone, a smooth stone, or a colorful leaf. All of these are confirmation that there is a thoughtful Creator behind this exquisite world. Developing an appreciation for the divine presence in the natural world reminds patients that they are not alone. The knowledge that they are not alone provides creative energy for the recovery journey.

Response piece: Integration of inner and outer blessings mandala

Media

One sheet of 12 x 18 inch (A3) white drawing paper, pencil, and whatever drawing or painting media patients prefer.

Directive

Therapists prepare for the mandala drawing by tracing around a dinner plate in the center of the paper. After breathing and relaxation, patients reflect on what they have learned about the divine presence inside them and in the outside world. They will make a mandala that reflects the essence of these two blessings in their lives. Patients may think of the mandala as a way of asking for divine guidance. They will begin the mandala painting in the center of the circle with a color or shape that appeals to them. Patients add colors and shapes around it until the mandala feels complete.

Expected themes

Patients should spend some time silently contemplating the integration mandala. After some reflection they may write a series of one-word associations to the mandala. Therapists can suggest that the mandala may have something to teach the patient about the purpose or meaning of their lives. Therapists ask patients to be open to a message about purpose. Patients may take additional time to contemplate their integration mandala with the idea of purpose in mind.

Integrating inner and outer blessings into a mandala drawing directs patients to a stronger sense of their own creative power. They are connected to the essence of the Creator inside themselves and in the world around them. From this creative power and the integration of inner and outer blessings can emerge a sense of purpose. In order to be fulfilled, patients must feel that their lives have a larger meaning. The eating disorder provided a false sense of purpose: to achieve a perfect body and thus please others. Without it, patients might feel a loss or emptiness. Therapists address this void directly by asking patients about the purpose revealed in the integration mandala.

Homework and healing dimensions

Patients may use the list of words generated by the art experiences to develop a poem or paragraph about the divine presence inside them and in the world around them. They will draw and write in their creative journals about a new-found sense of purpose if one was revealed through these images. Patients can be instructed to make a series of healing mandala paintings using their hand as a template, and as a symbol for their power in their own healing. Patients will trace their hand inside a circle and decorate the healing mandala with colors, lines, and shapes that demonstrate their power in healing themselves. Through this mandala patients will reinforce that they are separate, whole, and free. Patients are separate from past influences, whole and accepting of all of their personality traits, and free to act in new and healthy ways.

Labyrinth

Media
One piece of 12 x 18 inch (A3) white paper (extra paper if necessary), thin markers.

Directive
Patients are given a simple explanation of a labyrinth such as the one that follows. After breathing and relaxation patients are asked to draw a labyrinth that represents their spiritual journey or pilgrimage.

Expected themes
A labyrinth is a circular path walked for contemplation, meditation, or prayer. The earliest labyrinths were probably made to symbolize a pilgrimage to the Holy Land, which was a daunting if not impossible journey in medieval times (Gerding 2001). Today labyrinths represent spiritual journeys. The labyrinth walk is defined by three stages: 1. the way in, 2. the center, and 3. the journey out. The inward journey has been described as releasing the cares and concerns of the day. The center is a place to receive. The center should be contemplated as long as necessary in order to receive the spiritual message it contains. The outward journey, which occurs along the same path as the inward journey, has been described as returning to the world with a new attitude of union with God and the healing forces of the universe (Artress 1995).

At this point in recovery patients generally will be open to whatever healing message is available from their spiritual center. This journey is characterized by faith. One has to trust the labyrinth to provide a spiritual experience, and not confuse a labyrinth with a maze. A maze has a correct path, numerous choices, and blind alleys. Negotiating a maze is a left-brain activity, a puzzle to be figured out. Walking a labyrinth is a right-brain activity that requires emotion, intuition, and trust (Artress 1995). The form of the spiritual journey will further inform patients about the meaning and purpose of their lives.

The labyrinth experience probably required a few attempts in order for patients to get the feel of it. Patients might have impulsively drawn paths that were not connected or which led to dead ends. Making a pleasing labyrinth requires persistence. Impulsivity, the opposite of persistence, is a common personality trait among patients with bulimia nervosa and binge eating disorder (Stice 2001; Wonderlich, Connolly, and Stice 2004). Therefore, experiences that teach persistence, patience and the importance of practice are a necessary aspect of eating disorder treatment. Patients will experience through the labyrinth and other art experiences, that when they practice one set of skills they can become proficient at just about anything. The need for practice in drawing the

labyrinth can be used as a metaphor for the need for spiritual practice in a new and mindful life. Patients need to recognize that spirituality does not enter their lives fully formed. Spirituality requires persistent work in order to unfold. The development of spirituality will add depth and meaning to patients' lives that will sustain recovery and help prevent relapse long after treatment has ended.

Observing the lives of professional artists shows us that they are not necessarily born with great talent. We learn from the work of artists, especially those artists who have a spiritual inclination, that they developed their artistic talent over time through hard work. When talking of spirituality, practice means allocating set periods of time to enhancing one's relationship with a divine presence. Spiritual practice incorporates the notion that spiritual life is more fulfilling when patients dedicate thought, time, and effort to it. Practice also suggests regularity of spiritual discipline which can lead to real spiritual gratification, where a lack of dedication and "spiritual shopping" cannot (Wuthnow 2001).

Response piece: Heart of the labyrinth painting

Media
One sheet of 12 x 18 inch (A3) white drawing paper, painting media.

Directive
Patients take time to reflect upon the message received at the center of their labyrinth. They will imagine the colors, lines, and shapes there, and reflect upon the healing message that they received to take back out into the world. When an image is in mind, patients are instructed to make a heart-shaped painting of the center of the labyrinth.

Expected themes
The message from the heart of the labyrinth is often the most personal image of the healing journey. Drawing the shape of a heart encourages patients to access their soul and the deepest healing messages available to them (Azara 2002). Patients will reinforce for themselves through this image what the meaning and purpose of their lives are. This heart of the labyrinth painting can prepare patients for the end of psychotherapy and provide them with a direction for their lives. That direction will likely involve sharing their healing knowledge and spirituality with others.

Homework and healing dimensions

The labyrinth is a model for the healing journey. Patients traveled a path inside themselves during their healing journey and have found wisdom at their center. In the labyrinth journey patients follow the same path out that they followed into the center. On the outward journey patients will find themselves richer, laden with the gift of unity with a spiritual presence. They will feel a new sense of harmony with themselves. Patients should use their creative journals to form new images that further explore the message from the heart of the labyrinth.

Summary

After completing the art experiences in this chapter, patients will understand that they are not alone but always accompanied by a spiritual presence that they have defined for themselves. They will have the experience of integrating a sense of the divine presence and understanding the inner and outer blessings that exist in their lives. Patients will know that they can use art to give form to the spirit. They will experience accessing the spirit through an appreciation of nature and through religious practices.

Patients often begin treatment reporting negative images of God which might wrongly influence their perceptions of all things. Art experiences in this chapter helped patients reconnect with a benevolent higher power and develop spiritual practices that will help them gain energy from a new sense of life beyond themselves. When patients integrate their own inner wisdom with spiritual practices, images of God come from within and become more positive. When patients show the ability to integrate inner and outer blessings and to achieve healing energy from regular spiritual practice, it often means that they are ready for the end of psychotherapy.

When Therapy Comes to an End

It is through art and through art only that we can realize our perfection.
Oscar Wilde (1854–1900)

Introduction

This chapter discusses what happens at the end of therapy. Issues to keep in mind at termination include:

1. how to know when patients are ready to end therapy

2. how to consolidate the learning that has taken place through the therapeutic art experiences

3. how to continue to reinforce learning after termination.

Treatment using therapeutic art differs remarkably from verbal psychotherapy in that patients and therapists have a permanent visual record of the therapeutic journey to review. During a final evaluation of the artwork patients will look for themes among the art pieces and their responses to them. They will understand more fully and integrate more completely those characteristics that they have reclaimed through their healing journeys. Patients will learn to make daily affirmations that demonstrate their growth in recovery and reveal future directions. Finally, patients will learn how they can share with others the wisdom that they have discovered. At the end of treatment patients will appreciate that the best way to be fulfilled in life is to find meaningful ways to share themselves in their relationships, work, and communities.

Daily affirmations

Media
This is a continuing art experience for which patients will need a new blank journal. Similar to the original creative journal, a 9 x 6 inch (A5) book made of unlined art paper with a spiral binding is recommended. The medium size and unlined paper allow for greater expression than a smaller size and lined paper.

The spiral binding will allow the book to lie flat when patients are working on it.

The other materials that are needed are drawing and painting media, collage images, gel pens or permanent markers, and fixative spray for pastel images.

Directive

The first step in making an affirmations book is for patients to design the front cover. Patients will create a cover that conveys the spiritual presence that they have in their lives. Affirmations are written and drawn testimonies to the presence of blessings. They support the work that patients have done to foster a spiritual connection and demonstrate how that connection will sustain recovery in the future. Making a book of affirmations requires that patients notice divine influences in their lives, meditate about them, and write about them. Positive words that patients write will be illustrated with simple designs. Patients can use the words of writers, poets, the Bible, or sayings from other spiritual traditions for encouragement. For example, *The Teaching of Buddha* (Society for the Promotion of Buddhism 1966) contains metaphorical phrases of solace and inspiration; the Psalms are 150 poems of praise, reflection, and thanksgiving.

A young man that I worked with liked part of Psalm 23 that he heard adapted into a song. It said, "Shepherd me, Oh God, beyond my wants, beyond my fears, from death into life." To this young man, the Psalm represented his healing journey: being shepherded beyond his wants and fears, from the "death" of the eating disorder into a new life without it. With this Psalm as a background the young man made the cover of an affirmations book that heralded a new phase in his recovery journey.

A woman, formerly suffering from binge eating disorder, found inspiration in the words of II Timothy 1:7, "For God did not give us a spirit of timidity, but a spirit of power, of love and of self-discipline." This verse characterized her vision of sustained recovery. She explained that she would no longer be afraid and hide behind binge eating and obesity. She said that she would face the world with newly found self-love which would give her the self-discipline to avoid binge eating in the future. She would use this verse for inspiration. The woman made a number of beautiful art backgrounds and used different calligraphy styles to write the verse on each. One became the cover of her affirmations book, others she framed and gave as presents to family and friends who had been helpful in her recovery.

Affirmations themselves are realistic and positive self-statements, written in the first person, which celebrate the blessings of recovery and new life. Figure 11.1 is one example of an affirmation drawn and written by an adolescent girl

Figure 11.1: Affirmations are personal words of inspiration that can celebrate the healing journey

recovering from bulimia nervosa. She now has a book filled with her own self-affirming and hopeful words. The sayings celebrated her faith in herself and in the divine presence in her life. Patients should be reminded that affirmations are not merely cheerful or trite sayings applicable to anyone. Affirmations are realistic words of encouragement personalized to the patient's unique circumstances.

Expected themes

By this time patients are very familiar with the process of using art media for healing. They have used art to express a wide range of emotions, to solve problems, and to calm themselves. Patients will continue to use art to affirm the challenging and rigorous work they have done on the path to recovery and the future direction they wish for themselves. As they continue to celebrate growth in recovery, patients must not leave room for the negativity that can creep into their lives if they are inactive or unaware. Affirmations are helpful for developing a strong positive voice necessary to overcome the negative self-talk that previously characterized the eating disorder. In addition to being written, affirmations must be stated out loud and regularly for full effect (Reindl 2001). I have often told my patients that they have to be smarter and stronger than the eating disorder. Patients must be aware that eating disorders can reappear in their lives if they are not living mindfully. Repeating affirmations is one way to maintain awareness and strength. Patients should be encouraged to continue making written and vocal affirmations of growth, acceptance, and increased self-esteem to sustain their progress in recovery.

A lovely affirmation by a woman nearing the end of her recovery journey is shown in Figure 11.2. This affirmation celebrated the internal wisdom that the woman had come to know, trust, and reclaim during the course of her healing. The caption that she wrote went like this: "Inner Wisdom, like a tree, branching out, reaching for the sky, finding new leaves along the way." After many years of depending on others and perceiving herself as weak, this 50-year-old woman now trusted that she could find answers to new challenges *within herself*; she recovered her internal wisdom.

Patients should be counseled to set aside some time each day to create. Affirmations can be written about the new goals that patients are now striving to reach and about those things for which they are thankful. Patients can create affirmations emphasizing the parts of themselves that have been rediscovered and reclaimed while on their healing journey.

When is recovery achieved?

Patients will usually discover for themselves during the course of therapy that they will always be "in recovery." This does not mean that they will always be actively involved in psychotherapy, but merely that they will always be con-

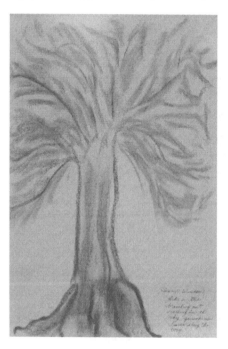

Figure 11.2: An affirmation celebrates the reclaiming of inner wisdom

scious of living life differently. It has been stressed throughout this book that recovery does not involve eliminating parts of the self, but that it involves incorporating all parts of the self. Recovery does not mean returning to the same state that patients were in prior to therapy or even prior to the onset of the eating disorder. Rather, recovery means achieving an appreciation for the constant transformation necessary for living a vital existence.

Ending therapy is considered when all treating professionals confer and agree that patients are ready. Physically, patients must be eating and exercising regularly, they should be at or approaching an appropriate weight for height, and binge eating, purging, and/or food restriction should not occur. The treating professionals should agree that patients have made significant gains in their abilities to express feelings and meet needs without food or food rituals. There will also be agreement among professionals that patients have made considerable progress in their ability to use coping skills and problem-solving skills. Patients will report a true sense of well-being.

Through participation in therapy patients have a new sense of security and self-awareness. They have new knowledge of themselves and the world, and new skills with which to approach life's challenges. Therefore, as therapy comes to an end patients are not returning to the state they were in prior to the onset of the eating disorder. They have achieved an *improved* state of being. Success in recovery has been related to being ready to engage in the therapeutic process, choosing to participate in therapy, having a strong personality, and having hope (Reindl 2001; Way 1993). Art makes visible the hope and strength necessary to carry on without the support of active therapy. Patients' images will contain the clues to their readiness for a new life. It has been my experience that spiritual symbols, or other symbols of hope and strength such as suns, trees, sunrises, or strong animal figures, will be evident in patients' artwork when they are ready for therapy to come to an end.

Finding meaning

Review of artwork

When patients are prepared to terminate therapy, a review of the artwork provides a method of structuring the experience. The accumulated images are a permanent visual record of the healing journey that patients have undertaken. This review can be an exciting and enlightening way to consolidate treatment gains. If all of the art experiences were completed there will be approximately sixty finished pieces to evaluate.

Therapists can arrange a series of termination sessions in order to review patient artwork and commemorate the end of therapy. One session can be dedi-

cated to study the artwork related to the topic presented in each of the chapters:
1. effects of the eating disorder, 2. childhood influences, 3. problem solving, 4.
reclaiming emotions, 5. body image, 6. self-acceptance, and 7. spirituality. One
or two final sessions can be devoted to an overall summary of the therapeutic
work and to issues of grief and loss which regularly occur at the end of therapy.
When reviewing the artwork, there should be space to display finished pieces
within each topic area. Patients should be allowed sufficient time to contem-
plate the artwork and its overall message or theme.

Because the images were often discussed according to their formal art
elements: color, form, or pattern, this can be one way to organize the patients'
approach to the review. They can look for similar artistic elements to see if there
are similar underlying themes or messages in those pieces. Determining the
main ideas that flow through the artwork will strengthen the recovery journey.
Patients keep in mind that they are recovering – getting back or reclaiming –
essential wisdom that was theirs from the beginning.

During the final evaluation of the artwork patients sometimes discover new
themes that were not evident during the initial viewing. With all of the art
images from a subject area laid out together, certain colors, lines, patterns, or
forms become noticeable in new ways. Patients should spend time reflecting
upon the images before discussion begins. From their notes about images and
their meanings, therapists direct the review and suggest areas to contemplate for
homework. After reviewing artwork related to the last subject area, spirituality,
patients and therapists look for overall themes of the images and recovery
journey.

The young woman who made the "celebration" pictures shown in Figures
1.4 and 1.5, noticed that a continuing theme in her artwork was that she
avoided letting people take care of her. She learned through the art review that
many of her images dealt with doing things independently, not asking for help,
and not getting her needs met. This young woman realized that an underlying
message of her healing journey was to allow people to participate in her life in
meaningful ways. She realized that she no longer had to do everything by
herself. She now knew that she could allow others to take care of her. The com-
prehensive message of the healing journey encouraged her to reclaim her ability
to connect with others in caring ways.

The woman who made the bird's nest drawing in Figure 5.2 discovered that
many of her art images related to the denial of her feelings and needs. The story
that unfolded from the images was that of a lonely young girl and later a lonely
woman who depended on food to meet all of her needs and help her soothe her
emotions. She weighed closed to 300 pounds (136 kg) and was miserable; food
could *not* do it all. During her healing journey, the woman recovered her innate

ability to use emotions as signals about what she needed in her life beyond food. She then began the process of expressing her feelings and asking assertively for her needs to be met. The woman continued using affirmations like the ones in Figures 11.3 and 11.4 to remind herself that the expression of emotions was a central step in her continued recovery. In explaining her image in Figure 11.3, she said she was still reluctant to present anything but the "perfect mother" façade to the world. In the course of therapy this woman had admitted to herself that she felt rage and frustration about not having her feelings acknowledged or her needs met. Admitting those emotions, first to herself and then to her therapist, was the first step toward being comfortable in expressing them to her husband and other important people in her life. The warm colors in Figure 11.4 helped the woman "warm up to the idea" of not holding back. She continued using art to inform herself about her emotions and needs, to share this information with her therapist, and to organize her ideas to help her express herself to significant people in her life.

Common themes that I have noted during final reviews of artwork include the following: 1. not allowing oneself to be taken care of, 2. denial and/or control of feelings and needs, 3. not feeling loved or needed, 4. using food

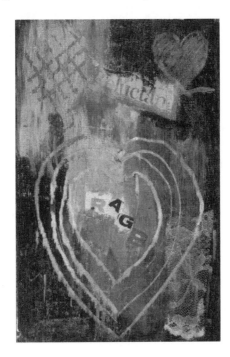

Figure: 11.3 "Reluctant Rage" – Art assists patients in identifying difficult emotions

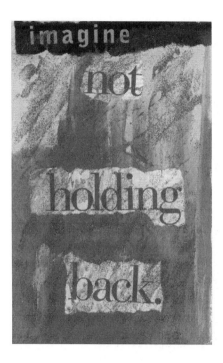

Figure: 11.4 "Imagine Not Holding Back" – Art helps patients express difficult emotions

exclusively to meet needs, and 5. fear of being close to people and being hurt. Ball and Norman (1996) noted these additional themes when using art therapy with eating disorders: 1. the inability to take in and retain anything good; 2. the potential for "good" to become damaging or to be destroyed by the bad; and 3. a fear of endless and overwhelming need within the self (p.56). There are as many different themes as there are different people. Everyone is unique and has distinctive elements to his or her life story. Identifying an underlying theme helps organize thoughts about the future. Understanding fundamental themes helps "inoculate" patients against future occurrences of thoughts and behaviors related to the theme. Awareness of themes aids patients in knowing what to look for in future emotionally charged situations when eating disordered behavior would have occurred in the past.

Patients can be taught that when they have meaning in their lives, when they are able to articulate the values and ideas that guide them, they are much less likely to feel overwhelmed by unexpected circumstances (Moore 1992). Prior to developing an articulated set of values, patients often tried to meet the unexpected by guessing what others wanted them to do. The stressful uncer-

tainty involved with guessing certainly would have provoked eating disordered thoughts and behaviors. With values and meaning in place, patients will more easily know what to do in unexpected circumstances; they will have principles and beliefs to guide them.

Themes can be revealed during the review by looking at the *types of media* that patients used and their change over time. For example, an adolescent girl struggling with anorexia nervosa initially used collage exclusively and taped her images to the paper. She would not use glue because she did not like the sticky residue on her fingers. The girl carefully trimmed each image and covered every bit of the white background paper. When asked to try a new medium she resisted for several sessions. After some time she accepted a change to oil pastels which created conscious tension in her with the oily residue they left. The oil pastels likely created unconscious tension as well because of the emotions brought up by this relatively less controlled, and more emotional, medium. Upon reviewing her art over time, the girl identified a significant shift in her willingness to trust the therapist and express her emotions after she began using this new medium. This shift marked the beginning of her wholehearted commitment to recovery.

As patients uncover the themes of their art, they will also review the learning that has taken place and the parts of themselves that have been reclaimed as a result of the healing art journey. They should be reminded that they have drawn out, lovingly tended, and understood previously feared or rejected parts of themselves (Williams 2002). During the course of treatment patients have taken a candid look at childhood influences that made them vulnerable to the eating disorder. They honestly evaluated the effects of the eating disorder on their lives. Through the art experiences they have had some of their first encounters with reclaiming emotions, effectively solving problems, accepting themselves in body, mind, and spirit, and making deeper connections with the divine presence in their lives.

A final session or two may be used for an art experience about the end of therapy. Patients should be free to express all of their emotions about the end of therapy – the excitement as well as the fear. Patients will likely feel a sense of loss at the end of the unique relationship that has characterized art-facilitated therapy. This is similar to feelings expressed by many patients at the end of psychotherapy. What might be unique at the end of art therapy are patients' thoughts and feelings that they will no longer be assisted in their creativity without the structure of the treatment. Patients may have taken on a new identity with the addition of creativity to their lives and wonder if it will be maintained without the weekly contact of therapy. Patients can be assisted in this transition by making daily affirmations in a new journal as discussed at the

beginning of this chapter. They can also be introduced to other books that can help them maintain a journal such as Lucia Capacchione's (2001a) *The Creative Journal; Inner Journeying Through Art-Journaling* (2005) by Marianne Hieb; or *The Artful Journal* by Carey *et al.* (2002).

Maintaining meaning

With each art experience in this book, the focus in reviewing the images has been on *meaning*. The meaning contained within the *process* of creating the image, the meaning attributable to the *person* creating the image, and meaning of the art *product* itself. The focus in examining the artwork has not been on beauty. It never has been implied that the art images had to be attractive. It was stated in the first chapter that the art did not have to *adorn*, it merely had to *inform*. Through the process of therapy and the review of artwork patients have discovered a wealth of information about themselves. It has been revealed that patients' lives have a deeper significance than just day-to-day occurrences. Patients have learned that they are much more than how they look or the physical bodies they inhabit.

While previously caught in the trap of eating disorders, patients may have obsessively searched for "beauty." They might have searched for "ideal beauty" in the perfect weight. They might have put off working toward personal and professional goals until they reached the perfect clothing size, that elusive measure of "beauty." Looking back now, patients will be able to see that the obsessive nature of eating disorders kept them so occupied with the search for intangible and ever changing "beauty" that there was little time for exploring the *meaning* of their lives. At the end of therapy patients realize that their lives are full of significance. They have shared that significance with therapists, family members, and friends. This uncovering and sharing of *meaning* will give patients a new direction and purpose in their lives.

Sharing meaning

The next step in recovery, and in living a full life, involves helping patients share the meaning of their lives with others. Margaret Bullit-Jonas, who recovered from binge eating disorder, wrote "When by the grace of God, you've managed to save your life, you want to pass on what you've learned" (1998, p.5). I have seen among my patients the same impulse to share their recovery journey. Sharing reinforces meaning. Sharing also helps patients express one type of purpose. Whatever else they decide to do in their lives, by sharing their recovery journey patients can help others who are struggling to overcome eating disor-

ders. They do not need to become trained eating disorder professionals to help others.

There are many respected organizations founded and managed by eating disorder professionals that can provide structure for reaching out to and helping others. Recovery involves sensing one's capacity to make meaningful contributions to society (Reindl 2001). Sharing knowledge about and faith in recovery can be one way for former patients to make a meaningful contribution. Patients can share their knowledge and beliefs with others in writing or in person. Sharing one's sense of purpose in life does not have to be done in the context of eating disorders. Some former patients want to be removed from anything to do with eating disorders. They will find different ways to become involved in the world and give of themselves. They could find fulfillment by giving their time or talents to their church or another religious or spiritual group. Some former patients become members of charitable organizations, or find a position working with children.

Resources for sharing the healing journey

This section presents an annotated list of organizations that can serve as resources for former patients to share their knowledge, beliefs, and feelings with others in the arena of eating disorders. This may be done by sharing personal art or writings related to the recovery journey, or by finding a place to volunteer time with others who are in recovery from eating disorders. Therapists should be confident before letting these patients go that they are recovered and will benefit from telling their stories. Therapists must be certain that the process of sharing their stories will not provoke new eating disorder symptoms in former patients.

Before patients go out in the world with a new purpose it is imperative that they have well-established self-care routines in place. When recovery is relatively new there can be a tendency to neglect oneself. Therapists should ensure that patients continue to assertively express feelings and needs, use a wide range of coping skills, and continue to create affirmations. They can use their creative journals to compose images of their experiences with relating their stories in a new capacity, and share these images with their therapists in "booster sessions" that reinforce the gains made in therapy and celebrate new growth outside of therapy.

www.anred.com: Anorexia Nervosa and Related Disorders (ANRED) was founded in 1979 as a nonprofit organization made up of eating disorder professionals who disseminate information about eating disorders. The website is updated monthly and contains information of all types. There is an ANRED forum that contains "poems, recovery stories, and inspirational thoughts written

by people with personal experience." The website warns former patients about jumping in too quickly to help others and cautions that former patients should make sure that they are taking care of themselves prior to helping others. In addition, patients are admonished to closely examine their motives for helping.

www.mirror-mirror.org: This is a website that has an area called the "survivor's wall" where patients can post a few words. The "survivor's wall" is a place for former patients to celebrate recovery and affirm that many people have overcome eating disorders. Because space for each individual post is limited, it can be a good place for former patients to begin public sharing of their recovery journey. A small space often feels less intimidating than a large free space for a first public posting about such a personal topic.

www.something-fishy.org: This website can be an informative and supportive place to embark on sharing one's story with a wider audience. Along with large amounts of factual information, this site has a place to post poetry and writing from people who have "made it to the other side." This can be a good place for patients to post some of their creative journal entries written in association with the art experiences. Patients can relate their entire recovery story. This website gets an untold number of hits per day by people looking for help and inspiration to overcome eating disorders. Patients can be certain that their story will be read by many and could inspire someone to begin his or her own recovery journey. Something-fishy has a special section for males. The site contains information about volunteer opportunities.

www.anad.org: The National Association of Anorexia Nervosa and Associated Disorders (ANAD) is a national organization that offers free support groups for persons with eating disorders, those in recovery from eating disorders, and their family members and friends. ANAD support groups are co-led by an eating disorder professional and a lay person who has recovered from an eating disorder. The groups can be an excellent place for former patients to recount their experiences in recovery and to continue to practice the skills that they have learned. An ANAD support group can be a forum for the honest expression of feelings and a place to share hope for continued recovery. If there is no ANAD support group located in the area, resources are provided for starting new groups. In addition, the ANAD website contains information for volunteer and advocacy opportunities. The ANAD group has taken on a "media internet guardian" function which began a campaign to alert internet service providers about pro-anorexia and bulimia websites and shut them down. According to ANAD website information, hundreds of pro-eating disorder websites have been eliminated since the group began this function in 2001.

www.eatingdisordersanonymous.org: Eating Disorders Anonymous (EDA) is a 12-step group founded along the same principles as Alcoholics Anonymous.

The group states that it seeks "balance, not abstinence" as a goal. The group meetings follow the format of other 12-step meetings, providing people with help and support through recovery. Persons with more experience in recovery become sponsors for others who are newer in recovery. There do not seem to be a large number of groups available yet, but the website contains information about how to start a group.

www.NationalEatingDisorders.org: The National Eating Disorders Association is one of the oldest eating disorder research, prevention, and recovery promoting organizations in North America. It has an annual national conference with educational opportunities for both professional and lay people. The organization offers a variety of volunteer opportunities including sponsoring National Eating Disorders Awareness Week each year in late February. There are many other ways for former patients to become involved as volunteers helping with prevention efforts. In addition, internships and regular employment opportunities also are available on a changing basis. The site contains comprehensive information about men and eating disorders.

http://About-face.org: About-face is a non-profit organization which combats negative and distorted images of women in the media. There are many ways to become involved in this organization, either locally or via the internet or letter writing. Among other things, About-face sponsors letter-writing campaigns against offensive commercials, television shows, and print advertisements. The website has a place for former patients to submit artwork or writing; it contains information about volunteer opportunities and sometimes regular employment. This organization shows former patients that their voices make a difference. They *can* help change society's inappropriate views of women one element at a time.

www.menstuff.org: Men's stuff is a website that offers information about a wide variety of issues that are of interest to men. The website provides links to articles on a many subjects including eating disorders. It also includes interviews with authors and advocates, original weekly or monthly columns on men's issues, and resources for getting involved in national or local initiatives.

This is only a partial list of organizations where former patients can make their voices heard and share their thoughts and feelings about recovery from eating disorders. Many communities have groups for *women* with eating disorders, fewer resources exist for men. Local support or recovery groups may not be structured by the organizations listed above. These might be fine organizations as well. When exploring groups and volunteer opportunities, former patients should be counseled to pay close attention to their wise internal voice. If an organization feels exploitive or otherwise harmful, they can walk away. Patients

should be encouraged to keep walking and exploring until they find a place that feels right.

Summary

As patients come to the end of therapy they will review the body of work they have produced and look for underlying themes. When themes are identified, patients have a clearer idea of the types of thoughts and behaviors that might influence them in future stressful situations. When they understand the themes that have influenced their growth and development they will be prepared to help themselves prevent relapse. Patients will find meaning in the final review of their artwork, and as therapy comes to an end they can discover ways to share that meaning with others. This chapter presented websites that can help patients identify volunteer opportunities or provide forums to describe their recovery experiences.

At the end of therapy patients are thoroughly familiar with the power of art and the use of art in recovery. They have experienced art as an effective coping skill and as a valuable way to delve into issues. In using art, patients bravely opened themselves up to a new way of communicating and receiving information. They will begin to use art to make daily affirmations that celebrate and reinforce the gift of inner wisdom recovered by their persistent hard work. Patients will know that art is always available. They can carry with them the tools to make art and use it anytime. Patients can surround themselves with opportunities to see things in new ways by visiting museums, art galleries, and craft shows. They can be encouraged to ensure that their lives continue to be filled with creative energy.

Final Considerations

Thanks to art, instead of seeing a single world, our own, we see it multiply
until we have before us as many worlds as there are original artists.
Marcel Proust (1871–1922)

Introduction

In this chapter ethical implications of using art in psychotherapy are discussed. As stated in Chapter 3, therapists must be careful not to practice outside the scope of their competence. Obtaining adequate training and supervision were recommended as two ways in which therapists could ensure themselves of ethically using new forms of treatment. Other ethical issues relating to the use of art in psychotherapy will be explored in this chapter such as: ownership of the art, transference issues, cultural implications, and patient resistance to art. In addition, the use of art in families and groups will be discussed, and the role of art in the prevention of eating disorders is examined.

Ethical considerations

It is generally accepted in the field of art therapy that the patient owns the art and therapists use digital pictures or photocopies of the artwork for record-keeping purposes. Records should include information about the image including its subject matter and context. In addition, therapy notes should contain information about the process of making the image. Both content and process information might be needed at a later date.

Malchiodi (2003) states that it is not necessary for therapists to keep original images, and that part of the joy of art therapy for the patient is possessing the artwork created. In contrast, I usually retain artwork while patients are in therapy. This way, I have access to the images when I need to refer to them, and can compile the images for the final review at the end of therapy as discussed in Chapter 11. When patients terminate therapy they can be presented with their artwork. Because I use the same size paper for most images, they can be bound in chronological order between covers. Patients are presented with a book of

their images at the final therapy session. I believe that patients' pride and joy of having persevered through therapy is enhanced by the presentation of a book such as this honoring their remarkable efforts.

As caretakers of artwork for patients during therapy, therapists are responsible for its ethical preservation and presentation. Therapists should preserve the art and show it, when necessary, in a respectful manner that guards patient confidentiality. Patients' written permission must be obtained before artwork is displayed outside the context of the agency; their informed consent should be gathered when presenting it within an agency at meetings such as case conferences. Patients' names might be covered, but if patients have a distinctive artistic style their identity may not be protected (Hammond and Gantt 1998). When giving informed consent to share their artwork, patients must be reminded that their identity might be known from their artistic style. They need to understand the full implications of disclosure especially when artwork is displayed to the public, such as in shows of patient art put on to raise awareness about eating disorders.

Therapists are responsible for protecting patient artwork just as they would protect verbal information communicated during therapy. Images replete with raw emotion or details of childhood abuse can be shocking and alarming to participants in case conference meetings or naïve observers. Therapists should present images in a way that preserves as much as possible of their original context. Contextual presentation helps reduce viewing shock (Hammond and Gantt 1998). Again, patients must be fully aware of the ways in which public display might compromise confidentiality, especially in small communities. They should be counseled to carefully consider displaying artwork that clearly distinguishes themselves or family members. Patients should be reminded that they must obtain family members' informed consent before the art can be displayed.

Resistance to art

Because they may not have used art materials since elementary school, some adults and adolescents will at first oppose the use of art. Their feelings of fear or vulnerability in a new situation might lead them to criticize art as childish and a misuse of their time. Patients who are inexperienced in art therapy might believe that the therapist will "analyze" them through their pictures. I introduce the use of art by telling patients that the art will function as a different way to communicate and gather information. As was explained in the first chapter, I make clear right brain/left brain handling of information, explaining that during the creation of art they will draw new and different information from their experiences. I reassure patients that they do not have to be artists to benefit from the

use of art in therapy. Patients can be shown examples of different sorts of line quality to demonstrate that just a simple line can reflect tension, relaxation, excitement, or other states of being.

These reassurances and rationales are usually sufficient to overcome typical resistance. Betensky (1973) points out that the therapist must not be too keen on proving the effectiveness of art. If therapists try too hard to demonstrate the powers of art they will inevitably make errors that put off patients who have had difficulty with trust issues all their lives. Such mistakes include being overly eager to offer interpretations, or insisting that a symbol or color must have a therapist-determined meaning. With experience, therapists using art in therapy will understand that the process of creating is life enhancing and healing; it does not always require words of explanation. Therapists will learn to "trust the process" of creating art (McNiff 1998). The therapist's casual manner and calm interest in the process and product will create an atmosphere of trust that allows the art to unfold naturally.

Resistance does not always take the form of outright refusal to use the art materials. Sometimes patients freely engage in the use of art media, but produce artwork containing only stereotypical art images such as hearts, rainbows, or flowers. I have had patients of all ages respond in this way, demonstrating that they were not yet ready to reveal personal information through the art. Again, the therapist must not be too eager to prove the effectiveness of art by criticizing patients' first attempts. Therapists should accept the presentation of stereotypical images and look for any slight variation of the images. When a variation is noticed, such as one heart made a different color or size, the patient can be asked to expand on that variation in a new image (Henley 1989). Thus, the patients' own comfort with deviation from the stereotypical leads the way to more personal expression in the artwork. Asking patients to use a different medium could also bring about a transformation of stereotypical images (Lusebrink 1990).

Cultural considerations

Eating disorders used to be thought of as disorders of upper-class Caucasian females. In fact, ethnic minority status was believed to be a "protective factor" against the development of eating disorders (Hinz and Roberts 1991; Smolak and Striegel-Moore 2001). In recent years there have been increasing numbers of men and women from all socioeconomic classes and ethnicities diagnosed with eating disorders (Polivy and Herman 2002). Ethnic minority status has been identified as a protective factor only if men and women value and embrace the ethnic beauty standard typical of their culture (Warren et al. 2005).

As men and women from diverse ethnic backgrounds internalize the Euro-centric beauty standard that idealizes thinness, anorexia nervosa, bulimia nervosa, and binge eating disorder have occurred with greater frequency in other cultures (Becker 2004; Presnell *et al.* 2004; Smolak and Striegel-Moore 2001). When women from non-dominant cultures internalize Eurocentric beauty myths and norms they face a threefold conflict. They struggle with the concept of thinness and how to meet and maintain it, they resist the features intrinsic to their culture of origin, and they feel pressure from members of their culture – and themselves – for having "sold out" to dominant cultural standards (Sudarsky-Gleiser 2004). Therapists must be aware of and competent to provide services in an ethnically and culturally diverse society.

Art can be a way to bridge cultural gaps because it does not depend on language for its full effect. Not speaking the dominant language could possibly cause inhibition and reservation in potential patients. According to Henderson and Gladding (1998) art can draw patients out of self-consciousness into self-awareness by using symbolic expression. In addition, art calls attention to the universal nature of graphic expression. Art helps articulate similarities in the process of creative expression, and at the same time it can highlight the distinc-tive nature of creativity in various cultures. Art helps patients integrate informa-tion from their unique experiences into meaningful records of their past, present, and future.

In some societies a direct and open communication style is not valued or allowed and thus indirect communication through art may facilitate therapy where verbal therapy would be inhibiting. Sudarsky-Gleiser (2004) points out that Eurocentric counseling professions value individual therapy. People raised in communal countries would not feel comfortable in individual counseling and would get the most assistance from a group approach. In addition, individuation of young adults is a value based in certain western cultures and often described as a goal for therapy. As discussed in Chapter 8, this independence would be an inappropriate goal in cultures where separation from parents is not valued, but viewed as disrespectful.

Cultural conflict often occurs among families of recent immigrants when members of the younger generations must translate and act as intermediaries for their parents and grandparents who do not speak the dominant language. Often these young men and women report feeling trapped between two cultures and unsure how to honor both, and yet maintain a unique personal identity. I have seen that eating disorders at times develop in immigrants who experience the tension of traversing two different traditions with diverse norms and rules for each. Art is one way in which both cultures can be expressed or contained. Through artistic expression patients can attempt to demonstrate what the expe-

rience of integrating two different cultures would be like. Different combinations of significant symbols, forms, and colors can be attempted until the experience feels more comfortable in art and in life. Again, it is not enough for therapists to be *aware of* cultural struggles and how they are related to the field of eating disorders. Therapists must be *competent* to deal with diverse patients and the impact of culture, ethnicity, minority status, and privilege on the therapeutic relationship (George, Greene, and Blackwell 2005; Smolak and Striegel-Moore 2001).

Transference issues with art

Transference in art therapy has been defined as "the collection of impulses and fantasies of the patient directed towards the therapist in the course of the creative activity" (McMurray and Schwartz-Mirman 1998, p.32). Transference can be seen especially in the patient's rigid repetition of an image or pattern of creation. This rigid behavior interferes with the progression of therapy and must be addressed. According to psychoanalytical thought, the interpretation and working through of transference issues allows greater flexibility of the creative process and thus increased psychological growth (McMurray and Schwartz-Mirman 1998).

The therapeutic relationship in art therapy brings with it other unique transference concerns. Transference can be a valuable *asset* in therapy utilizing art, as discussed by the pioneering art therapist Mala Betensky (1973). According to Betensky one positive transference issue resides in the therapist's offering of art materials to patients. She stated that when real and challenging materials are given to patients the therapist is perceived as giving the patient a gift. The gift is the therapist's faith in the patient's ability to create. This faith might not be so clearly established in verbal psychotherapy. Betensky points out that therapists indicate through the recurrent offering of media and instruction that they are available to help, but have faith that patients can create on their own. The fundamental message of the gift of art media is that the patient has something unique and important to convey.

It is my opinion that other unique transference issues occur when utilizing art in therapy. These topics include therapists' preferences for particular types of information processing, and therapists' comfort with the art media. These two areas of concern interact because the type of media used often leads to a particular way of processing information and vice versa. It was stated in Chapter 3 that therapists should experiment and be comfortable with all varieties of art materials. Betensky (1973) wrote that by their nature certain media invite us to create while others put us off. Therapists' lack of awareness of their personal preferences could inhibit their ability to use all varieties of art media with patients.

Familiarity with media might not *change* strong preferences, but it will increase therapists' awareness that they have to overcome preferences or aversions to broaden their use of art materials.

Therapists should also be aware that they have preferences in the way that they most readily process information. Some therapists work best intellectually. They will have many facts at their disposal and when using art will tend to prefer restrictive media such as pencil or collage. If they are not aware of these preferences, and exclusively use collage with patients, they might not be helpful to patients who need to process information more emotionally and would benefit from a more fluid media such as paint or pastel. It often has been said in the fields of counseling and psychotherapy that therapists cannot take their patients where they cannot go themselves. This extends to media properties and information processing preferences. Therapists should understand media properties and be competent using a range of art materials so that they can knowledgeably and sensitively use the methods that will best benefit their patients. If therapists are not comfortable and familiar with a variety of media and information processing strategies, they will avoid those less known and less appreciated, and deprive their patients of the full therapeutic experience.

Using art with families

Art tends to be an equalizer in families because it requires family members to communicate in ways that they have not before. The youngest and oldest family members are on even playing field when the use of art is introduced into family communication (Riley and Malchiodi 2003). With usual modes of communication interrupted, different information can be sent and received. I have counseled families in several ways. Sometimes all family members have worked on individual but similar art pieces, other times they have worked on combined projects. At times, patient artwork, carried out individually with the therapist, is brought into a family session to demonstrate a point. For example, the adolescent girl who drew the checkerboard trap of anorexia nervosa shown in Figure 1.2 used her individually created art in family therapy as a means of deepening her parents' understanding of her ambivalence about recovery.

Some of the art experiences that I have used with families include those written about in the previous chapters. For instance, family members each have made abstract family portraits. Individual perceptions of the family can be compared and contrasted by viewing all of the images. With the help of art, subjects might be introduced that have not been discussed before or which have been denied or dismissed with words. An adolescent girl had not been able to use words effectively to tell her father how his alcohol abuse made her feel. Her attempts to talk with him were met with anger and rejection. She was able to

demonstrate the information using art and her father was able to see the effects of his alcoholism, which he had denied in the past. The girl's abstract family collage is shown in Figure 12.1. In it the girl concretely demonstrated the isolation she and the rest of the family felt. The father's alcoholism is depicted as a large red sphere raining "pain." The mother is the brown "fence" trying to shelter the family and hold it together. One sister has run away; she is the small sphere outside the fence. A brother stayed "on the fence." The girl depicted herself as having a hole in the middle and reaching out to the outside world. With the help of the therapist and the art, the girl explained to her father that the hole was what she was trying to fill with food – a gaping hole where his love should have been.

In addition to single images or images created by individual family members, families can be asked to perform a task together. I have had families build bridges together, construct common worlds, sculpt their families, and use art to communicate nonverbally. The family dynamics are easily viewed in these types of family projects with each family member taking on a familiar role. Art makes visible roles such as helplessness or overdoing which can be identified as the family carries out the task and also seen in the finished art product. When the task is complete each family member can generate a list of word associations to the process and product. These words will help them remember important points in a discussion of the creative process and family dynamics that follows. Family group projects clearly demonstrate the ways in which a family functions effectively or unsuccessfully. This type of project can represent the beginning of constructive change that can be prescribed and reinforced in further family art therapy sessions.

Figure 12.1: Abstract collage in family therapy – Art can express what has been denied or dismissed in words

Using art with groups

With advice and support from other families facing similar issues, multi-family groups are an effective environment for identifying problems and generating change. In multi-family groups spouses, parents, and siblings of patients meet with other families to receive and exchange information and empathy. Root (1989) described a method of family sculpture that I have found especially effective for demonstrating family roles in multi-family groups. In family sculpture, patients and their family members use clay to create their families in an abstract manner. Group members then take turns posing people from the group – family members or other people – to match the clay sculpture. Group members viewing the sculpture talk about what the family looks like from the outside. The people involved in the sculpture talk about what the family feels like on the inside. Each family poses and discusses in turn. Again, the goal of such an experience is to help families take the first steps toward improving communication and changing nonproductive or harmful roles.

In the *Practice Guideline for the Treatment of Patients with Eating Disorders*, the American Psychiatric Association recommended group psychotherapy for patients as an effective means to reduce the shame and isolation characteristic of eating disorders (American Psychiatric Association, 2000b). Eating disorders are solitary and patients report feeling socially isolated and alone. General group therapeutic factors identified by Yalom (1995) such as imparting information, universality, altruism, and the instillation of hope are necessary factors in recovery. Patients often have never encountered another person with an eating disorder and report tremendous shame at feeling so deviant from others. Through meeting other patients at various stages of recovery, sharing their stories, and participating in the treatment of others, patients gain hope that recovery is a real possibility. The group becomes a microcosm where patients try out new and adaptive behaviors and get feedback on changes from their peers.

Using art in groups provides added dimensions beyond the primary therapeutic factors common to group psychotherapy. When a group first meets or a new member joins, specific ground rules for the use and clean up of art materials must be defined. As was explained in Chapter 1, the added structure of well-defined rules provides a framework for helping patients organize their emotional and behavioral responses in group art therapy (Ball and Norman 1996). The way in which art is introduced into the group process also must be established.

Group art therapy seems to work best if the group first comes together in a circle to "check in" about feelings and themes (Cooper and Milton 2003; Johnson and Parkinson 1999). According to McNiff (1981) this "circling" evokes a feeling of protectiveness and order in the group. After all group

members have said a few words about their mood state or mind state, the art assignment is given and individual work begun. Group members come together at the end of the group to discuss their experiences with the art. Johnson and Parkinson (1999) reported that when they began group sessions by allowing group members to come in and immediately begin working with art materials the experience was isolating and less therapeutic. They explained that starting and ending group sessions in a circle helped increase group cohesiveness and the therapeutic value of the art experiences.

Making art in group psychotherapy gives permission for group members to work individually on their own issues as well as participate in the group dynamics (Johnson and Parkinson 1999). Group members begin to understand from the outset of therapy that they are dependent on the group and yet separate from it. With time and experience, art therapy group members learn that they can be dependent on others to help them process their images, or they can function effectively separately. This situation mimics life issues of separation and individuation in families, society, and therapy.

Group members benefit from both the *process* and *content* of others' artwork. In describing the *process* of group art therapy, Cooper and Milton (2003) stated that some patients become role models, with more experienced group members showing new members how to approach the use of art in therapy and how to respond to their own and other patient's creations. Cooper and Milton (2003) state that over time less organized patients "borrow ego strength" from more organized patients and higher level functioning is seen "in their behavior, the organization of their artwork, and the quality of verbalization about their artwork" (p.173). Group members watch and imitate each other in developing new and appropriate coping mechanisms.

Group members may not be able to tolerate the emotional or psychological *content* of their own artwork, but others may profit from viewing and responding to it (Johnson and Parkinson 1999; Levens 1990). Seeing others respond positively with their own symbolic associations to their art, group members learn to be more tolerant and accepting of themselves. Patients might have difficulty recognizing the significance of their own work, but may relate to a similar projection in another's image. In verbal group therapy patients may resist others' spoken ideas which they have thought and rejected themselves. In group art therapy they could be drawn in by another patient's image that speaks to them in ways they would not have allowed to become conscious thought in their own mind. In group art therapy patients have the opportunity to see universal symbols created by others and test how they apply in their own lives. As an example, when one group member painted the safety and serenity of a meadow, others responded that they also might find a meadow relaxing and safe.

Copying and competition are additional issues that must be addressed in group art therapy. I approach copying by telling group members that everyone benefits from sharing ideas. When taking inspiration from a fellow patient's symbol, one group member will never copy another's image *exactly*. The person "copying" will always imbue the copied symbol with his or her own associations or feelings. Sometimes I have asked group members to draw or paint the same object. Invariably, the resulting images and the dialogue provoked by them are different, demonstrating that artists add their own thoughts and feelings about an object to its representation.

Competition occurs when one group member stands out as having greater ability than others and group members decline to participate, or engage only half-heartedly, in the art activities. Cooper and Milton (2003) recommended confronting the issue of competition head on and using the discussion as a springboard for talking about competition with siblings or peers. Competition can be a central issue for patients with anorexia nervosa and bulimia nervosa. If patients are taught how to manage their competitive strivings in appropriate ways, they will have made great gains in recovery.

The impact of group members upon one another, or the effects of outside forces on group members, can be examined through art experiences performed together. A mural exposing and scrutinizing media influences can be created as a combined effort (Matto 1997). Patients add drawn or collage images to express their feelings and opinions about media influences on body image. The effect of working in a group adds tremendous energy to the atmosphere, greatly increases group cohesion, and inspires collective problem-solving. On many occasions I have witnessed patients profiting greatly from sharing their "collective conscious" which is McConeghey's (2003) term for beliefs, attitudes, and emotions held in common as a result of participating in the same culture.

The effects of group members upon one another can be examined in a different sort of art experience. An interesting technique that I have used is to have each patient choose one colored marker and begin a scribble drawing. Drawings are passed to adjacent group members who add lines and begin to develop the scribble drawing. The drawings are passed around the circle until they reach the original patient. The resulting image is remarkably different than the initial scribble. Patients can talk about the process from the point of view of the patient whose drawing was completed by others, or the patient who embellished another's work. This experience graphically demonstrates the effects of group members on each other. Patients understand how their words and actions directly impact one another in group therapy and in life.

This experience also can be used as a way to terminate a time-limited group and can be combined with a poem made in a similar fashion. The first patient

writes the opening line of a poem and passes it to the patient next to him. Each group member adds one line until the completed poem is given back to the original writer. All patients leave the group with a small part of each of them invested in an image and a poem. An example of the group scribble drawing is shown in Figure 12.2. This drawing was created at the end of an eating disorders treatment group. The accompanying poem was as follows:

The intrusion of man …
… just as you knew it had to come.
It can be cleaned by the rain
… just as you knew it could be healed.
It can be eased by the tears
… and soon comes the sunshine again.

From what I have seen over the years, the majority of poems and images made at the end of group therapy, like this one, show optimism about recovery and continued healing. These images and poems are a reminder of the camaraderie and caring that characterized the group experience. They can be used to reinforce commitment to the healing journey.

Art and the prevention of eating disorders
Early eating disorder primary prevention programs followed substance abuse prevention models with similar outcomes and criticisms. They were usually delivered to a wide audience in the context of school classrooms. The initial

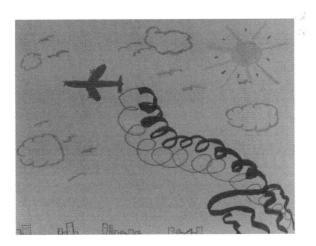

Figure 12.2: Group art image – Art provides a reminder of the caring and camaraderie of group therapy

programs focused on the disorders: their symptoms, causes, and consequences. Primary prevention programs resulted in varied measures of success. Results sometimes demonstrated changes in attitudes about eating disorders or body image. Sometimes there were noted increases in eating disordered attitudes, and the programs were criticized for including too much symptom-specific information that may have increased the severity of risk factors (Crago *et al.* 2001; Pearson, Goldklang, and Striegel-Moore 2002).

Secondary prevention programs focus on providing information and skills to high risk young people (Becker *et al.* 2004; Varnado-Sullivan and Zucker 2004). These programs have yielded positive results as demonstrated by lasting changes in eating disorder attitudes or improved body image (Pearson *et al.* 2002). Targeted programs are more labor intensive and difficult to implement, requiring a more highly trained staff and more financial resources. Nevertheless, many agree that secondary prevention programs targeting at-risk audiences have an important place in the field of eating disorder prevention (Levine and Piran 2001).

The concurrence among writers about prevention is that universal life skills training programs aimed at increasing protective factors and decreasing risk factors produce the longest lasting and most reliable changes in attitudes and behaviors (Crago *et al.* 2001; Levine and Piran 2001; Pearson *et al.* 2002). These sorts of broad-based programs are protective against many different disorders because they teach a range of competencies such as problem-solving skills, decision-making models, self-acceptance, and stress management. The art experiences described in this book can easily be adapted for use with late elementary, middle or high school aged students, as well as college students. I have used the *Fat is ... Thin is ... drawings* discussed in Chapter 8 to help middle school students understand and talk about their body image beliefs and biases (Hinz 1995).

Universal prevention programs could include the *Problem-solving collage*, the *Decision-making collage*, *Collage of emotions and faces*, and *Mandala drawings* of all sorts. The inclusion of art activities in life skills prevention programs enhances the experience for participants by giving them a more active role and thus allowing them to feel more responsible for the changes in attitude and behavior that occur. Participants come away from the prevention program with a piece of artwork and perhaps written associations created about the life skill taught. They have a personal, permanent, and significant symbol of the experience.

Prevention efforts should include parents, peers, and school personnel in an effort to change not just the participants of the programs, but also the persons around them who unwittingly support eating disordered attitudes (Crago *et al.* 2001; Levine and Piran 2001; Varnado-Sullivan and Zucker 2004). Levine and

Piran (2001) argue that the best prevention programs also take into account and discuss the specific culture in which the program is given. In that case, a high school of performing arts will have significantly different body image concerns than an academically rigorous prep school. Smolak and Striegel-Moore (2001) stressed that prevention programs serving culturally diverse populations should focus on themes common to all such as the negative effects of childhood teasing on body image, but should incorporate race specific topics as well. Prevention program coordinators must be knowledgeable about the specific group to which they are presenting, include faculty and parents in the program if possible, and provide a dynamic and participatory program where individuals feel empowered to act as active advocates for change. Art can mobilize and direct group energy and discussion.

Summary

This chapter presented information on a variety of topics related to the ethical use of art in therapy and patients' responses to the use of art. The images created in therapy belong to the client and should be treated with the same respect and confidentiality as information gathered in verbal psychotherapy. Patients should be warned about the ways in which art can compromise confidentiality differently than verbal therapy. Resistance to the use of art also should be respected and gently dealt with to maintain patient dignity. Cultural issues of all sorts were discussed because eating disorders are affecting more and more diverse populations. Therapists must not only be aware of ethnic and cultural issues, they must be able to treat an increasingly diverse patient population. This chapter discussed the use of art in families and groups and the ways in which art functions as a leveler among family members and group participants. The ability to communicate with universal symbols expands the type of information sent and received in typical interpersonal interactions. The use of art can enhance prevention programs by making the experience more active and participatory. Family members, school personnel, and peers can be involved in prevention efforts that use art to increase resiliency and decrease the risk for eating disorders.

Final thoughts

Persons with eating disorders are a challenging and highly rewarding group of patients with which to work. Although there can be a great deal of denial at the beginning of treatment, once a problem has been identified and a commitment made to change it, eating disorder sufferers are an eager and motivated group of patients. The use of art can be a way to help break through the denial and awkward silences that frequently characterize the early stages of treatment, par-

ticularly with adolescents. Art can help patients identify the problem and its many facets. Creating an image of the eating disorder separates it from themselves. Images help patients name the problem, detail its effects on their lives, and agree to work on it. Commitment to therapy comes from patients seeing their own thoughts, beliefs, biases, and feelings take on color and shape in the pictures they create.

When the images come from within, patients spend less time fighting against them and more quickly make the commitment to changing thoughts and behaviors that are not working effectively in their lives. During treatment patients will occasionally experience ambivalence about change. The art will aid in explaining and containing the ambivalence that patients feel about giving up a well-learned habit. The eating disorder gave the illusion of comfort and control; it is understandable that patients gravitate back to it at stressful times during treatment. By using art patients do not have to verbally defend their actions. They can *visually* demonstrate their ambivalence and create a response piece about how to deal with it. Finally, patients will be able to use art in the future to calm themselves and to solve problems. They will make affirmations for as long as they need to, reinforcing the healing that they have experienced. Learning to use art to enhance personal growth is a skill that will remain with patients for the rest of their lives.

References

Alberti, R.E. and Emmons, M.L. (2001) *Your Perfect Right: Assertiveness and Equality in Your Life and Relationships*, 8th edn. Atascadero, CA: Impact Publishers.

Allison, D.B. and Weber, M.T. (2003) "Treatment and prevention of obesity: What works, what doesn't work and what might work." *Lipids 38*, 2, 147–155.

American Art Therapy Association (2005) Website at http://www.arttherapy.org/

American Psychiatric Association (2000a) *Diagnostic and Statistical Manual of Mental Disorders*, 4th edn., text rev. Washington DC: American Psychiatric Association.

American Psychiatric Association (2000b) *Practice Guideline for the Treatment of Patients with Eating Disorders*, 2nd edn. Washington DC: American Psychiatric Association.

American Psychological Association (2002) "Ethical principles of psychologists and code of conduct." *American Psychologist 57*, 12, 1060–1073.

Andersen, A., Cohn, L., and Holbrook, T. (2000) *Making Weight: Healing Men's Conflicts with Food, Weight, and Shape*. Carlsbad, CA: Gurze Books.

Artress, L. (1995) *Walking a Sacred Path: Rediscovering the Labyrinth as a Spiritual Tool*. New York: Riverhead Books.

Aviera, A. (2002) "Culturally sensitive and creative therapy with Latino clients." *California Psychologist*, July/August, 18.

Azara, N. (2002) *Spirit Taking Form: Making a Spiritual Practice of Making Art*. Boston: Red Wheel/Weiser.

Bachar, E., Latzer, Y., Canetti, L., Gur, E., Berry, E.M., and Bonne, O. (2002) "Rejection of life in anorexic and bulimic patients." *International Journal of Eating Disorders 31*, 1, 43–48.

Ball, B. (2002) "Moments of change in the art therapy process." *The Arts in Psychotherapy 29*, 2, 79–92.

Ball, J. and Norman, A. (1996) "Without the group I'd still be eating half the co-op: An example of groupwork with women who use food." *Groupwork 9*, 1, 48–61.

Barry, L. (2002) *One Hundred Demons*. Seattle, WA: Sasquatch Books.

Becker, A.E. (2004) "Television, disordered eating, and young women in Fiji: Negotiating body image and identity during rapid social change." *Culture, Medicine, & Psychiatry 28*, 4, 533–559.

Becker, A.E., Franko, D.L., Nussbaum, K., and Herzog, D.B. (2004) "Secondary prevention for eating disorders: The impact of education, screening, and referral in a college-based screening program." *International Journal of Eating Disorders 36*, 2, 157–162.

Becker-Stoll, F. and Gerlinghoff, M. (2004) "The impact of a four-month day treatment programme on alexithymia in eating disorders." *European Eating Disorders Review 12*, 3, 159–163.

Bellafante, G. (2003) "When midlife seems just an empty plate." *New York Times*. 9 March 2003.

Benson, H. and Proctor, W. (2003) *The Breakout Principle: How to Activate the Natural Trigger That Maximizes Creativity, Athletic Performance, Productivity and Personal Well-Being*. New York: Scribner.

Betensky, M.G. (1973) *Self-Discovery Through Self-Expression: Use of Art Psychotherapy with Children and Adolescents*. Springfield, IL: Charles C. Thomas.

Betensky, M.G. (1995) *What Do You See? Phenomenology of Therapeutic Art Expression*. London: Jessica Kingsley Publishers.

179

Bilich, M. (1983) *Weight Loss From the Inside Out: Help for the Compulsive Eater*. San Francisco: Harper & Row Publishers.

British Association of Art Therapists (2005) Website at http://www.baat.org/

Bruch, H. (1973) *Eating Disorders: Obesity, Anorexia Nervosa, and the Person Within*. New York: Basic Books, Inc.

Bullit-Jonas, M. (1998) *Holy Hunger: A Memoir of Desire*. New York: Alfred A. Knopf.

Burns, D.D. (1999) *Feeling Good: The New Mood Therapy*, rev edn. New York: Avon.

Burns, R. (1982) *Self-Growth in Families: Kinetic Family Drawings*. New York: Brunner-Routledge.

Calogero, R.M., Davis, W.N., and Thompson, J.K. (2005) "The role of self-objectification in the experience of women with eating disorders." *Sex Roles 52*, 1, 43–50.

Canetti, L., Bachar, E., and Berry, E.M. (2002) "Food and emotion." *Behavioural Processes 60*, 2, 157–164.

Capacchione, L. (2001a) *The Creative Journal: The Art of Finding Yourself*, 2nd edn. Franklin Lakes, NJ: New Page Books.

Capacchione, L. (2001b) *Living with Feeling: The Art of Emotional Expression*. New York: Tarcher/Putnam.

Carey, M., Fox, R., and Penney, J. (2002) *The Artful Journal: A Spiritual Quest*. New York: Watson/Guptill Publications.

Carroll, K.M., Nich, C., and Ball, S.A. (2005) "Practice makes progress? Homework assignments and outcomes in treatment of cocaine dependence." *Journal of Consulting and Clinical Psychology 73*, 4, 749–755.

Cassidy, J. (1994) "Emotion regulation: Influences of attachment relationships." *Monographs of the Society for Research in Child Development 59*, 228–283.

Cassou, M. and Cubley, S. (1995) *Life, Paint and Passion: Reclaiming the Magic of Spontaneous Expression*. New York: Tarcher/Putnam.

Connors, M.E. (2001) "Relationship of sexual abuse to body image and eating problems." In J.K. Thompson and L. Smolak (eds) *Body Image, Eating Disorders, and Obesity in Youth*. Washington DC: American Psychological Association.

Cooper, B.F. and Milton, L.B. (2003) "Group art therapy with self-destructive young women." In D.J. Wiener and L.K. Oxford (eds) *Action Therapy with Families and Groups: Using Creative Arts Improvisation in Clinical Practice*. Washington DC: American Psychological Association.

Cornell, J. (1990) *Drawing the Light from Within*. New York: Prentice Hall.

Cornell, J. (1994) *Mandala: Luminous Symbols for Healing*. Wheaton, IL: Quest Books.

Crago, M., Shisslak, C.M., and Ruble, A. (2001) "Protective factors in the development of eating disorders." In R.H. Striegel-Moore and L. Smolak (eds) *Eating Disorders: Innovative Directions in Research and Practice*. Washington, DC: American Psychological Association.

Cudney, M.R. (1983) *Self-defeating Behaviors: Free Yourself from the Habits, Compulsions, Feelings, and Attitudes That Hold You Back*. San Francisco: Harper.

Curry, N.A., and Kasser, T. (2005) "Can coloring mandalas reduce anxiety?" *Journal of the American Art Therapy Association 22*, 2, 81–85.

Dacey, J.S., and Lennon, K.H. (1998) *Understanding Creativity: The Interplay of Biological, Psychological, and Social Factors*. New York: Jossey-Bass.

Davis, C., Shuster, B., Blackmore, E., and Fox, J. (2004) "Looking good – Family focus on appearance and the risk for eating disorders." *International Journal of Eating Disorders 35*, 2, 136–144.

Diaz, A. (1992) *Freeing the Creative Spirit: Drawing on the Power of Art to Tap the Magic Wisdom Within*. San Francisco: Harper.

DK Illustrated Oxford Dictionary (2003) London: Dorling Kindersley.

Edwards, B. (1989) *Drawing on the Right Side of the Brain*. Los Angeles: Jeremy P. Tarcher, Inc.

Ekman, P. (2003) *Emotions Revealed*. New York: Henry Holt Publishers.

Ellenbecker, T.K. (2003) "Effect of content choice freedom on drawer's creative engagement."
 Journal of the American Art Therapy Association 20, 1, 22–27.
Espina, A. (2003) "Alexithymia in parents of daughters with eating disorders: Its relationship with
 psychopathology and personality variables." *Journal of Psychosomatic Research 55*, 6, 553–560.
Fairburn, C. (1995) *Overcoming Binge Eating*. New York: Guilford Press.
Farrelly-Hansen, M. (2001) "Nature: Art therapy in partnership with the earth." In M.
 Farrelly-Hansen (ed.) *Spirituality and Art Therapy: Living the Connection*. London: Jessica Kingsley
 Publishers.
Fincher, S.F. (1991) *Creating Mandalas for Insight, Healing, and Self-Expression*. Boston, MA:
 Shambhala.
Fisher, J.O. and Birch, L.L. (2001) "Early experience with food and eating: Implications for the
 development of eating disorders." In J.K. Thompson and L. Smolak (eds) *Body Image, Eating
 Disorders, and Obesity in Youth*. Washington DC: American Psychological Association.
Fleming, M.M. (1989) "Art therapy and anorexia: Experiencing the authentic self." In L.M.
 Hornyak and E.K. Baker (eds) *Experiential Therapies for Eating Disorders*. New York: Guilford
 Press.
Forman, M. (2005) "Characteristics of middle-aged women in inpatient treatment for eating
 disorders." *Eating Disorders: The Journal of Treatment and Prevention 13*, 3, 231–243.
Freedman, R. (2002) *Bodylove: Learning to Like Our Looks and Ourselves*. Carlsbad, CA: Gurze Books.
Freeman, L.M.Y. and Gil, K.M. (2004) "Daily stress, coping, and dietary restraint in binge eating."
 International Journal of Eating Disorders 36, 2, 204–212.
Furth, G.M. (1988) *The Secret World of Drawings: Healing Through Art*. Boston: Sigo Press.
Ganim, B. (1999) *Art and Healing: Using Expressive Art to Heal Your Body, Mind, and Spirit*. New York:
 Three Rivers Press.
George, J., Greene, B., and Blackwell, M. (2005) "Three voices on multiculturalism in the art
 therapy classroom." *Journal of the American Art Therapy Association 22*, 3, 132–138.
Gerding, J. (2001) *Drawing to God: Art as Prayer, Prayer as Art*. Notre Dame, IN: Sorin Books.
Gillespie, J. (1996) "Rejection of the body in women with eating disorders." *The Arts in
 Psychotherapy 23*, 2, 153–161.
Gimlin, D.L. (2002) *Body Work: Beauty and Self Image in American Culture*. Berkeley, CA: University of
 California Press.
Goldberg, N. (2002) *Living Color: A Writer Paints Her World*. New York: Bantam Books.
Goldkopf-Woodtke, M. (2001) "Recovery." In B.P. Kinoy (ed.) *Eating Disorders: New Directions in
 Treatment and Recovery*, 2nd edn. New York: Columbia University Press.
Green, J.D. (1993) *ArtEffects*. New York: Watson-Guptill Publications.
Greenberger, D. and Padesky, C. (1995) *Mind Over Mood: Change How You Feel by Changing the Way
 You Think*. New York: Guilford Press.
Greenspan, M. (2004) *Healing Through the Dark Emotions: The Wisdom of Grief, Fear, and Despair*.
 Boston: Shambhala.
Grogan, S. (1999) *Body Image: Understanding Body Dissatisfaction in Men, Women, and Children*.
 London: Routledge.
Hammond, L.D. and Gantt, L. (1998) "Using art in counseling: Ethical considerations." *Journal of
 Counseling and Development 76*, 3, 271–276.
Hayaki, J., Friedman, M.A., and Brownell, K.D. (2002) "Emotional expression and body
 dissatisfaction." *International Journal of Eating Disorders 31*, 1, 57–62.
Henderson, D.A. and Gladding, S.T. (1998) "The creative arts in counseling: A multicultural
 perspective." *The Arts in Psychotherapy 25*, 3, 183–187.
Henley, D.R. (1989) "Stereotypes in children's art." *The American Journal of Art Therapy 27*,
 116–125.
Henriques, A.R. (1997) *The Book of Mechtilde*. New York: Alfred Knopf.

Hepp, U., Spindler, A. and Milos, G. (2005) "Eating disorder symptomatology and gender role orientation." *International Journal of Eating Disorders 37*, 3, 227–233.

Herzog, D.B. and Delinsky, S.S. (2001) "Classification of eating disorders." In R.H. Striegel-Moore and L. Smolak (eds) *Eating Disorders: Innovative Directions in Research and Practice.* Washington, DC: American Psychological Association.

Hieb, M. (2005) *Inner Journeying Through Art-Journaling.* London: Jessica Kingsley Publishers.

Hill, J.O., Catenacci, V., and Wyatt, H.R. (2005) "Obesity: Overview of an epidemic." *Psychiatric Clinics of North America 28*, 1–23.

Hinz, L.D. (1995) "Primary prevention of eating disorders." Paper presented at the Association of Women in Psychology meeting, March 4, Indianapolis, IN.

Hinz, L.D. and Ragsdell, V. (1990) "Using masks and video in group psychotherapy with bulimics." *The Arts in Psychotherapy 17*, 3, 259–261.

Hinz, L.D. and Roberts, R. (1991) "Racial differences in body image and risk for eating disorder." Paper presented at the 99th Annual Convention of the American Psychological Association, August 19–22, San Francisco, CA.

Hoek, H.W. and van Hoeken, D. (2003) "Review of the prevalence and incidence of eating disorders." *International Journal of Eating Disorders 34*, 4, 383–396.

Israel, C.C. and Friedman, B.H. (2004) "Autonomic specificity of discrete emotion and dimensions of affective space: A multivariate approach." *International Journal of Psychophysiology 51*, 2, 143–153.

Janzing, H. (1998) "The use of the mask in psychotherapy." *The Arts in Psychotherapy 25*, 3, 151–157.

Jensen, E. (2001) *Arts with the Brain in Mind.* Alexandria, VA: Association for Supervision and Curriculum Development.

Johnson, K. and Parkinson, S. (1999) "There's no point in raging on your own: Using art therapy in groups for people with eating disorders." *Group Analysis 32*, 1, 87–96.

Jung, C.G. (1964) *Man and his Symbols.* New York: Doubleday.

Jung, C.G. (1969) "Mandalas." *Archetypes of the Collective Unconscious*, 2nd edn. Volume 9 of the Collected Works. New York: Bollingen Foundation.

Junge, M.B. and Asawa, P.P. (1994) *A History of Art Therapy in the United States.* Mundelein, IL: The American Art Therapy Association, Inc.

Kagin, S.L. and Lusebrink, V.B. (1978) "The expressive therapies continuum." *Art Psychotherapy 5*, 2, 171–180.

Kantor, A. (1971) *The Book of Alfred Kantor.* New York: McGraw-Hill.

Kashubeck-West, S. and Saunders, K. (2001) "Body image." In J.J. Robert-McComb (ed.) *Eating Disorders in Women and Children: Prevention, Stress Management and Treatment.* Boca Raton, FL: CRC Press.

Katzman, D.K. (2005) "Medical complications in adolescents with anorexia nervosa: A review of the literature." *International Journal of Eating Disorders 37* (Suppl), S52–S59.

Kazantzis, N., Lampropoulos, G.K., and Deane, F.P. (2005) "A national survey of practicing psychologists' use and attitudes toward homework in psychotherapy." *Journal of Consulting and Clinical Psychology 73*, 4, 742–748.

Key, A., George, C.L., and Beattie, D. (2002) "Body image treatment within an inpatient program for anorexia nervosa: The role of mirror exposure in the desensitization process." *International Journal of Eating Disorders 31*, 2, 185–190.

King, N. (2001) "College women: Reflections on recurring themes and a discussion of the treatment process and setting." In B.P. Kinoy (ed.) *Eating Disorders: New Directions in Treatment and Recovery*, 2nd edn. New York: Columbia University Press.

Kinoy, B.P. (2001) *Eating Disorders: New Directions in Treatment and Recovery*, 2nd edn. New York: Columbia University Press.

Kjelsas, E., Borsting, I., Gudde, C. (2004) "Antecedents and consequences of binge eating episodes in women with an eating disorder." *Eating & Weight Disorders 9*, 1, 7–15.

Klauser, H.A. (2000) *Write it Down, Make it Happen: Knowing What You Want and Getting it.* New York: Touchstone Books.

Knapp, C. (2003) *Appetites: Why Women Want.* New York: Counterpoint.

Koenig, H.G. (1999) *The Healing Power of Faith: Science Explores Medicine's Last Great Frontier.* New York: Simon and Schuster.

Kramer, E. (1971) *Art as Therapy with Children.* New York: Schocken Books.

Krueger, D.W. (1989) *Body Self and Psychological Self: A Developmental and Clinical Integration of Disorders of the Self.* New York: Brunner/Mazel.

Kucharska-Pietura, K., Nikolaou, V., Masiak, M., and Treasure, J. (2003) "The recognition of emotion in the faces and voice of anorexia nervosa." *International Journal of Eating Disorders 35*, 1, 42–47.

Landgarten, H.B. (1994) *Magazine Photo Collage: A Multicultural Assessment and Treatment Technique.* New York: Bruner/Mazel.

Langer, E.J. (2005) *On Becoming an Artist: Reinventing Yourself Through Mindful Creativity.* New York: Ballantine Books.

Lawrence, B.K. (1999) *Bitter Ice: A Memoir of Love, Food and Obsession.* New York: William Morrow and Co.

Leit, R.A., Gray, J.J., and Pope, H.G. (2002) "The media's representation of the ideal male body: A cause for muscle dysmorphia?" *International Journal of Eating Disorders 31*, 3, 334–338.

Levant, R.F. (2003) "Treating male alexithymia." In L.B. Silverstein and T.G. Goodrich (eds) *Feminist Family Therapy: Empowerment in Social Context.* Washington, DC: American Psychological Association.

Levens, M. (1990) "Borderline aspects in eating disorders: Art therapy's contribution." *Group Analysis 23*, 4, 277–284.

Levens, M. (1995a) "Art therapy and psychodrama with eating disordered patients: The use of concrete metaphors for the body." In D. Dokter (ed.) *Arts Therapies and Clients with Eating Disorders: Fragile Board.* London: Jessica Kingsley Publishers.

Levens, M. (1995b) *Eating Disorders and Magical Control of the Body: Treatment Through Art Therapy.* London: Routledge.

Levine, M.P. and Piran, N. (2001) "The prevention of eating disorders: Toward a participatory ecology of knowledge, action, and advocacy." In R.H. Striegel-Moore and L. Smolak (eds) *Eating Disorders: Innovative Directions in Research and Practice.* Washington, DC: American Psychological Association.

Levine, M.P. and Smolak, L. (2001) "Primary prevention of body image disturbance and disordered eating in childhood and adolescence." In J.K. Thompson and L. Smolak (eds) *Body Image, Eating Disorders, and Obesity in Youth.* Washington DC: American Psychological Association.

Lewis, L. (2001) "Spirituality." In J.J. Robert-McComb (ed.) *Eating Disorders in Women and Children: Prevention, Stress Management and Treatment.* Boca Raton, FL: CRC Press.

London, P. (1989) *No More Secondhand Art: Awakening the Artist Within.* Boston: Shambhala.

Lovallo, W.R. (1997) *Stress and Health: Biological and Psychological Interactions.* Thousand Oaks, CA: Sage Publications.

Lubbers, D. (1991) "Treatment of women with eating disorders." In H.B. Landgarten and D. Lubbers (eds) *Adult Art Psychotherapy: Issues and Applications.* New York: Brunner/Mazel.

Lundh, L.G. (2004) "Perfectionism and acceptance." *Journal of Rational-Emotive & Cognitive Behavior Therapy 22*, 4, 255–269.

Lusebrink, V.B. (1990) *Imagery and Visual Expression in Therapy.* New York: Plenum Press.

Luzzato, P. (1995) "Art therapy and anorexia: The mental double trap of the anorexic patient. The use of art therapy to facilitate psychic change." In D. Dokter (ed.) *Arts Therapies and Clients with Eating Disorders: Fragile Board*. London: Jessica Kingsley Publishers.

MacBrayer, E.K., Smith, G.T., McCarthy, D.M., Demos, S., and Simmons, J. (2001) "The role of family of origin food-related experiences in bulimic symptomatology." *International Journal of Eating Disorders 30*, 2, 149–160.

Mahon, J., Winston, A.P., Palmer, R.L., and Harvey, P.K. (2001) "Do broken relationships in childhood relate to bulimic women breaking off psychotherapy in adulthood?" *International Journal of Eating Disorders 29*, 2, 139–149.

Makin, S. (2002) *More Than Just a Meal: The Art of Eating Disorders*. London: Jessica Kingsley Publishers.

Malchiodi, C.A. (1999) *Medical Art Therapy with Children*. London: Jessica Kingsley Publishers.

Malchiodi, C.A. (2002) *The Soul's Palette: Drawing on Art's Transformative Powers for Health and Well-Being*. Boston: Shambhala.

Malchiodi, C.A. (2003) "Scope of practice, education, supervision, standards of practice, and ethics." In C.A. Malchiodi (ed.) *Handbook of Art Therapy*. New York: Guildford Press.

Mandali, M. (1998) *Everyone's Mandala Coloring Book*. Helena, MT: Mandali Publishing.

Mann, R.L. (1998) *Sacred Healing: Integrating Spirituality with Psychotherapy*. Nevada City, CA: Blue Dolphin Publishing.

Maslin, J. (2002) "Books of the times." *New York Times*. 10 October.

Maslow, A.H. (1990) *Toward a Psychology of Being Human*, 3rd edn. New York: John Wiley and Sons.

Matto, H.C. (1997) "An integrative approach to the treatment of women with eating disorders." *The Arts in Psychotherapy 24*, 4, 347–354.

McConeghey, H. (2003) *Art and Soul*. Putnam, CT: Spring Publications.

McMurray, M. and Schwartz-Mirman, O. (1998) "Transference in art therapy: A new look." *The Arts in Psychotherapy 25*, 1, 31–36.

McMurray, M., Schwartz-Mirman, O., and Maizel, S. (2000) "Art therapy: Indications for treatment of choice." *The Arts in Psychotherapy 27*, 3, 191–196.

McNiff, S. (1981) *The Arts and Psychotherapy*. Springfield, IL: Charles C. Thomas.

McNiff, S. (1998) *Trust the Process: An Artist's Guide to Letting Go*. Boston: Shambhala.

Mendell, D.A. and Logemann, J.A. (2001) "Bulimia and swallowing: Cause for concern." *International Journal of Eating Disorders 30*, 3, 252–258.

Moore, T. (1992) *Care of the Soul: A Guide for Cultivating Depth and Sacredness in Everyday Life*. New York: Harper Collins.

Naumberg, M. (1987) *Dynamically Oriented Art Therapy: Its Principles and Practice*. Chicago: Magnolia Street Publishers.

Newmark, G.R. (2001) "Spirituality in eating disorder treatment." *Healthy Weight Journal 15*, 5, 76–77.

Occhiogrosso, P. (1991) *Through the Labyrinth*. New York: Viking.

Okubo, M. (1983) *Citizen 13660*. Seattle, WA: University of Washington Press.

Olivardia, R., Pope, H.G., Borowiecki, J.J., and Cohane, G.H. (2004) "Biceps and body image: The relationship between masculinity and self-esteem, depression, and eating disorder symptoms." *Psychology of Men & Masculinity 5*, 2, 112–120.

Pearson, A. (2002) *I Don't Know How She Does It: The Life of Kate Reddy, Working Mother*. New York: Alfred A. Knopf.

Pearson, J., Goldklang, D., and Striegel-Moore, R.H. (2002) "Prevention of eating disorders: Challenges and opportunities." *International Journal of Eating Disorders 31*, 3, 233–239.

Pipher, M. (1995) *Hunger Pains: The Modern Woman's Tragic Quest for Thinness*. New York: Ballantine Books.

Polivy, J. and Herman, C.P. (2002) "Causes of eating disorders." *Annual Review of Psychology 53*, 187–213.

Pollak, S.D., Cicchetti, D., Hornung, K., and Reed, A. (2000) "Recognizing emotion in faces: Developmental effects of child abuse and neglect." *Developmental Psychology 36*, 5, 679–688.

Pope, H.G., Phillips, K.A., and Olivardia, R. (2000) *The Adonis Complex: The Secret Crisis of Male Body Obsession.* Carlsbad, CA: Gurze Books.

Presnell, K., Bearman, S.K., and Stice, E. (2004) "Risk factors for body dissatisfaction in adolescent boys and girls: A prospective study." *International Journal of Eating Disorders 36*, 4, 389–401.

Prinzhorn, H. (1972) *Artistry of the Mentally Ill*, rev.edn (first published 1923). New York: Springer-Verlag.

Rabin, M. (2003) *Art Therapy and Eating Disorders: The Self as Significant Form.* New York: Columbia University Press.

Reas, D.L. and Grilo, C.M. (2004) "Cognitive-behavioral assessment of body image disturbance." *Journal of Psychiatric Practice 10*, 5, 314–322.

Rehavia-Hanauer, D. (2003) "Identifying conflicts of anorexia nervosa as manifested in the art therapy process." *The Arts in Psychotherapy 30*, 3, 137–149.

Reindl, S.M. (2001) *Sensing the Self: Women's Recovery from Bulimia.* Cambridge, MA: Harvard University Press.

Rhyne, J. (1984) *The Gestalt Art Experience: Creative Process and Expressive Therapy.* Chicago: Magnolia Street Publishers.

Richards, P.S., Hardman, R.K., Frost, H.A., Berrett, M.E., Clark-Sly, J.B., and Anderson, D.K. (1997) "Spiritual issues and interventions in the treatment of patients with eating disorders." *Eating Disorders: The Journal of Treatment and Prevention 5*, 4, 261–279.

Riley, S. (2004) "The creative mind." *Journal of the American Art Therapy Association 21*, 4, 184–190.

Riley, S. and Malchiodi, C.A. (2003) "Family art therapy." In C.A. Malchiodi (ed.) *Handbook of Art Therapy.* New York: Guilford Press.

Rios, L.M. and Rios, T.M. (2003) *The Anorexia Diaries: A Mother and Daughter Triumph Over Teenage Eating Disorders.* Emmaus, PA: Rodale Press.

Robert-McComb, J.J. (2001) "Physiology of stress." In J.J. Robert-McComb (ed.) *Eating Disorders in Women and Children: Prevention, Stress Management and Treatment.* Boca Raton, FL: CRC Press.

Roberts, J. (1999) "Beyond words: The power of rituals." In D.J. Wiener (ed.) *Beyond Talk Therapy: Using Movement and Expressive Techniques in Clinical Practice.* Washington, DC: American Psychological Association.

Rome, E.S. (2003) "Medical complications of eating disorders: An update." *Journal of Adolescent Health 33*, 6, 418–426.

Root, M.P.P. (1989) "Family sculpting with bulimic families." In L.M. Hornyak and E.K. Baker (eds) *Experiential Therapies for Eating Disorders.* New York/London: Guilford Press.

Rosen, J.C. (1990) "Body image disturbances in eating disorders." In T.C. Cash and T. Pruzinsky (eds) *Body Images: Development, Deviance, and Change.* New York: Guilford Press.

Rust, M.J. (1995) "Bringing 'the man' into the room: Art therapy groupwork with women with compulsive eating problems." In D. Dokter (ed.) *Arts Therapies and Clients with Eating Disorders: Fragile Board.* London: Jessica Kingsley Publishers.

Sayers, D.L. (1970) *The Mind of the Maker.* Westport, CT: Greenwood Press.

Schaverien, J. (1995) "The picture as transactional object in the treatment of anorexia." In D. Dokter (ed.) *Arts Therapies and Clients with Eating Disorders: Fragile Board.* London: Jessica Kingsley Publishers.

Schoemaker, C., Smit, F., Biji, R.V., and Vollebergh, W.A.M. (2002) "Bulimia Nervosa following psychological and multiple child abuse: Support for the self-medication hypothesis in a population-based cohort study." *International Journal of Eating Disorders 32*, 4, 381–388.

Schwartz, N. (1996) "Observer, process, and product." *Journal of the American Art Therapy Association 13*, 4, 244–251.

Serpell, L. and Treasure, J. (2002) "Bulimia nervosa: Friend or foe? The pros and cons of bulimia nervosa." *International Journal of Eating Disorders 32*, 2, 164–170.

Shisslak, C.M. and Crago, M. (2001) "Risk and protective factors in the development of eating disorders." In J.K. Thompson and L. Smolak (eds) *Body Image, Eating Disorders, and Obesity in Youth.* Washington DC: American Psychological Association.

Sim, L. and Zeman, J. (2004) "Emotion awareness and identification skills in adolescent girls with bulimia nervosa." *Journal of clinical Child & Adolescent Psychology 33*, 4, 760–771.

Smolak, L. and Levine, M.P. (2001) "Body image in children." In J.K. Thompson and L. Smolak (eds) *Body Image, Eating Disorders, and Obesity in Youth.* Washington DC: American Psychological Association.

Smolak, L. and Murnen, S.K. (2001) "Gender and eating problems." In R.H. Striegel-Moore and L. Smolak (eds) *Eating Disorders: Innovative Directions in Research and Practice.* Washington, DC: American Psychological Association.

Smolak, L. and Murnen, S.K. (2002) "Meta analytic examination of the relationship between child sexual abuse and eating disorders." *International Journal of Eating Disorders 31*, 2, 136–150.

Smolak, L. and Striegel-Moore, R.H. (2001) "Challenging the myth of the golden girl: Ethnicity and eating disorders." In R.H. Striegel-Moore and L. Smolak (eds) *Eating Disorders: Innovative Directions in Research and Practice.* Washington, DC: American Psychological Association.

Society for the Promotion of Buddhism (1966) *The Teaching of Buddha.* Tokyo, Japan: Society for the Promotion of Buddhism.

Stemmler, G. (2004) "Physiological processes during emotion." In P. Philippot and R.S. Feldman (eds) *Regulation of Emotion.* Mahwah, NJ: Lawrence Erlbaum.

Stewart, T. (2004) "Light on body image treatment: Acceptance through mindfulness." *Behavior Modification 28*, 6, 783–811.

Stice, E. (2001) "Risk factors for eating pathology: Recent advances and future directions." In R.H. Striegel-Moore and L. Smolak (eds) *Eating Disorders: Innovative Directions in Research and Practice.* Washington, DC: American Psychological Association.

Stone, H. and Stone, S. (1993) *Embracing Your Inner Critic: Turning Self-Criticism into a Creative Asset.* San Francisco: Harper.

Stone, K. (2003) *Image and Spirit: Finding Meaning in Visual Art.* Minneapolis, MN: Augsburg Books.

Striegel-Moore, R.H. and Cachelin, F.M. (2001) "Etiology of eating disorders in women." *The Counseling Psychologist 29*, 5, 635–661.

Sudarsky-Gleiser, C. (2004) "The voice of the eating disorder is loud among us too: Challenging the Euro-centric bias of our profession." *The Renfrew Perspective,* Winter, 22–24.

Swados, E. (2005) *My Depression: A Picture Book.* New York: Hyperion.

Tamres, L.K., Janicki, D., and Helgeson, V.S. (2002) "Sex differences in coping behavior: A meta-analytic review and an examination of relative coping." *Personality & Social Psychology Review 6*, 1, 2–30.

Thompson, B.W. (1994) *A Hunger so Wide and So Deep: American Women Speak Out on Eating Problems.* Minneapolis: University of Minnesota Press.

Thompson, R.A. and Sherman, R.T. (1989) "Therapist errors in treating eating disorders: Relationship and process." *Psychotherapy 26*, 1, 62–68.

Tinker, K.N. (1997) *Out of My Mind: An Autobiography.* New York: Harry N. Abrams, Inc. Publishers.

Ulman, E. (1975) "Art therapy: Problems of definition." In E. Ulman and P. Dachinger (eds) *Art Therapy in Theory and Practice.* New York: Schocken Books.

Vanderlinden, J., Grave, R.D., Fernandez, F., Vandereycken, W., Pieters, G., and Noorduin, C. (2004) "Which factors do provoke binge eating? An exploratory study in eating disorder patients." *Eating & Weight Disorders 9*, 4, 300–305.

Varnado-Sullivan, P.J. and Zucker, N. (2004) "The body logic program for adolescents: A treatment manual for the prevention of eating disorders." *Behavior Modification 28*, 6, 854–875.

Waller, G., Babbs, M., Milligan, R., Meyer, C., Ohanian, V., and Leung, N. (2003) "Anger and core beliefs in the eating disorders." *International Journal of Eating Disorders 34*, 1, 118–124.

Warner, J. (2002) "Having it all." *Washington Post Review of Books.* 27 October 2002.

Warren, C.S., Gleaves, D.H., Cepeda-Benito, A., and del Carmen Fernandez, M. (2005) "Ethnicity as a protective factor against internalization of a thin ideal and body dissatisfaction." *International Journal of Eating Disorders 37*, 3, 241–249.

Warriner, E. (1995) "Anger is red." In D. Dokter (ed.) *Arts Therapies and Clients with Eating Disorders: Fragile Board.* London: Jessica Kingsley Publishers.

Way, K. (1993) *Anorexia Nervosa and Recovery: A Hunger for Meaning.* Binghamton, NY: Harrington Park Press.

White, M.A. and Grilo, C.M. (2005) "Ethnic Differences in the prediction of eating and body image disturbances among female adolescent psychiatric inpatients." *International Journal of Eating Disorders 38*, 1, 78–84.

Wiener, D.J. and Oxford, L.K. (eds) (2003) *Action Therapy with Families and Groups: Using Creative Arts Improvisation in Clinical Practice.* Washington DC: American Psychological Association.

Williams, H.C. (2002) *Drawing as a Sacred Activity: Simple Steps to Explore Your Feelings and Heal Your Consciousness.* Novato, CA: New World Library.

Williamson, D.A., White, M.A., York-Crowe, E., and Stewart, T.M. (2004) "Cognitive-behavioral theories of eating disorders." *Behavior Modification 28*, 6, 711–738.

Winerman, L. (2005) "Express yourself: Psychologists are bringing creative arts therapies into the mainstream." *Monitor on Psychology*, February, 34–35.

Wiseman, C.V., Sunday, S.R., and Becker, A.E. (2005) "Impact of the media on adolescent body image." *Child & Adolescent Psychiatric Clinics of North America 14*, 3, 453–471.

Wonderlich, S.A., Connolly, K.M., and Stice, E. (2004) "Impulsivity as a risk factor for eating disorder behavior: Assessment implications with adolescents." *International Journal of Eating Disorders 36*, 2, 172–182.

Wuthnow, R. (2001) *Creative Spirituality: The Way of the Artist.* Berkeley, CA: University of California Press.

Yalom, I.D. (1995) *Theory and Practice of Group Psychotherapy*, 4th edn. New York: Basic Books.

Ying, Y. (2002) "The conception of depression in Chinese Americans." *California Psychologists*, July/August, 20.

Zonnevylle-Bender, J.J.S., van Goozen, S.H.M., Cohen-Kettenis, P.T., van Elburg, A., and van Engeland, H. (2004) "Emotional functioning in adolescent anorexia nervosa patients: A controlled study." *European Child & Adolescent Psychiatry 13*,1, 28–34.

Subject Index

Author Index

Made in the USA
San Bernardino, CA
21 January 2020

63455947R00109